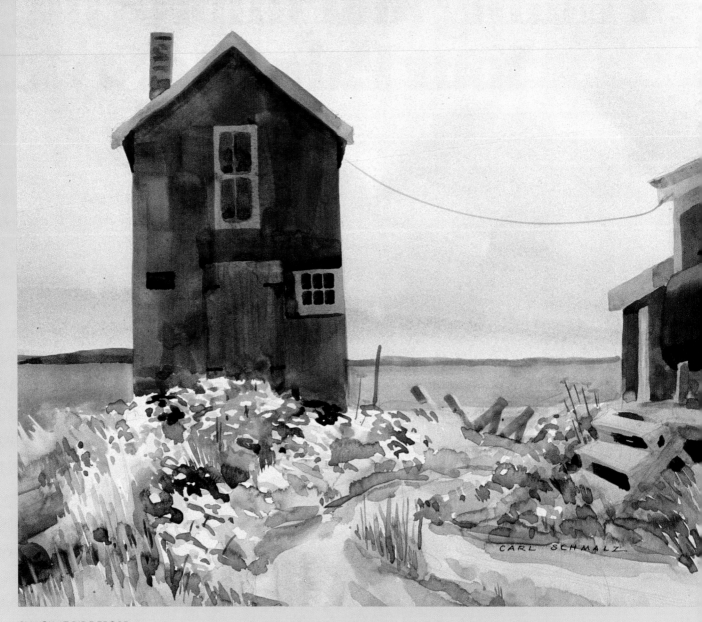

SHACK AT BIDDEFORD
POOL
by Carl Schmalz, 1974, 21"
× 15" (53 × 38 cm), 140 lb.
hot-pressed paper,
collection of the author.

Finding and Improving Your Painting Style

Carl Schmalz

DAVID & CHARLES
Newton Abbot London

ISBN 0 7153 8906 8
First published in Great Britain by David & Charles 1986

Printed in Japan by Toppan Printing Company
for David & Charles Publishers plc
Brunel House Newton Abbot Devon

Acknowledgments

No book is written except by building on the works of others. This book owes, first, a great debt to the late Professor Arthur Pope of Harvard University and his predecessor Professor Denman Ross, especially for the material in Chapter 7, which is based closely on Professor Pope's work. It also is based on the special knowledge and pedagogical gifts of Professor James M. Carpenter of Colby College as well as many others of my teachers and colleagues.

I have tried, in an abbreviated way, to adapt what I learned from Professors Pope and Carpenter about the great art of the world to the special nature of transparent watercolor in America. I trust that what I have said will be useful. It is not, however, all that either of those distinguished mentors could have said.

A book of this sort requires illustrations. I have tried to present a good cross-section of contemporary watercolors, together with a few fine examples from the past. I have also tried to include as many paintings as possible by people from all parts of this country, paintings by both women and men, and by people of different races, backgrounds, and different degrees of fame. I feel only partially successful in this, although I believe that the variety of illustrations achieved is still unusual.

I am deeply obliged to many people for the illustrations that appear here. Owners, artists, dealers, and museum staffs were particularly helpful. Among them, I single out the staffs of the Boston Museum of Fine Arts, the Fogg Museum, the Bowdoin College Museum, and Colby College Museum. I am particularly grateful to Dr. William C. Landwehr, Director of the Springfield Art Museum in Springfield, Missouri, who lent me a wealth of photographs of works awarded purchase prizes in the splendid Watercolor U.S.A. Exhibitions run by that institution for the last two decades. Equally, I salute David Stansbury, whose skill and care produced the color photographs that are not individually acknowledged.

I would like to thank Bonnie Silverstein, senior editor at Watson-Guptill Publications, whose interest in the original edition of this work, *Watercolor Your Way,* is responsible for this revision; and Betty Vera, who sensitively reorganized and abbreviated it. I am also deeply grateful to Murray Greenberg, chief chemist at M. Grumbacher, Inc., for providing most of the information and clarifying much else included in Chapter 8.

Finally, I owe an obligation to Professor Joel M. Upton of Amherst College, whose critical reading of my text aided me; to my wife, who not only made the initial typescript but protected me from unnecessary intrusion and bore with me through the long months of labor; and to all of my students from whom I learned something of how to talk about these matters.

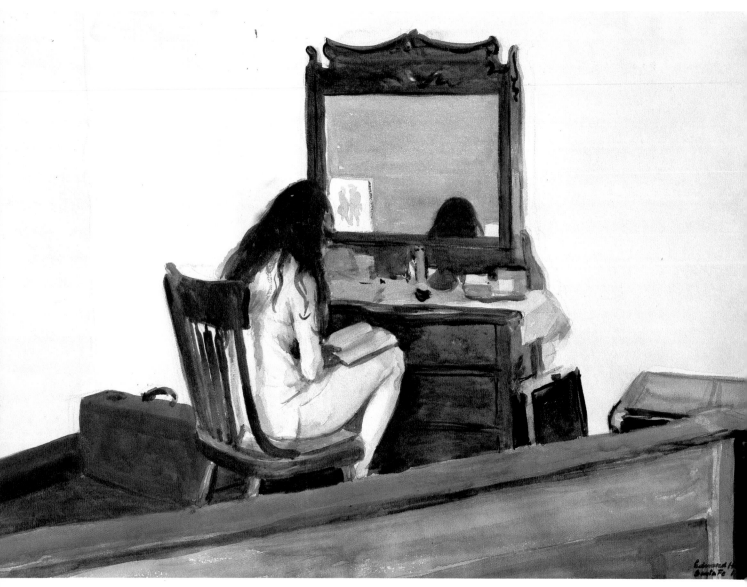

INTERIOR, NEW
MEXICO
by Edward Hopper, 1925,
13⁹/₁₆" × 19⁹/₁₆" (34 × 50
cm), courtesy of the Art
Institute of Chicago.

Contents

Acknowledgments 5
Introduction 8

MAKING THE INITIAL DECISIONS 9
 1. Choosing Subjects 10
 2. Focal Distance and Space 16
 3. Paper Size and Shape 24

BUILDING THE COMPOSITION 29
 4. Designing from the Center 30
 5. Using Similarities 36
 6. Exploiting Contrasts 42

USING COLOR 47
 7. Knowing Your Palette 48
 8. Transparent and Opaque Pigments 54
 9. Color Mixing 60
 10. Color Design 66

WORKING WITH LIGHT 75
 11. Lighting 76
 12. Colored Light 82
 13. Drawing, Pattern, and Darks 90
 14. Coherence Without Using Light 98

PAINTING TECHNIQUES 103
 15. Working from Light to Dark Values 104
 16. Strokes and Washes 110
 17. Edges and Reserved Lights 118
 18. Paint Texture 124

PUTTING IT ALL TOGETHER 130
 19. Coherence and Viewing Distance 131
 20. Discovering Your Style 136

Bibliography 142
Index 143

Introduction

When you make a painting, you make a completely new world. You do not just copy what you see; like a god, you create it. Your understanding and perception of the human experience—your strengths and weaknesses, your sympathies and dislikes—emerge on that sheet of blank white paper and reflect your responses to the world, to be translated by your vision and skill into a watercolor. That is because painting is a language—a visual one—and, like any language, it can have many personal "dialects." Thus, just as it can be said that *Madame Bovary* is written in French, indeed "in Flaubert," it can also be said that *Polish Rider* is painted "in Rembrandt."

Style and Pictorial Coherence

Even if you're unaware of having a particular viewpoint of your own, after a few years of painting, your work will begin to take on a certain look, a consistent integrity that reflects your personal style. And that is the subject of this book—how to recognize your style, improve and develop it.

Throughout, I address the basic problem of finding the simplest ways to integrate your technique with your subject, so that each painting you make is a *coherent* statement of your expressive aim. What is a coherent painting? To borrow from a dictionary definition of the term, it is one that is "logically and consistently ordered" and "connected or unified by certain principles, relationships, or themes." Your style develops from the way *you* achieve coherence in your paintings, and this process will be different for each individual artist.

Developing Critical Judgment

Regular, informed criticism of your work may not always be available once you're out of school, particularly if you live in a rural area and depend on attending infrequent workshops given by visiting artists, or on taking expensive and time-demanding painting trips. But developing critical ability is particularly important for the maturing artist who already has acquired the basic watercolor skills. You will need to be able to select your best paintings for an art show. You will also have to know which of your paintings to present to an art dealer as representative of your ability. Developing an analytical capacity will help you to sell yourself to others. It will also help you see the paintings of other artists more objectively. Finally, it will help you to improve your own work—and that is the most vital reason of all.

As you put paint on paper, you continually assess your progress. Every painting makes you alert to new possibilities or forces you to be wary of changing or refining old techniques. You are forced to make critical judgments constantly. For an artist, creating and judging are facets of the same process. Hence, learning to see paintings with some sophistication is just as central to your task as an artist as learning to handle paint with competence and facility.

How to Use This Book

This book is primarily about how to see, and most especially about how *you* see and work. It is an introduction to criticism, not a book on how to paint. So, apart from the mention of a few materials in Chapter 18 to help you achieve texture, there is no special list of materials. You will need only your usual gear. The focus here will be on your selection of subjects, your palette, your working habits, and your way of producing coherent paintings—not on your materials. However, you might find it worthwhile to spend some time looking through your materials critically and asking yourself why you use particular items.

The principal thing you should be doing is looking hard and analytically at your own work. To that end, I want you to select about twelve to fifteen paintings that you think represent your best and, preferably, your most recent work (though a few can be as old as five or ten years). Ideally, your pictures should represent an accurate cross-section of your achievement to date; so choose paintings with a variety of shapes, sizes, subjects, and treatments.

In assessing your style, you will be analyzing the definite "look" that characterizes most of your work, holding it together as a product of your own personality and experience. You will also be concentrating on developing your artistic strengths rather than dwelling on your weaknesses. And finally, I will suggest ways you can develop your own critical skills so you can analyze objectively—and thereby improve—your work.

Making the
Initial Decisions

CHAPTER ONE

Choosing Subjects

Why do you paint what you paint?

Every choice you make in painting is an intensely personal one. Each picture you paint is a separate, self-defining world. It is your creation, and you are responsible for its order, its wholeness, and its meaning. Since the subject you choose to paint is usually the source of your first germ of an idea about the making of the picture, it is both the beginning and the end. Its importance is central. The freer you can be about this basic decision, the better.

The purpose of this chapter is to help you determine whether or not you are in an involuntary subject rut—and, if so, to suggest ways of shocking yourself out of it. Although your subject matter may be limited somewhat by external factors beyond your control, most of your choices are a matter of personal decision.

We are often influenced by the subjects selected by friends who are painters or by other artists whose work we see in exhibitions, magazines, and homes. If travel and acquaintance with the work of others inspire you to try new subjects, this sort of influence is a good thing. But be sure it is not just a smoke screen behind which you are hiding a refusal to come actively to grips with your own subject preferences.

The Trap of Tradition

One of the most insidious constraints on your choice of subject matter may be the weight of tradition. You may have been to many watercolor shows and felt you were seeing a dreary redundancy of subject matter: New England barns, fishing boats and shacks, and abandoned farm machinery. Such extreme conservatism derives from watercolor's history as a medium over the last two hundred years, as well as from public expectation.

During the early nineteenth century, artists commonly used watercolor as a sketching medium (just as Dürer had around 1500). It was a quick way of making color notes for landscapes. Turner, Constable, and other European artists worked in the ambience of Romanticism, which tended to infuse nature with human sentiments.

Romanticism lingered, and Impressionism exerted its influence on watercolor painting during the last third of the century. Although Winslow Homer was never truly an Impressionist, his work does reflect the intense concern with light effects that lay at its heart. John Singer Sargent's later watercolors are very close to Impressionism, both in subject choice and handling. And many other Americans, including Childe Hassam and Dodge Macknight, worked in the Impressionist mode.

The twin heritage of Romanticism and Impressionism remains with us, profoundly influencing the subjects of contemporary watercolorists. Romantic nostalgia (broken-down evidences of earlier habitation) and anthropomorphism (the persevering tree deformed by the wind) continue, and there is still a dominant concern with landscape and an emphasis on the total effect of illumination.

There is nothing inherently wrong with such subjects. I usually paint them, and probably so do you. Perhaps if you had an irresistible desire to engage different sorts of artistic problems, you would not be painting in transparent watercolor at all! Even so, tradition may tend to limit your choices, often more than you would like. But it is still possible, and desirable, to extend your range of subjects.

Returning to the Same Subjects

Availability of subjects can be a serious problem. Unless you are content to depend on photographs, you cannot paint Brazil unless you go there.

Artists also tend to return again and again to familiar subjects, a practice that is fine if it is deliberate. The red bait shack on its pier in my paintings *Government Wharf* and *Fisherman's Morning* was a "Motif No. 1" in my summer classes. I have painted it about twenty times, and each picture is different. In *Government Wharf* the day is foggy, the tide is low, and colors are very low in intensity. I flooded opaque mixtures onto the paper to increase the surface interest caused by the sedimentation and the granulation of pigment.

Fisherman's Morning, also a demonstration painting, was done on a very different day; external factors such as a bright sun and nearly full tide help differentiate this picture from the other one. But there are many internal differences, too. The design is a horizontal with vertical accents rather than almost evenly balanced horizontal and vertical axes. I used

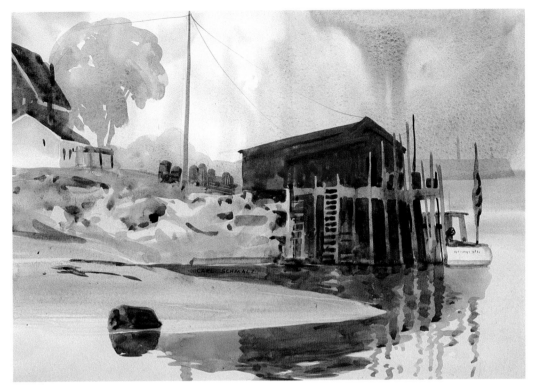

GOVERNMENT WHARF
*by Carl Schmalz, 1972,
15½" × 22" (39 × 56 cm),
140 lb. hot-pressed paper,
collection of the author.*

This painting and the one below show how the same subject can generate different paintings.

FISHERMAN'S MORNING
*by Carl Schmalz, 1975,
15½" × 22¼"
(39 × 57 cm), 140 lb.
hot-pressed paper,
collection of the author.*

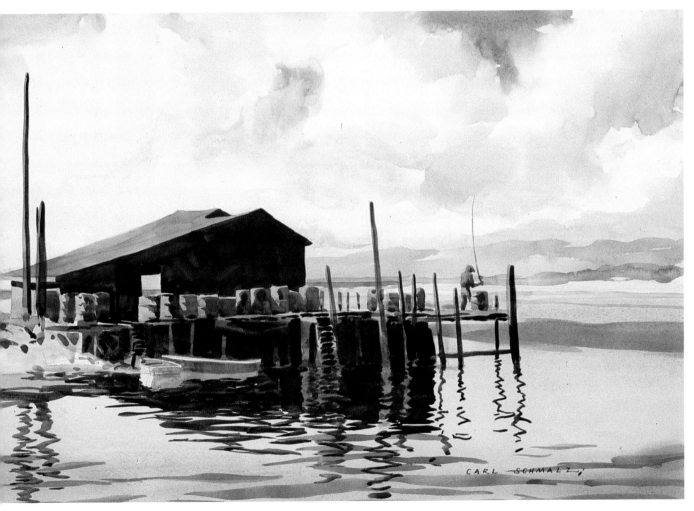

many more transparent colors to achieve the high intensities I wanted. Surface interest was created by brushstrokes instead of pigment granulation.

As *Government Wharf* and *Fisherman's Morning* illustrate, a representational painting is about much more than the specific objects depicted; the subject is the sum of all the recognizable elements, the materials used, and how they were used—the brush marks, colors, shapes, lines, and values. And so, although the basic subject of my two paintings seems to be the same, one picture is actually "about" a man out early for fishing, while the earlier one is "about" mood.

Broadening Your Range of Subjects

You can benefit from widening your choice of subjects, if only to enlarge your drawing capacity and technical skills. Even more important, pushing out toward new subjects enlarges your imaginative power and nourishes sensitive perception.

The main reason for seeking variety in subject matter, however, is to increase control and mastery of your art—to give yourself the greatest possible amount of freedom to paint and say what *you* want.

You do not have to travel far to find fascinating subjects. Consider interiors, for example. Paul C. Burns, in his *Studio Door*, has put together a dramatic composition that speaks explicitly of the painter's world—books and references, other paintings, an antique chair, and the open door. The importance of what is outside the door is seen in the light reflections it brings into the studio. Margaret Graham Kranking's *Waiting for Spring* (page 43) is a type of "domestic" still life. Consider such possibilities around *your* house.

The outdoors provides a wealth of subjects besides traditional landscapes. Look at Osral B. Allred's *The Tender*, a powerful recognizable image that suggests a Franz Kline abstraction. A variation on the old-machinery theme, it evokes thoughts of still other subjects, such as the granite footings and beams of barns. But newer things also come to mind—the business end of a cement truck, bridge underpinnings, and a trailer-truck rig. My *Maine Still Life* (page 120) and *Enclosed Garden* (page 92) are further examples of this type. Mary Kay D'Isa's *Prancing Wooden Horses* offers yet another successful variation. Sounds of long-ago merriment echo through the artist's skillful placing of the darks, the rhyming pattern of legs, and the spare indication of poles.

Don't forget, either, the possibilities in going back to a familiar subject but reinterpreting it through unusual lighting.

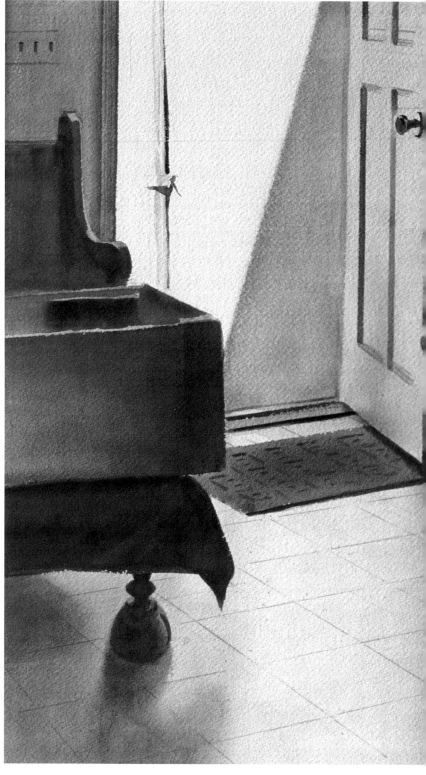

STUDIO DOOR
*by Paul C. Burns, A.W.S.,
1971, 22" × 30"
(56 × 76 cm), 300 lb. rough
paper, collection of the
artist.*

This is a subject available to anybody—and one open to virtually endless variations.

MAKING THE INITIAL DECISIONS

PRANCING WOODEN HORSES
by Mary Kay D'Isa, 1983, 14½" × 20" (37 × 51 cm), 140 lb. rough paper, collection of the artist.

D'Isa avoids sentimentality by isolating the carousel horses against a stark white background and focusing on their color and pattern.

THE TENDER
by Osral B. Allred, 1967, 15½" × 21¼" (39 × 54 cm), rough paper, collection of the Springfield Art Museum, Springfield, Missouri.

This unusual close-up of old machinery makes a striking image.

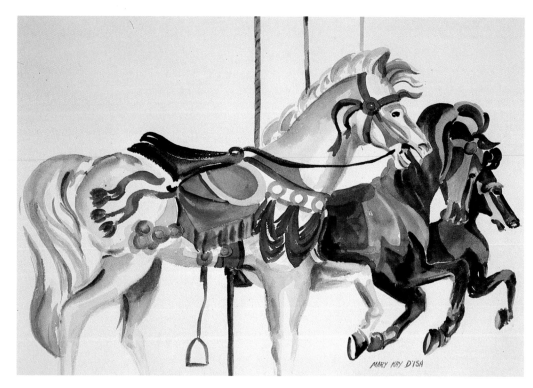

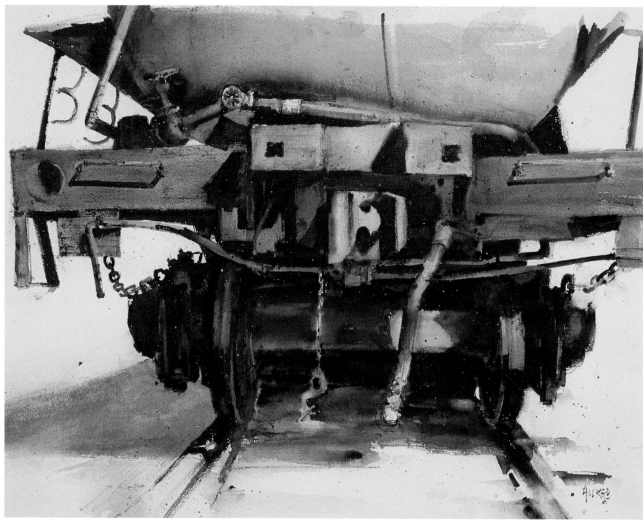

MAKING THE INITIAL DECISIONS

Ask Yourself . . .

What kinds of subjects do I paint?

Get out your picture collection now and spread it around so you can see all your paintings easily. Begin by dividing your work into broad subject groups. For example, have you only landscapes, or are there still lifes, portraits, figures, and interiors among your subjects? You can then subdivide each category that contains more than one picture. You might divide your landscapes, for example, into groups that have rural and urban themes, those with and without buildings, and those with or without water. Or you could divide them according to distant or close-up views.

This kind of analysis organizes your sense of what subjects in general are interesting to you. It also gives you an opportunity to reflect on the degree to which your conscious choice has been operating in subject selection. It may also encourage you to consider trying some different subjects or different approaches to familiar themes.

Do I tend to avoid certain subjects?

You enjoy painting particular subjects, but is this a result of conscious choice? Do you know an artist who is a whiz at and "loves" painting flowers, but who actually paints them chiefly because of a lack of confidence with perspective? Real or imagined inability to draw well is an all-too-frequent subject selector for many artists. Do you never put figures in your landscapes because you prefer the "feel" of barrenness? Or don't you draw figures very well? Do you avoid subjects of intense color because you seek the modesty and calm of low intensities? Or do you fear the power and potential for disharmony inherent in full intensities?

Look again at your paintings. Try to figure out what may be inhibiting you. If it is a reluctance to draw buildings, get a book on perspective from the library and practice, or take a course—but learn. You can overcome any limitation of mere technique. The same thing applies if you are uncomfortable drawing "pure" landscape. Practice trees and foliage, look for the structure of the land, notice how it is modeled. Sketch at every opportunity. Figures and faces also can be mastered through vigorous effort.

How can I broaden my range of subjects?

If your subjects tend to be rather similar, that is not necessarily disastrous. In the final analysis, you can only paint well those subjects that interest you and prompt a personal responsive resonance in your mind and spirit. You may have, even subconsciously, selected a class of subjects that appeals to you, and you may have learned to treat them in ways that satisfy you. But if you have the slightest yen to try something new and different, go ahead; it can only lead to further growth.

There is only one way to learn new ways; that is to try them, again and again. Put out some new colors and try a really bright painting. Take a weekend trip—not necessarily very far away, but somewhere you've not painted before. If you don't drive or you are otherwise housebound, take another look around you. There must be views and corners out of which you could squeeze a different picture.

How about attempting an interior? Every home has interesting corners. Think what might be done with sinks, after-dinner clutter, unmade beds, the paint shelf, corners of garages, vegetable gardens, gardening tools, cellars, and attics.

Popular subjects are sign-covered building façades and walls, often embellished with fire escapes, street junk, or old machinery. How about looking even closer at these subjects? Could anything be done with peeling plaster itself?

How about pavements, with or without gutter detritus? Where are the paintings of dumps, car graveyards, freeways, and billboards—all ubiquitous evidence of civilization's impact on earth and all loaded with pictorial potential. If you are put off by seaminess, then why not think about exterior close-ups, what I call "outdoor still lifes"?

In short, adopt an actively seeking attitude, look everywhere for subjects, draw as much as possible, and put down every picture idea that crosses your vision. Never turn off your painter's eyes.

Focal Distance and Space

How are you organizing the focal distance and space in your pictures?

Selecting a subject for a painting is only a beginning. Your response to that subject demands a great many decisions as you translate your sense of it into a visual order for the viewer. Focal distance and the overall organization of pictorial (or illusory) space are among these decisions, and they are the primary concerns of this chapter. I won't attempt to cover all possible types of spatial organization in representational painting, but will suggest a few ways of categorizing treatment of depth to help you think critically about it.

There are three primary ways of focusing a painting: in the foreground, in the middleground, and in the distance. Each general type of spatial treatment is subject to virtually infinite variations and combinations. There are other sorts of spatial organization and structure that you also need to be aware of. For example, do you like to look *up* at, *out* at, and *around* your subject? Or do you like to look *down* at and *into* it? If your focus is in the middleground or distance, do you prefer to give the foreground approximately equal interest or to vault the viewer's eye over it? Further, do you use a variety of interesting ways to link spatial order to the surface organization of your picture?

No matter what your preferences, the spatial organization of your picture must be consistent in itself and also congruent with both surface design and expression if your painting is to become an unassailable "world" of its (and *your*) own.

Foreground Focus

The foreground can be an emphasized, even exclusive, focal point. It permits the near and little to become large and important, allowing you to concentrate on descriptive textures. Larry Webster's *The Latch*, for instance, symbolizes all our experiences of opening and closing. Webster has emphasized and combined painterly and descriptive textures, increasing them sequentially from the periphery of the painting to the center.

THE LATCH
by Larry Webster, 21" × 29" (53 × 74 cm), smooth-surface illustration board, collection of the artist.

Webster exploits his foreground focus, changing an ordinary piece of old hardware into a portentous symbol.

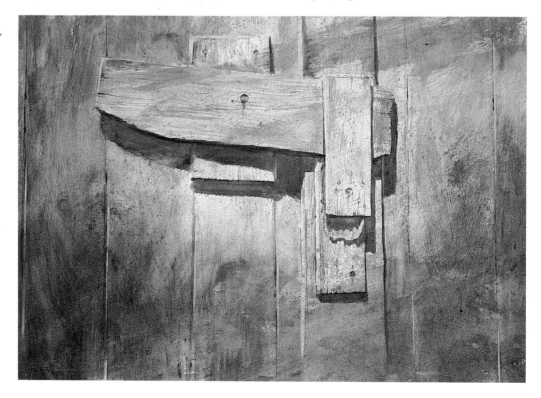

Middleground Focus

Traditionally, most watercolorists—indeed, most representational landscapists—have focused their subjects in the middleground. This focal point allows the artist to balance or contrast the foreground against the subject, which may also be set off by the distance behind or beyond it. This is one excellent way of expressing a great many human concerns, but it does not exhaust the variations.

Middleground focus usually includes deep space, presenting the artist with the classic foreground problem as well as more options and risks in surface organization. Nicholas Solovioff's *Lighthouse on Gibbs Hill, Bermuda* (page 80) is a simple solution. He treats the foreground grass as paint texture, which introduces the viewer to the more complicated strokes and textures of the middle distance (where, of course, he places the center of interest). The sky is a pictorial *diminuendo*, both as illusory distance and as paint.

In *Beinn Tangaval, Barra* (page 34) I have done a similar thing. A few zigzags take the viewer through the foreground to the dunes, modeled and colored by the afternoon light. The mountain is a coda in the distance, modeled by delicate hue and value changes. As for

surface design, it is the simplest: the dunes and cows are the subject. They are near the center, and they place in perspective the beach and more distant mountain.

Note that the foreground in my painting has been given scale by small darks at left that suggest perspective. Foregrounds are best handled (until you have other ideas) by keeping your treatment of brushstrokes or washes compatible with the rest of your surface. You can be detailed or vague, but your first obligation is to the *painted* integrity of your picture. This may allow a kind of vignetting, which is very successful in Mary Kay D'Isa's *A Brush with Winter*. Or it may call for about the same degree of descriptive detail as other parts of the picture.

Distant Focus

The least used, and least understood, focal point is the distant one. Its difficulty lies in the fact that it makes the foreground an introduction, as it were, to nothing. Yet the distant focus offers some really splendid subject treatments. Look at Nicholas Solovioff's *Crawl Hill, Bermuda*. Most of the foreground is filled with the rainwater-collecting basin, and foliage and buildings have been pushed into the middle

CRAWL HILL, BERMUDA
*by Nicholas Solovioff, 1979,
15" × 22" (38 × 56 cm),
140 lb. cold-pressed paper,
collection of the artist.*

In this panoramic view, the sea's distant edge is the real focus of the painting, just as spaciousness is its subject.

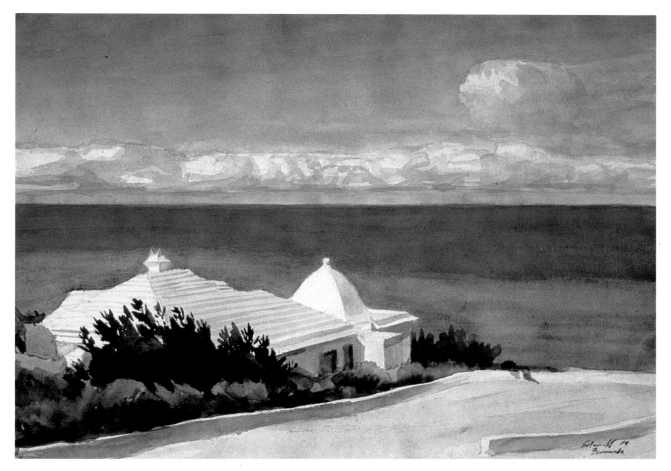

distance. But when you try to see that area as "the subject," your eye will not stay there. The upward thrust of the oleanders, stepped roof, chimney, and buttery tower keeps pushing attention toward the upper, larger portion of the paper. You are forced to realize that the subject is, in fact, the expanse of sea and its junction with the low-lying clouds—the edge of the world.

There are two basic ways of handling a distant-focus landscape painting—by using a low horizon or a high one. Since your center of interest is far away, you must usually produce a panoramic view. This means that you want either an interesting sky or a foreground and middleground that enhance your main focus without stealing the show from it.

The first solution is illustrated by my *Meditation, Warwick Long Bay*, which sets the horizon somewhat below the middle of the picture but still includes a good deal of sky. A bit of cloud at left and some purposeful brush-strokes at right help keep the area interesting; the foreground is articulated by footprints and seaweed; the middleground is marked by the seated figure. I left brushstrokes in the sky to give it a "painted" look. Some of the strokes also parallel the foot tracks on the beach. Color organization runs from yellow/green through the cool colors to purple and red/purple—all at fairly high intensities. Low-intensity orange, the complement of blue, occurs in the sand.

Salt Marsh, June (page 67), with its high horizon, exemplifies the alternative option. The lower, or earth, section of the picture had to be interesting without challenging the focus on the distant buildings and tree lines. I used color intensity, color contrast, and highly visible brushstrokes, but I tried to avoid very much specific descriptive detail.

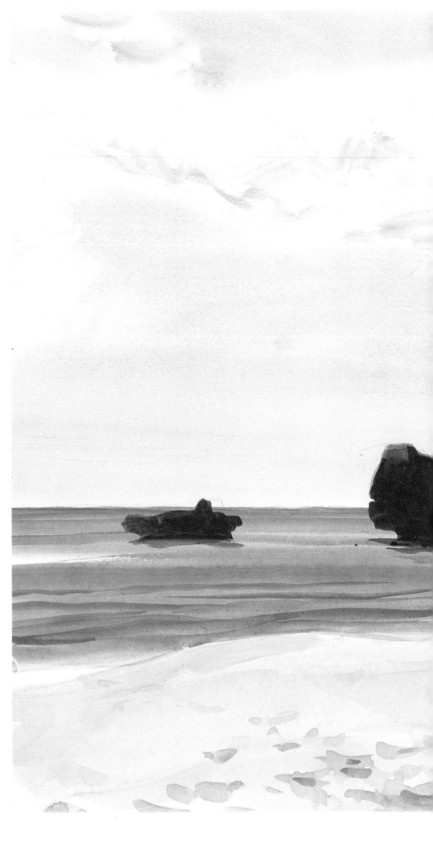

MEDITATION,
WARWICK LONG BAY
by Carl Schmalz, 1976,
15¹/₂" × 22" (39 × 56 cm),
140 lb. hot-pressed paper,
collection of the author.

This distant-focus picture is somewhat modified by the figure in the middle distance, but the real center of interest remains the oddly sculptured, faraway Bermuda rocks.

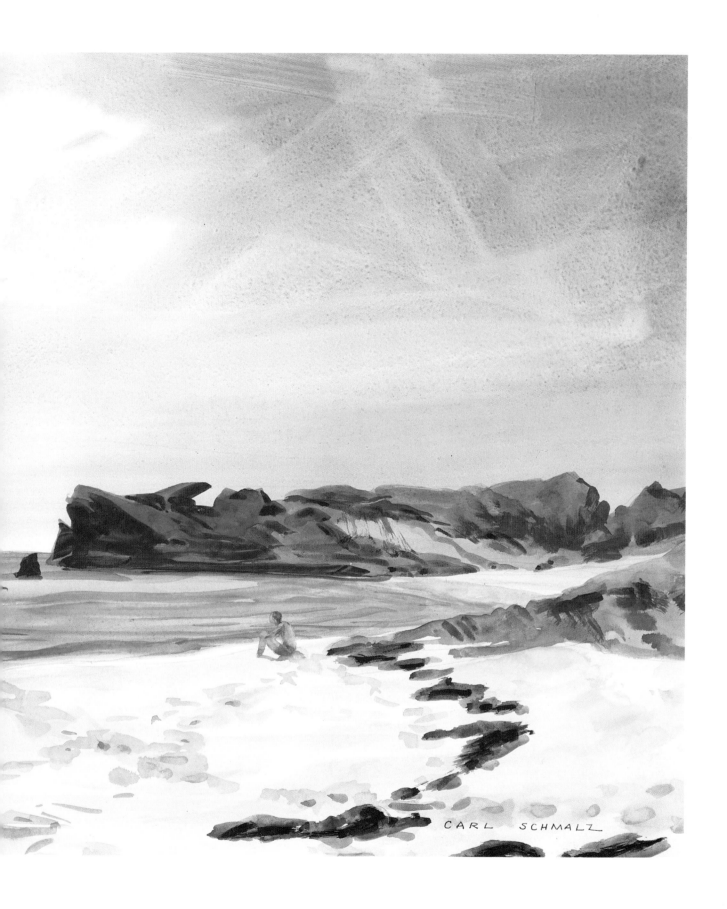

CARL SCHMALZ

Spatial Organization and Picture Space

In recent years watercolorists have favored flat, head-on views of the walls of buildings or other wall-like subjects. Characteristic of this type of spatial arrangement is a very shallow picture space, as in Phoebe Flory's *Wall Pattern, Venice*, in which subject and treatment emphasize both descriptive textures and paint-surface. Flory rubbed and drew on waxed paper laid over the surface to produce the resist textures on the wall and in the grillwork.

The "wall" in such a painting can be placed anywhere from immediately behind the picture plane to several "yards" into pictorial depth, as in Everett Raymond Kinstler's *Morning—19th St.* This is a powerful and effective means of ordering space precisely because it establishes a right-angle relationship between the viewer's line of vision into illusory space and the surfaces of both the painting and the wall depicted in it. This same theme can then be amplified on the two-dimensional surface of the wall, where the shapes of doors and windows echo the shape of the picture itself. Two- and three-dimensional spaces are linked through these right-angle repetitions.

Pictures organized this way almost always have a foreground focus, but this is not invariable. For example, in *Boat House Basement* the closest piles establish a clear foreground plane, but they are then played against more distant verticals and diagonals, unifying the strong linear contrasts that form the surface design. The viewer's attention is directed from the nearest to the farthest supports and back again, enhancing the sense of progress through the depth of the painting. The viewer feels threatened by the heavy, dark horizontal of the floor above, but protected by the posts. The picture expresses something of our experienced confusion of fear and confidence.

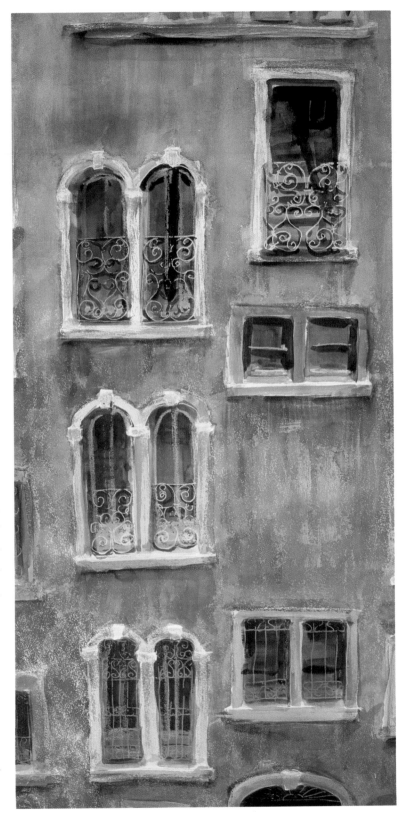

WALL PATTERN, VENICE
by Phoebe Flory, 22" × 12" (56 × 30 cm), 140 lb. hot-pressed paper, collection of Mr. and Mrs. Donald Rorabacher.

The design of this head-on view of a wall, with its shallow picture space, is based largely on subtle placement of objects of importance—in this case, the windows.

MAKING THE INITIAL DECISIONS

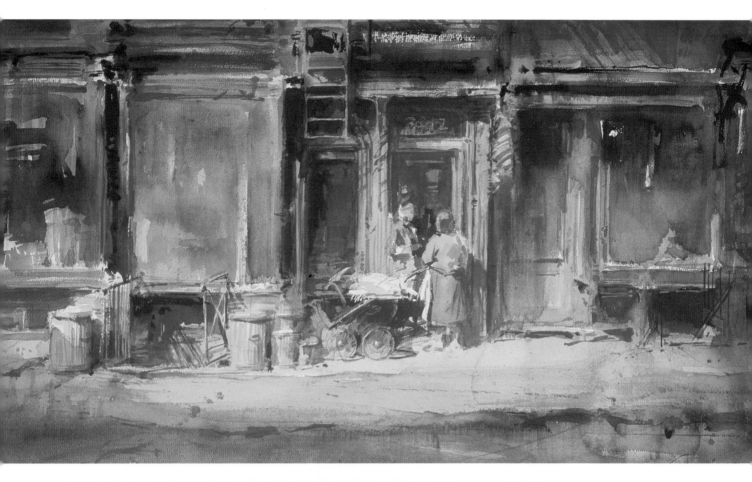

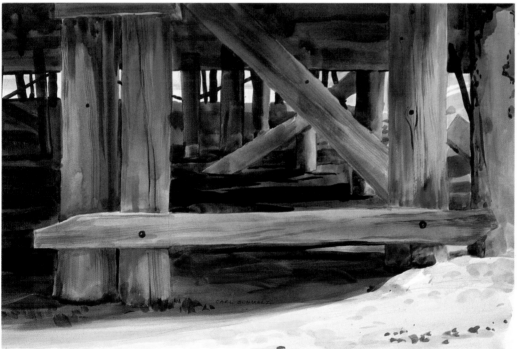

MORNING—19TH ST.
by Everett Raymond Kinstler,
15" × 28" (38 × 71 cm),
rough watercolor board,
collection of the artist.

Here the wall is placed
well back in the picture
space, but the basic
spatial organization is
the same as that in
Flory's *Wall Pattern,*
Venice.

BOAT HOUSE
BASEMENT
by Carl Schmalz, 1982,
15" × 22" (38 × 56 cm),
140 lb. hot-pressed paper,
collection of the author.

Here the viewer's eye
is encouraged to wan-
der through the deep
space between the
nearby "wall" elements.

UNIVERSALIST
CHURCH,
GLOUCESTER
*by Edward Hopper,
14" × 19¼" (28 × 50 cm),
cold-pressed paper,
courtesy of The Art
Museum, Princeton
University.*

A view from below often creates dramatic angles and expressive diagonal lines on the surface.

A similar spatial organization can be created by a view from above, in which the ground plane is tilted into the picture from foreground to background—often with little or no sky included—so that the ground plane itself becomes the subject. If the view is seen head on, horizontal and vertical axes frequently order the surface. Seen at an angle, such views produce a network of diagonals on the surface, as in Eliot O'Hara's *Gargoyles over the Seine.*

Frequently, architecture seen from below also creates dramatic diagonals on the picture surface, as in Edward Hopper's *Universalist Church, Gloucester;* such a view can be used to monumentalize almost any subject. Notice how Hopper plays the steep roof and eaves in

perspective at left against the chimney shadows at right. These lines are at right angles to each other and, in a subliminal way, restore the right-angle regularity of the buildings that had been distorted by the artist's viewing position.

Larry Webster's *Dock Square Florist* illustrates another sort of spatial organization, the simple central placement of a main feature with more distant things falling away at the sides. Webster has greatly reinforced this center-focused design by adding spatial emphasis to it. A similar strengthening occurs with the opposite spatial treatment, in which depth is greatest near the center of the painting.

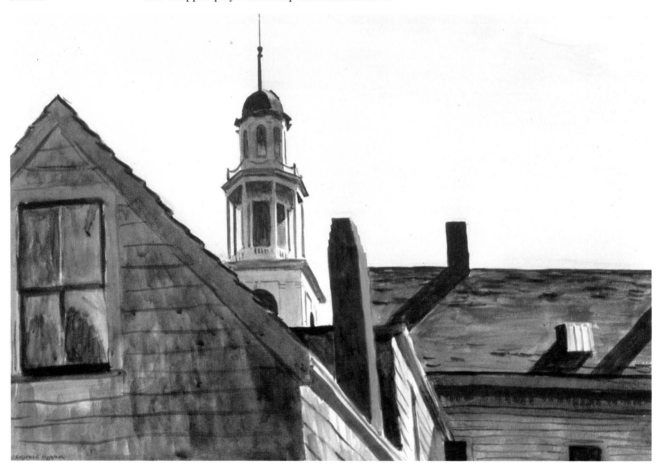

MAKING THE INITIAL DECISIONS

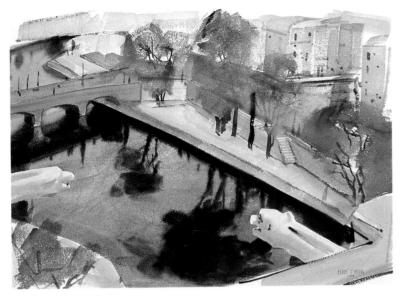

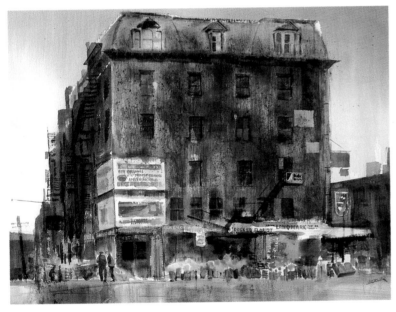

GARGOYLES OVER THE SEINE

by Eliot O'Hara, 1948,
15" × 22" (38 × 56 cm),
140 lb. rough paper,
courtesy of O'Hara Picture
Trust. Photo by Woltz.

This middleground-fo-
cused view from above
produces a surface or-
ganization based on in-
terlaced diagonals ac-
cented by smaller
verticals.

DOCK SQUARE FLORIST

by Larry Webster, 1968,
21" × 29" (53 × 74 cm),
300 lb. cold-pressed paper,
collection of the artist.
Obrig Prize for Watercolor,
National Academy of
Design, 1970.

In this head-on view
the recession at the
sides gives a special
prominence to the cen-
ter façade.

Ask Yourself . . .

Are all three focal distances represented among my pictures?

Line up all your selected paintings so you can
examine them from the point of view of spatial
focus and organization. Do you tend to use one
type fairly exclusively? Remember that your
subject preferences have considerable effect
on your choice of focal distance. If you have a
relatively narrow range of subjects, you can
expect this to be reflected in a somewhat
restricted treatment of space. For example, if
you enjoy painting flowers or still lifes, you are
likely to have a lot of paintings with a fore-
ground focus.

Are the similarities (or differences) of focus justified?

Look at your paintings again. Are their focal
distances the result of deliberate decision?
Have you consciously chosen the best focus
for effectively expressing each subject, or are
your paintings pretty much the same due to
unexamined habits? If there are many different
focal distances among your pictures, is it be-
cause you tried to fit them to your expressive
aim, or is it variety for its own sake?

The point here, as always in this book, is to
increase control over your painting by helping
you become aware of your choices. There is
no law against using the same focal distance in
every picture you paint, but if this is happening
unconsciously, you might explore other op-
tions—and vary your subjects as well!

Is there diversity of spatial organization in my pictures?

Do many of your paintings resemble one of the
examples discussed in this chapter? Do you
always tend to look up, out, and around? Or
down and in? Do you look from above? From
below? At a centered object? At a centered
space? Or—since this chapter has by no
means exhausted the possible forms of spatial
organization—do your pictures tend to fall into
some other category of similarity?

Subject matter is not the only controlling
factor, of course. Each artist has profound
underlying preferences in spatial organization,
as in color and all other aspects of art. As you
study your paintings, you are getting to know
better what some of your preferences are,
what you like about your own work, and what
characteristics are most "you."

If you feel you could afford to be more
adventurous in spatial organization, try to be
bold about it. Set hard problems for yourself
and be imaginative about solving them. Try a
painting of nothing much but a distant water
tower. Paint something head on, such as your
cellar wall or the side of your house.

CHAPTER THREE

Paper Size and Shape

Do you consciously select the best format for each painting?

Do you usually paint your watercolors on Imperial half-sheets or full sheets? (There are other habits as questionable.) If so, I'd bet that your *honest* reasons are mainly practical. That is, for exhibition purposes you may have mats, glass, frames, and shipping crates already fitted for your usual sizes. By now these sizes and shapes may seem to be your "natural" way of envisioning a picture, but can you stop a moment to consider what an insidious inhibition you are imposing on yourself?

The size and shape of a painting are partly a function of the purpose it is to serve. Paintings made for exhibition will be suitable for living rooms or other large spaces, but they may not work in halls or smaller rooms. You may not want to produce for exhibition to the exclusion of other possibilities. Most homes have places for small paintings, as well as for high, narrow ones, low, wide ones, and even round or oval ones. Each format offers you exhilarating new compositional challenges as well as the opportunity to broaden the range of usefulness of your "product."

Unusual Formats

You may not be able, for important reasons—your special vision, your economic circumstances, or your health—to produce large pictures. Good, then! Make smallness a virtue. Be realistic about where people live and what they do. Some of the greatest prayers in the Judeo-Christian tradition are about washing hands. Why should you not say to the world that you have wonderful paintings to hang over the sink, on the bathroom wall, or even next to the vacuum-cleaner closet? (I keep a serious and much-loved tiny painting near the washing machine in my cellar.)

Raphael designed the paintings in Pope Julius II's bathroom, and small pictures still have a place in less grand homes. Look at Larry Webster's *Fractured Face*. This circular painting might easily—almost automatically—have been a standard Imperial 22″ × 30″ (56 × 76 cm) size rectangle. The composition would have been stable and satisfying. But instead, Webster has set up lively tensions among the verticals and dynamic diagonals of the rock face by enclosing them in a circle. The contrast creates a visual excitement that a more stan-

dard format would have lacked. The circle also emphasizes continuity, which is developed in a pronounced sequence of angles formed by the cracks from the left of the picture to the right vertical. Thus the viewer senses both the durability of rock and the changes that affect it.

Oriental painters have long used a type of narrow hanging scroll called *kakemono* by the Japanese. *Tide* (page 31) approximates this shape, which permits an upward development of the design, enabling me to give extra emphasis to the cleft through which we glimpse the sea. Similarly, Phoebe Flory's *Wall Pattern, Venice* (page 20), with its tall, vertical shape, permits emphasis on the varied shapes and sizes of the windows while reinforcing the sense of architectural height. The size and shape of the paper have been determined as much by the subject as by any anticipated purpose to be served by the picture. This is true also of Kinstler's *Morning—19th St.* (page 21), where the long and repeated horizontals are echoed by the shape of the paper itself.

Size

Small pictures can be very powerful, though more often they are planned for intimate viewing and to express more private thoughts. Such is the painting on this page, which never had an official title because my wife and I have always known what it was: Do's hat, in siesta light, on the dresser in our *pension* room in Madrid. Little pictures need not be so personal, of course, but small studies (despite photography!) serve real purposes, both decoratively and expressively. Here, for instance, the correspondence in shape and size between the hat and vase is not accidental. The flowers above the vase and the light over the hat evoke a deep awareness of nature, humanity, and love.

Very large watercolors can create enormous impact. The large shaded surface of Larry Webster's *Backdoor* emphasizes the suspended dagger of white at right, a moving triangle threatening the stolid rectangularity of the closed door. The ongoing defeat of dark closeness by light openness is a fit subject for the picture's dimensions.

When you work with transparent water-

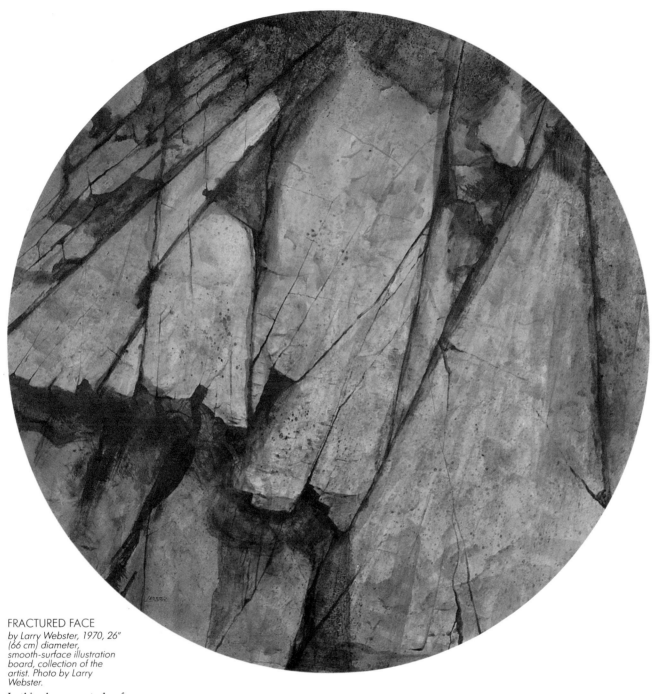

FRACTURED FACE
by Larry Webster, 1970, 26"
(66 cm) diameter,
smooth-surface illustration
board, collection of the
artist. Photo by Larry
Webster.

In this close-up study of
a quarry face, the
round enclosure serves
an expressive purpose,
suggesting images seen
through a microscope.
Think about how your
subject matter might be
enhanced by a different
format. The paintings
on this page are repro-
duced in proportion to
each other to show how
paper size (and shape)
can permit a different
kind of emphasis.

DO'S HAT
by Carl Schmalz, 1952,
4¼" × 5⅞" (11 × 15 cm),
90 lb. cold-pressed paper,
collection of the author.

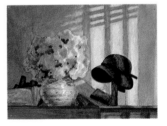

Small size doesn't auto-
matically imply trivi-
ality or intimacy, but there is
a relationship between
a painting's size and its
function.

RELATIVE PAINTING SIZES

Several paintings from this book are reproduced here to show their sizes relative to one another. Notice how the size of a painting affects the artist's message.

Standard Imperial, 30″ × 22″ (page 113)

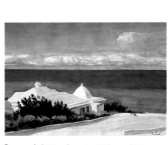

Imperial ½ sheet, 15″ × 22″ (page 17)

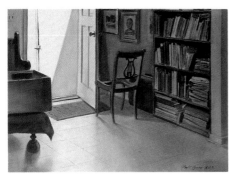

Standard Imperial, 22″ × 30″ (pages 12-13)

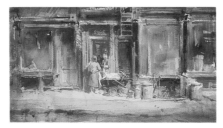

15″ × 28″ (page 21)

Imperial ½ sheet, 22″ × 15″ (page 85)

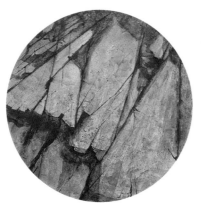

26″ round (page 25)

7″ × 10½″ (page 100)

9″ × 11″ (page 37)

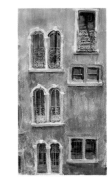

22″ × 12″ (page 20)

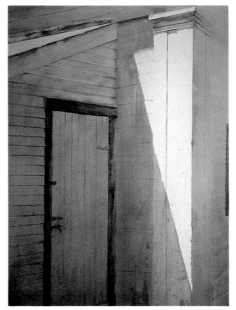

Illustration board, 40″ × 30″ (page 27)

MAKING THE INITIAL DECISIONS

color, however, you know that a large painting is not just a medium-sized one blown up. Several factors contribute to the difficulty of large watercolors. A basic one is finding paper in dimensions greater than the Imperial 22″ × 30″ (56 × 76 cm). Few art suppliers stock Double Elephant, which is 26½″ × 40″ (67 × 102 cm), or Antiquarian at 31″ × 53″ (79 × 135 cm), the two traditional sizes larger than Imperial. Hence, many artists such as Webster have used illustration board as a surface. This is available in 30″ × 40″ (76 × 102 cm) and 40″ × 60″ (102 × 152 cm) sizes. With a good-quality rag surface, it offers a solid support. Also, some manufacturers have recently begun to make paper available in wide roll form, which enables you to cut sheets to suit your own needs. Finally, you can always do as Charles Burchfield did: piece together sheets of watercolor paper and glue them on a fiberboard base to make any shape and size.

The primary problem with a large watercolor, however, is the technical one of getting enough paint onto extensive surfaces in one drying time. This requires a larger palette than normal, bigger squeezes of paint, and brushes larger than you could afford, if they were made. When painting, you often wish your arms were longer, too! Watercolorists who build up their paintings with brushstrokes will, in general, have fewer difficulties with large sizes than those whose method is based on washes. In either case, the secret is to plan your picture thoroughly, proceed deliberately, and paint area by area as much as possible. If you have trouble, remember that a successful large watercolor is a real tour-de-force, and keep trying.

The purpose of large paintings in the current art market is normally as exhibition pieces. Nevertheless, they can also fit into homes and, because of their size, serve in public spaces such as lobbies, board rooms, and auditoriums. The size of a painting usually says something immediate and compelling about the significance of its expression or message: the smaller a picture, the more casual its subject can afford to be. A large painting with a trivial subject comes across as bombast.

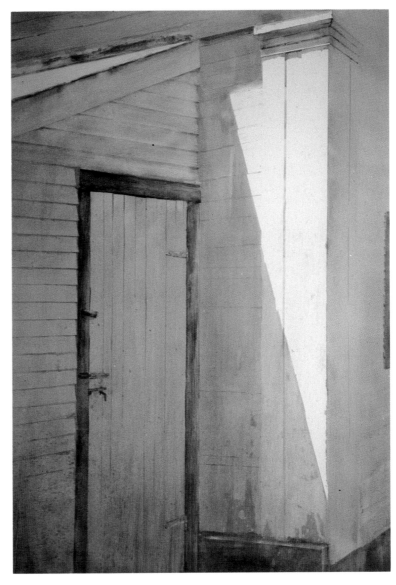

BACKDOOR
by Larry Webster, 1979, 30″ × 40″ (76 × 102 cm), smooth-surface illustration board, collection of Diane Davis.

This large painting is handsomely adapted to its format in both shape and size.

Ask Yourself . . .

Are most of my paintings pretty much the same in size and shape?

Get all your paintings out and consider them from this point of view. If nearly all of them have the same type of format, ask yourself whether this results from unexamined assumptions, the pragmatic reasons discussed earlier in this chapter, or a deliberate artistic decision on your part.

Perhaps you have simply not thought about how size, shape, and pictorial purpose relate to one another as they affect your artistic decisions. If so, consider what format changes might be desirable. Do you have a painting that looks as though it could be larger? Would it be more effective if it were smaller? Is there one that might have been vertical rather than horizontal? Could one be even stronger as a circular or oval composition?

How do you visualize your pictures in homes? Can you see them displayed comfortably only in living or dining rooms and perhaps occasionally in a bedroom, library, or den? Would any of them make good kitchen pictures or go over a telephone table? Could they hang on a stair wall, in a front hall, or in a dressing room? What about public spaces? Do any of your pictures have the panache for a bank or a theater lobby? How might they look in a doctor's or dentist's waiting room, a restaurant, or a hospital room?

Remember, of course, that the subject itself must be considered, as well as size and shape. These factors may predispose your pictures for one use over others. That's fine, as long as you are not overlooking alternate possibilities just because you have reached a comfortable plateau in your work. Perhaps a little aggressive outreach is called for. Some years ago I decided that my interest was in the middle and far distance, and so for quite a long time I painted almost exclusively on narrow horizontal sheets. That way I could minimize the foreground and keep my interest in the center.

If your pictures are similar in format for pragmatic reasons, you might reexamine the need for this self-imposed stricture. Perhaps you could retain your standard mats, frames, crates, and so on for a portion of your work—to save some trouble and expense—while permitting yourself special framing for an affordable number of more exploratory (even eccentric) sizes and shapes per year?

Am I falling into compositional habits?

This real danger can spring from working on the same size and shape of paper. It is depressingly easy to develop three or four basic designs that you unconsciously repeat with variations. The shock that comes from dealing with a different paper shape can help put you back on the road to growing as an artist.

If you have made a deliberate artistic decision to limit the shapes and sizes of your pictures, go to it! You will have found ways of achieving the degree of variety you want; you may even have become a specialist of a kind; and you will not waste time experimenting only for the sake of experiment.

Is there a good deal of variety in the formats of my paintings?

If so, ask yourself why. Have you altered the shape and size of some paintings by judicious surgery after they were painted? Have you been parsimonious with your paper, or are you given to employing scraps as best you can? There is nothing wrong with any of these practices, of course. But the variety they produce is likely to be almost accidental; it is not the result of a planned, thought-out congruence between the subject of the painting and its intended purpose. Although exhibition is important, it usually should be an incidental function of a painting. Think seriously about the way a picture of a given subject might be used by the purchaser; this can lead to greater coherence between the finished work and its ultimate purpose.

Painting on commission is the ideal way to achieve this sort of coherence, and you might consider doing it. Portraits are regularly commissioned, but there is also a largely untapped market for "portraits" of homes or the views from homes, and there is no reason why you cannot paint certain *kinds* of subjects, if not specific scenes, on a commission basis. This way you can see the room in which your picture will hang, talk with the potential owner about his or her feelings about it, discuss subject and color, and set about solving very particular and personal artistic problems. Some artists feel constrained by the commission situation, but others enjoy its special pleasures and challenges.

Building the Composition

Designing from the Center

Do rules of composition get in your way?

Since the sixteenth century, and probably before that time, painting students have used compositional rules as an aid. Many rules are helpful: "Never put the horizon in the middle," for example, and "Don't allow a strong diagonal to run out of the corner of the picture." Nevertheless, just trying to remember so many rules is stifling, and often they seem to contradict one another. "Don't put a large object in the middle" and "Don't put a large object at the edge" leave you with few places to put it! Rules of composition can be as bewildering as they are illuminating.

This chapter approaches the whole question of pictorial design from another point of view. It focuses essentially on how designing lines, axes, and surface shapes affects compositions.

Taking a Fresh Approach

One simple, sound way to think about composition is to determine what interests you most in a subject and put it near the middle of your paper. A few preliminary sketches will start you thinking, and then you can count on your own sensibility, intelligence, and experience to help you create a good composition.

Often the basic trick, though, is discovering precisely what it *is* that interests you. One purpose of this chapter is to help you recognize more easily what interests you in a subject for a painting.

Why You Paint a Particular Picture

Many representational artists paint something because "I like it" or "the subject appeals to me." But these are rather vague reasons. We don't often hear ourselves saying something as concrete as "I think these angles and shapes will make a great composition." And yet, for many of us, it is just such a subliminal perception that sets us to work. I have often been two-thirds along in a painting in which I fully intended to omit a telephone pole before realizing that the pole was essential to what I had seen as a good potential picture in the first place.

It is always possible that the central thing that interests you isn't a "thing" at all, but some eloquent space or gap, as in my *Tide*, which is really about neither water nor rocks, but about their power as expressed by the narrow constriction of the central cleft. You may also find yourself drawn by a group of things *around* a center.

Organizing the Composition Around the Center

A picture is not just "of" a thing or a group of things; it is also of their context, transformed by you into a new context—that of a sheet of paper of a certain shape and size. The paper context must become its own organized world, as well as a translation of the things represented. To make this happen, you must first decide what interests you, then see how the paper context can be ordered.

Often it is easy to identify what first caught your eye. In *Kitchen Ell* (page 32), I knew from the start that my primary interest was the window with the flowerpots on the sill and the tree shadows moving diagonally up the end of the ell. But the context seemed useful, for there were some verticals that could relate my central "thing" to the paper edges. I also saw some possibilities for linking foreground to distance. I cut my paper to a shape proportional to the window, but I doubt that I thought much further before beginning the drawing. I worked from a sketch.

I placed the focal window in *Kitchen Ell* to the left instead of at the exact vertical center of the paper in order to vary the intervals at either side of the window and make the proportional relationships more interesting. The right edge of the shadow inside the right side of the frame is almost at the exact vertical center of the sheet. I located the top of the window about a quarter of an inch below the horizontal center of the picture because I wanted enough bright blue sky at the top to balance the irregular shapes and value contrasts of the tree shadows on the foreground snow. However, my main focus is close enough to the center to demand attention.

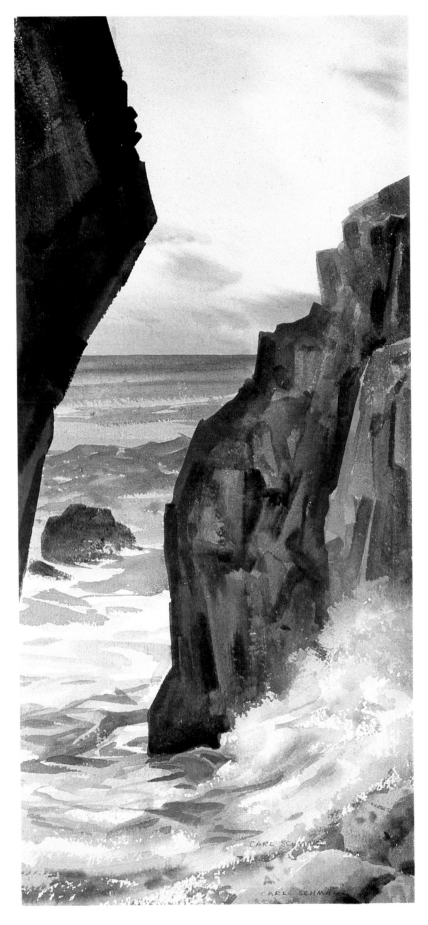

TIDE
*by Carl Schmalz, 1959,
22¹/₂" × 10¹/₄"
(57 × 26 cm), 140 lb. rough
paper, collection of the
author.*

The centrally placed focal point is not an object but a space—between overwhelming rocks that barely let the viewer (and the water)—escape to the open sea, giving a sense of conflicting forces.

KITCHEN ELL
by Carl Schmalz, 1970,
23" × 17" (58 × 43 cm),
140 lb. hot-pressed paper,
collection of the author.

The window and its flowerpots attracted me, and so I placed them near the center of my paper.

This sketch for *Kitchen Ell* is also reproduced and discussed on page 108.

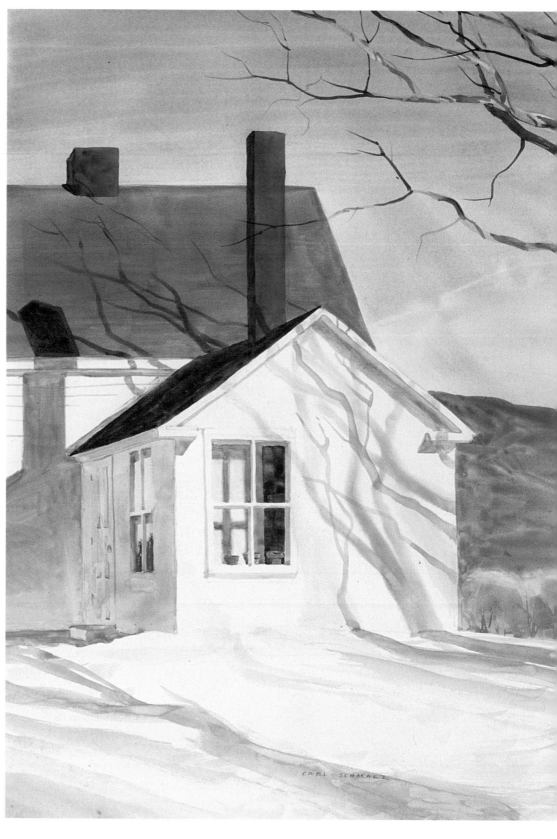

The composition is based on a series of verticals. The window becomes not only the representational center of interest but also the main compositional focus. Its horizontals are picked up in other elements, and there are architectural subthemes, too; the white triangle to the left of the ell roof appears as an inverted echo of the gable. The shape of the shadow on the snow at the bottom of the paper is strongly echoed in the lowest branch coming in from the upper right. The angle of the shadows makes it clear that the shadow cannot have been cast by this branch. This kind of deliberate echoing, while visually linking dissimilar things, also makes an expressive statement about the similarity between transience and insubstantiality (the shadow) and permanence and tangibility (the branch). The picture as a whole is about the consistency of change—the winter sun picking out the clay pots that will grow green plants when spring comes.

In *Marineland Porpoises*, Eliot O'Hara capitalizes upon the porpoises' streamlined bodies and flowing movement to establish a circular rhythm of concentric curves. The composition carries the painting's primary expressive message: undersea grace.

Another—and more usual—way of designing around a centrally placed focus can be seen in *Beinn Tangaval, Barra*. The top of the central dune provides a leitmotif that is echoed in the line of the mountain against the sky at upper right. Another parallel links the shoulder of the mountain at left and the dune below it. The viewer's eye is guided into the center by a series of implied zigzags in the sand and the shadows. Some of these angles are picked up in the brushstrokes used in the mountain itself. Without the structure that an architectural subject automatically provides, you must find likenesses and rhythms appropriate to your theme. The gentle diagonals that organize this picture and carry us into it also suggest the surge of the ocean that we know is nearby—even without our seeing it.

MARINELAND
PORPOISES
*by Eliot O'Hara, 1955, 15"
× 22" (38 × 56 cm), 140 lb.
rough paper, courtesy of
O'Hara Picture Trust.*

The artist designed from the center and also effectively used similarity of line, shape, and size.

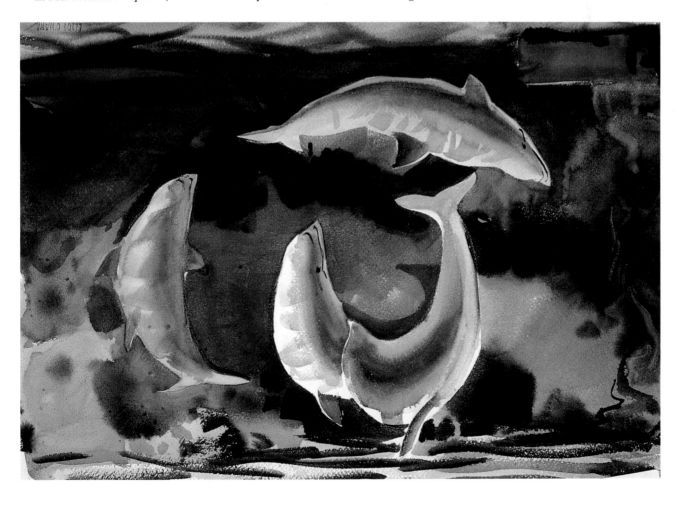

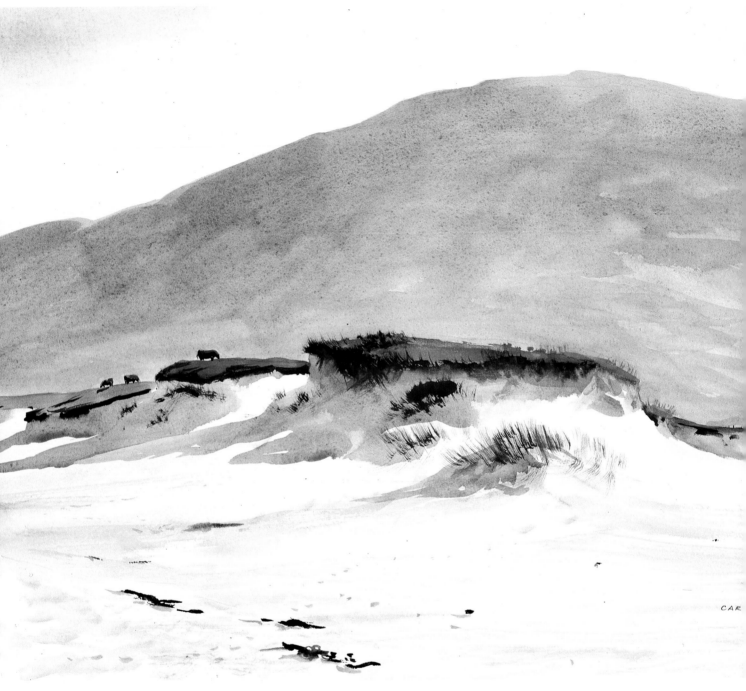

BEINN TANGAVAL,
BARRA
*by Carl Schmalz, 1972,
15½" × 22" (39 × 56 cm),
140 lb. hot-pressed paper,
courtesy of Mathew N.
Schmalz.*

The central dune here
is in the middle of the
paper—and also in the
middle distance.

BUILDING THE COMPOSITION

What are my compositional tendencies and preferences?

Before you get out your group of paintings to study, start with some doodling. Get out a sketch pad, some half-sheet backs of old watercolor papers, and a couple of large pieces of paper, if you have them (newsprint will do also). You'll need a pencil, crayon, brushes, and black paint.

Take your usual painting position. Let your mind become as blank as possible and then begin drawing with your pencil on your pad. Make fairly small marks and combinations of marks, doodling until you have filled up at least one sketchbook page, two if you can. Switch to crayon and do another page or two of doodles. Using a medium-sized round or flat brush, doodle with black paint—this time, on a half-sheet back. Work as fast and as mindlessly as you can. If you have larger paper, try a shot or two at it (using a bigger brush if you have one).

Rest a minute. If you have really forgotten yourself, you may be inexplicably tired. Look at your sketchbook pages. You should quickly spot similarities of shape, size, angle, and interval among your marks, even if you tried hard to vary them. You will probably notice resemblances even though you used different techniques and different sizes.

This adventure demonstrates the orderly repetition that is inherent in all human beings and is the basis of design. But it also should provide you with some clues about the kinds of lines and shapes that attract *you*. If something in your subject reflects those lines and shapes, this may provide a key to your interest in it.

What tendencies can I see in my doodles?

Perhaps your doodles tend to be bold and angular, or they include lots of parallel lines, right angles, or oval or circular lines. Compare the doodles with your paintings to see whether any of them maintain a similar boldness, angularity, or other tendency you've noted. The chances are that you'll see the same propensity in most of your paintings. And you may find that these similarities to your doodles appear most often in those parts of your pictures where you feel most secure and have to think least consciously. Check skies, for instance, or backgrounds, or the peripheral areas of your pictures. Sometimes your very choice of subject may reflect your preferences; for example, a person who likes curvilinear forms will avoid architectural subjects, or a person who is attracted to acute angles will rarely undertake pure landscape.

Where is my center of interest?

Now study your paintings further. Have you been placing your center of interest near the middle of your format? Is it still clearly the picture's focus? If not, can you figure out whether you misunderstood what your interest was, failed to emphasize it sufficiently, or tried to place it deliberately off center? If you maintained primary interest in your focal point and, even better, reinforced and enhanced it compositionally, you can start to think more adventurously about creating a composition in which the focus is definitely *away* from the center.

If your paintings seem to display a variety of forms (especially if they differ significantly from your doodles), and if the center of interest tends to become lost or deemphasized, you should probably do the following when painting: (1) try very hard to decide exactly what interests you most in the subject; (2) place it near the middle of the format; and (3) look for similarities between your subject and its context that can be used for both design and expression.

CHAPTER FIVE

Using Similarities

Do you use similarity as an ordering principle or as boring repetition?

Similarity is the basic ordering principle in human thought. Perceived similarities help us simplify and organize our complex world. Furry animals with four legs, for example, are usually mammals. Mistaken likenesses can be tragic, as when a driver sees a "shadow" across the road that is, in fact, a log. Poetic and artistic perceptions of likeness often express some unusual insights.

For artists the most important types of similarity are repetition, sequence, and balance. These can occur in both color and spatial relationships (in both two and three dimensions). Color relationships are discussed later in this book, in the section on color. This chapter will deal primarily with the two-dimensional spatial elements of line, shape, size, and interval. Similarities are among the most powerful means of organizing coherent paintings. Excessive or thoughtless repetition, on the other hand, can produce boring pictures. Unless you consciously seek effective and imaginative ways of using similarities, uncontrolled repetitions may rob your paintings of expressive force.

Everybody experiences moments of fatigue or inattention while painting, when the brush, almost by itself, makes a group of marks that add nothing to the picture's development and may actively ruin it. As you emerge from such a trance, you wonder how you could possibly have made all the trees so nearly the same size and shape! You can avoid this problem by becoming more *aware* of your particular tendencies and learning to discipline them. Painting is always partly a matter of turning a fault into a virtue.

Repetition and Sequence

Louis J. Kaep's *Antique Dealer's Porch* is dominated by repeated vertical lines. The centaur weathervane, rising up the vertical middle of the design, includes a base that is the wrought-iron equivalent of the grasses, a ball that is repeated as a contrapuntal shape across the horizontal center of the paper, and the centaur—an organic horizontal reinforced by the

ANTIQUE DEALER'S PORCH
by Louis J. Kaep, A.N.A., 9" × 11" (23 × 28 cm), collection of Dr. and Mrs. Richard Hartzell.

Any sequence of diminishing sizes tends to direct the eye powerfully into pictorial space, but Kaep counters this force with the screen of trees at left and the horse weathervane.

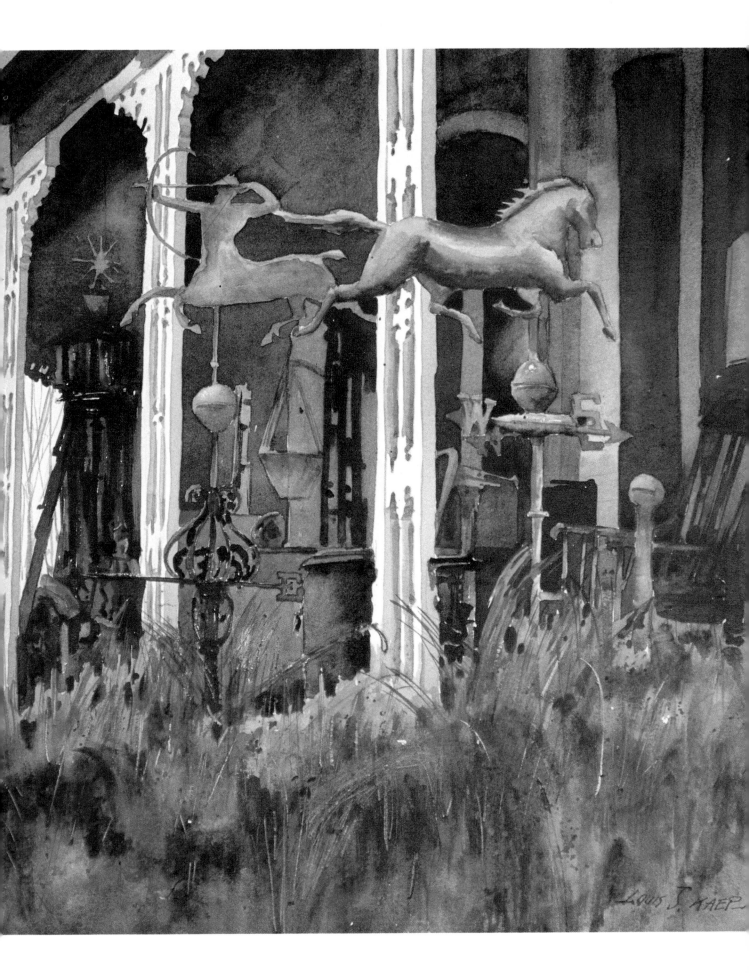

USING SIMILARITIES

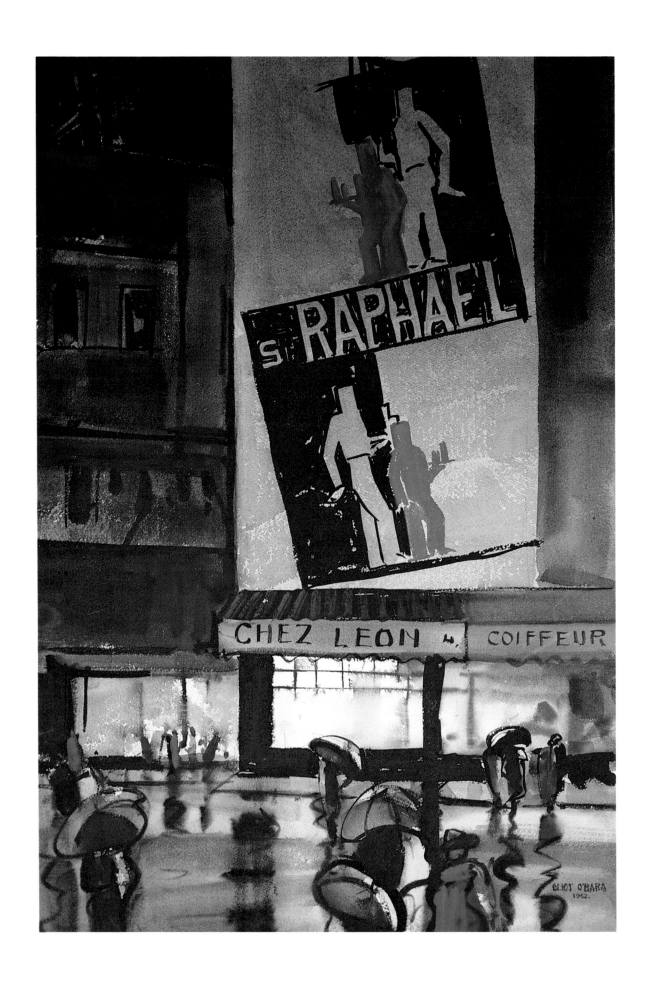

BUILDING THE COMPOSITION

drawn arrow. The insistent verticals of the porch pillars—whose ornamented "capitals" resemble trees—are repeated in the grasses below and in the bare trees at left, as well as by bits of architecture within the porch. The pillars avoid dreariness because of the sequential gradation of their size and the intervals between them, and the variety of ways in which they are interrupted—mostly by horizontals. The horizontal bodies of the horse and centaur weathervanes are loosely echoed by the hill at the extreme left, linking foreground and background shapes.

In this picture, repetition of vertical lines and similar horizontal shapes (as well as many other refinements) not only knits the composition together but enhances its meaning. Though Kaep's literal description of the antique shop projects nostalgia, he also uses sequences and gradations of spatial elements to connote change in a purely visual way. Plants grow and change, and the prominently displayed weathervanes have the express function of indicating change. Kaep links these ideas together with horizontal/vertical contrasts, variations in height and interval, and shifts between near and far. The central weathervane also represents the changing di-

rection of the wind—a metaphor for the passage of time—which is opposed to the stability of the compass points. Hence the subject of the picture is not just an old porch, but fixity versus fickleness.

Eliot O'Hara's *Chez Leon* uses similarity of size and shape quite simply. Echoing the paper shape, variously oriented rectangles organize the surface. Loosely repeated in the rain reflections, they are played off against the more organic shapes in the figures as well as the tilted rectangles of the St. Raphael billboard. The axis of the ad is subtly picked up in the "real" figures whose similar size (though different shape) plays them off against the flatly treated figures on the sign.

Balance

My *Great Maple II* is an obvious study in balance. But in representational painting, balance is rarely just a matter of simple symmetry. Here the mass of red that nearly fills the right half of the painting is balanced by the intrinsic interest of the architecture at left. The green shrub also plays some part by its intense complementary color as well as its echo of the foliage shapes that animate the right side of the picture.

Eliot O'Hara's *Plaza Borda, Taxco* uses similar intervals in an interesting way. The distances from the bottom of the picture to the base of the buildings and from there to the eave of the roof are about equal; the distance from there to the top of the next light is almost the same. Similarly, the height of the roof and that of the darker horizontal band behind the foliage above are nearly equivalent. These likenesses provide a scaffolding of somnolent regularity against which O'Hara can play his strong value contrasts and brilliant colors.

PLAZA BORDA, TAXCO
by Eliot O'Hara, 1937,
22" × 15½" (56 × 39 cm),
140 lb. rough paper,
courtesy of O'Hara Picture
Trust.

O'Hara uses intervals tellingly here, both to organize the picture surface and to reinforce expression.

BUILDING THE COMPOSITION

Do I use repetitions in my compositions?

Examine a minimum of six or eight paintings for similarity in the four elements: line, shape, size, and interval. Ask yourself whether you are taking advantage of similarity in one or more of these elements. It is unlikely that you are not, since they tend to appear spontaneously. But should you discover that you are ignoring them, consider what adjustments you might have made to enhance compositional unity. It is probable that you *are* using these similarities, but doing so somewhat unconsciously. You may also discover that you are alert to similarities of line and shape, but not to those of size and interval.

As you look for line, remember that it describes more than just linear elements such as ropes, wires, and twigs; it refers also to direction and includes dominant or highly visible edges, as well as the axes of shapes.

Shape isn't limited to the contours of easily recognized objects such as houses, boats, mountains, clouds, or squares, triangles, and circles. All these *do* constitute shapes, but you must also train yourself to see less obvious ones. Remember that the shapes of relatively light or dark areas, even those that include more than one represented object, often carry great visual force.

As you check your pictures for size similarities, keep in mind that size is different from shape. Two quite distinct shapes can be very nearly the same size. In fact, poorly handled size relationships can be treacherous in a painting for this reason. It is all too easy to produce a foreground in which rocks, bushes, and logs—although varied in shape and color— have a deadening effect because they are too similar in size.

Seeing intervals also can be tricky because, on a picture surface, they are not limited to just the spaces *between* objects, often referred to as "negative shapes." The width or height of an object itself constitutes an interval as well.

How am I using visual similarities in my work?

Ask yourself, picture by picture, what purpose (or purposes) is being served by similarities of line, shape, and so on. Pay special attention to size and interval, because they are the most easily overlooked spatial elements. At this point concentrate on similarities that seem to serve a purely compositional function.

How are you using arbitrary lines, for instance? If you like to "contain" your pictures with lines that cut off the painting's corners, are you integrating them with the rest of the paper by making them parallel or perpendicular to other lines or edges?

Do you tend to make the humps of cumulus clouds the same shape and size? What about rocks and bushes? If all three are similar to each other, dullness is compounded, even though a metaphorical significance may be intended. This kind of repetition is boring, and your meaning is not likely to be grasped.

You may have found that you are using similarities intelligently, but as compositional devices only. This is fine, but you also can strengthen your expressive purposes through similarity. In this way, you are integrating what your picture *is* and what it *says*. This is what you must look for now. You may discover that you have done something good without knowing it, but the more you can *knowingly* reinforce your meaning with your design, the richer your paintings will become.

Exploiting Contrasts

Is the thoughtless use of contrast disrupting your paintings?

Strong contrasts create visual excitement and demand the viewer's attention, attracting and holding the eye. Hence you must use your contrasts carefully, placing them only where they will enhance your purpose. You must *contain* your contrasts, hedge them with appropriate similarities, so that the world of your picture does not fly apart from excessive differentiations. It is easy to overstate differences: the too-sharp gable, the too-big mouth, the too-sharp edge, the too-dark, too-light, too-red, and so forth. However, the human tendency toward rhythmic repetition will help you here, and nature itself offers countless examples of compelling similarities. A pine tree, despite its differences from other trees, shares its vertical form with its birch and maple neighbors.

As with similarity, there can be contrast in spatial elements—line, shape, size, and interval—and in the elements of hue, value, and color intensity. This chapter will deal with spatial elements but will include value as well, since it provides one of the strongest types of visual contrast.

It is not difficult to recognize similarity, but some contrasts can escape notice. The easiest contrasts to see are those of size, interval, and value. Linear contrasts may be more subtle.

Linear Contrasts

Lines can contrast in position or in quality of movement. The strongest positional contrast is opposition, as when lines or axes meet at right angles. A strong contrast in quality of movement would be a straight line versus a wavy one or a jagged line versus a curve. Firmly drawn lines also contrast powerfully with deliberately hesitant ones.

Shore Rain, like many architectural subjects, has strong linear contrasts, both vertical/horizontal and diagonal oppositions. We see these contrasts as a coherent whole partly because we recognize them as man-made structures. But the abrupt clash of the vertical posts with the roof, horizon, and floorboards is also tamed by a multitude of sequential relationships in size and interval, in this case owing chiefly to perspective. The diminution of the floorboards is one example. The great differ-

SHORE RAIN
*by Carl Schmalz, 1981,
15" × 22" (38 × 56 cm),
140 lb. hot-pressed paper,
collection of the artist.*

Here sequential repetitions help to integrate the linear contrasts of thrusting verticals and strong horizontals.

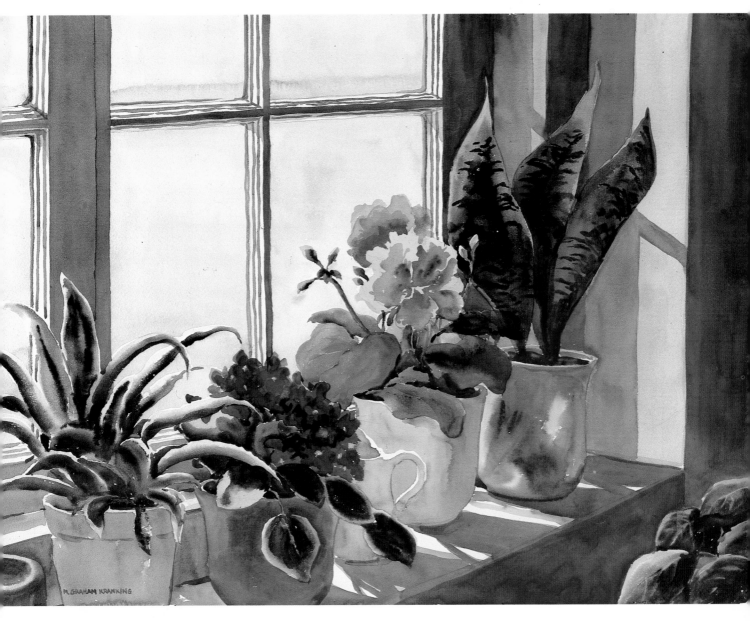

ence in color and value between the red table and benches and the rest of the painting is modified by the repeated crisscrosses in the railing supports and the bench legs. Note also that a very general similarity between the shape of the window at extreme right and the spaces between the porch posts at center left creates an expressive link between the contrasting senses of seeing in and seeing out.

Contrasts in Shape

Contrasts in shape also vary: circles contrast with squares or triangles, and geometric shapes contrast with nongeometric ones.

Margaret Graham Kranking's *Waiting for Spring* is of four very different kinds of plants on a windowsill. They contrast with each other in shape, and they—and the pots that hold

them—contrast as well with the shapes in the windowpanes. Similarity of size among both plants and pots, however, controls these contrasts, and taken as a whole, each potted plant corresponds roughly in size to a windowpane. These strong size likenesses allow Kranking to exploit contrast for expressive purposes. The entire theme is centrally stated by the geranium bud. Kranking subtly sets up an antagonism between the bud and the glass behind it by making the axis of the stem parallel to the diagonal that bisects the pane. The bud itself forms a cross shape, echoing the configuration of the mullions that seem to form a barrier to the light and air beyond. With such strong oppositions at the very heart of the painting, Kranking's size similarities are vital to pictorial coherence.

WAITING FOR SPRING
by Margaret Graham Kranking, 1983, 22" × 30" (56 × 76 cm), 140 lb. cold-pressed paper, collection of Mr. and Mrs. Michael J. Manning. Photo Billy Arce.

Abundant similarities in size and shape temper the expressive uniqueness of these four plants.

44

Intervals and Value Contrasts

Roman Prospect is a painting in which a tremendous diversity of intervals (which are necessary to the representation) is held together by sequential ordering, as well as by repetition of shapes. Notice, for instance, how the height of the large wall at left is twice that of its roof and that the windowed wall just above it is half the height of the roof. The cornice above the windows is once more about half the height of the windowed section. Such proportional relationships help to structure the otherwise chaotic architecture. In an analogous way, the shape of the porch roof at lower right is repeated sequentially into the distance by other, similarly shaped roofs.

My painting *Steven's Studio* (following page) shows the use of dramatic value contrasts. I used similarities of paint texture and, especially, shape to establish the picture's coherence. Rectangular elements form a dominant theme that is emphasized by a subtheme of triangular shapes. Color intensity is important as well; notice how the brilliant yellows in the foreground and the bright blue-green patch of sea help to balance the bits of dark foliage at upper right.

Although *Spring Studio: Swamp Azaleas* (page 71) depends upon other elements for its organization, controlled contrasts of shape, interval, and value play a significant part. The complexity of the azaleas, for example, is tamed by their color likeness to the lady's slippers, as well as by their textural relationship to the corkboard background. Notice, too, that the overall width of the bunch of azaleas is approximately the same as the width of corkboard between the lady's slippers and the window. The flowers' pale value also links them to the world outside the window.

ROMAN PROSPECT
by Carl Schmalz, 1965,
22" × 30" (56 × 76 cm),
140 lb. hot-pressed paper,
Southern Missouri Trust
Purchase Award,
Watercolor U.S.A., courtesy
of Southern Missouri Trust
Company, Springfield,
Missouri.

Architectural subjects
frequently demand con-
trasts of interval and
size as well as of line.

Ask Yourself . . .

Do my paintings have *enough* contrast?

As you examine each of your pictures, keep a notebook handy; you may want to come to some conclusions later. Look for contrasts in the spatial factors—line, shape, size, and interval—and remember that these may often be expressed as *value* differences.

Sometimes we are timid about putting strong contrasts in our work, but this can lead to pictures that seem to say, "Why look at me? I'm not doing anything." You may be a person who is subtle, tender, and quiet by nature. Remember that these are *positive* qualities; you want to express them affirmatively, not make pictures that are visual shrinking violets. You might try using more vigorous contrasts in the spatial elements while calming down your color a little.

Do my paintings have *too much* contrast?

If so, they will tend to be uncomfortable to look at. They may have an explosive quality—making a big noise about nothing—and lack of unity.

You probably only need to get contrast under control. A good way to start is to reduce *all* contrast quite consciously for a while. It will help if you can figure out what type of contrast seems to be the problem. Is it mainly one of the spatial elements? Or are the value contrasts overstated? If you can identify the source of the problem, you can overcome it more quickly.

Does contrast contribute to the meaning of my paintings?

Have you placed contrasts in the most advantageous locations for your subject? Are you using contrasts to focus attention on the most significant sections? Ideally, you should be integrating contrasts judiciously into a coherent picture surface, not placing very strong contrasts way down in the corner of your paper or very close to its edge. Check your work once again to be sure you are using contrasts as *expressively* as possible.

What general tendencies do I see in my use of contrasts?

Spread your paintings out at this point and refer to your notes if you have made any. Remember that you are looking at shape, size, interval, and value. Is contrast weak in more than half your pictures? If so, you might deliberately try to intensify it. If you are using it well, could you do better? Could you tie contrast to your expressive intent more subtly? More strongly?

Using Color

CHAPTER SEVEN

Knowing Your Palette

Is your palette working for you or against you?

Despite a multitude of books and articles on the subject, color perception is one of the least understood elements in human vision. Even painters do not know much about how it works (although over the centuries they have accumulated a good deal of practical information about how to use it). Color is one of the most powerful tools at your command, and you need to know as much as possible about it.

This chapter will analyze charts more than pictures. My purpose is to review the basic dimensions of color, outline fundamental color relationships, and describe some of the peculiar properties of color so that you can better judge the results of the exercises you will be doing next.

Evaluating Your Palette

The color situation closest to home is your own palette. How long has it been since you really thought about what colors you're using, much less about any other tubes of paint that remain in your box or drawer? Curious collections of paint can turn up on an unexamined palette. Perhaps now is the time to evaluate what you have, what you can do with it, and whether it is contributing to or limiting your expression.

It is all too easy to fall into comfortable color habits and forget about the intelligent control you can exercise over your palette. Especially nowadays, with manufacturers of artists' pigments developing new colors every year, it is important for painters to do some exploring. Not too many years ago we were still in antiquity with respect to a good permanent purple; now there are several available. Indeed, today you can paint with a palette close to the full-intensity hue scale, if you wish.

Many painters are subject to the limitations of their local art supplier. Too often only one brand of watercolor is available. You may have formed habits that have nothing to do with informed choice. Try to familiarize yourself with the products of all the reputable manufacturers; each makes some useful colors not produced by the others. I regularly use three, sometimes four, major brands of paints.

It remains true that experienced artists tend to use fewer colors but in more varied ways.

However, you can still seek an economy of color consistent with your expressive needs, while remaining open to new possibilities.

The Elements of Color

Most of the colors we ordinarily perceive are composed of three elements. These are *value* (lightness or darkness), *hue* (blueness, redness, greenness, and so forth), and *intensity* (brightness or dullness).

Value

Value can be measured on a scale of nine *neutrals* (colors with no hue or intensity), ranging from white through grays to black. On this scale there are seven value levels, excluding white and black, with level five being the middle value. This middle value contrasts equally with white and black; level three contrasts equally with white and the middle; level four contrasts equally with three and five, and so forth.

The nine-value scale gives you a useful number of divisions and a way to understand an important relationship between value and hue. If you are accustomed to designing within a framework of fewer values than nine, this scale can easily be simplified to five—white, light (three), middle (five), dark (seven), and black. Or you can limit values to three—white, middle gray, and black.

Hue

Hue is most usefully diagrammed for painters on a circular scale in which the spectrum that results from breaking down white light is bent into a circle, joining the red and blue ends at purple at the bottom. Yellow is at the top, with the *warm* hues (reds and oranges) at left and the *cool* hues (blue and greens) at right. (Yellow and purple may be warm or cool, depending on context).

Red, yellow, and blue cannot be mixed from other colors; they are the *primaries*. Orange, green, and purple can be formed by mixing red and yellow, yellow and blue, and blue and red, respectively; they are called *secondaries*. Each of these six colors can be mixed with the one adjoining it to form six intermediate colors (red-purple, blue-green, and so forth); these

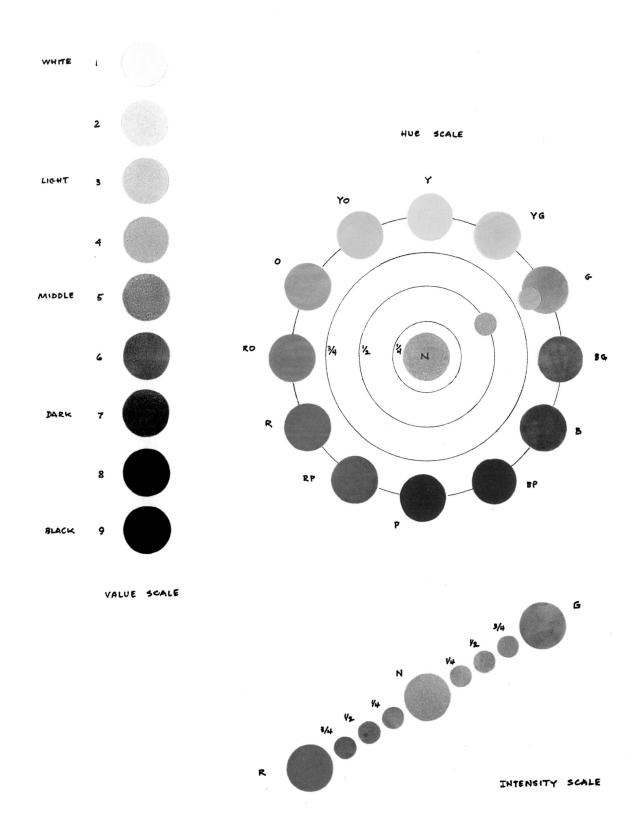

WHITE 1

2

LIGHT 3

4

MIDDLE 5

6

DARK 7

8

BLACK 9

VALUE SCALE

HUE SCALE

Y

YO YG

O G

RO 3/4 1/2 1/4 N BG

R B

RP BP

P

INTENSITY SCALE

G 3/4 1/2 1/4 N

R 3/4 1/2 1/4

are called *tertiaries*. These twelve hues are ordinarily enough for common description and discussion of color, although, theoretically, any number of intermediate colors exists.

This division of the hue scale is somewhat arbitrary, since there are, for instance, many more possibilities for hues in the yellow family—according to the spectrum breakdown of white light—than in the purple family. As painters, however, we are interested less in what light can do than in what pigment can do, and since this simplification is made for pigment, it serves well enough.

Intensity

When someone says "green," you almost certainly think of green at its most characteristic, its greenest. Most people do. We rarely think of the color of some plastic trash bags, for example, although they are also green. The difference, of course, is one of intensity (and perhaps value). On the hue scale, the hues are shown at the highest intensity achievable by pigments—at *full intensity*.

You know that to dull a hue, you can mix it with its *complement*, the hue opposite it on the scale. Hence, full-intensity red and green mixed in approximately equal proportions will yield a gray of a value about halfway between the values of full-intensity red and green, or at about middle value (five). The same thing happens with other mixed complementaries.

If you add only a little green to your red, you will dull it (lower its intensity) much less. Similarly, if you add only a little red to your green you will obtain not a gray, but a relatively less intense green. If we imagine the middle-value neutral at the center of the hue scale, as illustrated here, and then imagine three steps each way from neutral to full-intensity green on one side and from neutral to full-intensity red on the other, we can measure off intensity: 0 intensity (or neutral), $1/4$ intensity, $1/2$ intensity, $3/4$ intensity, and full intensity, which are the terms I will use here. These terms provide a scale of intensities that will enable you to think more clearly about this most elusive aspect of color.

For example, if you mix blue and yellow to produce green, this combination will produce a green of about $1/2$ intensity; whereas, if you mix yellow-green and blue-green, the green

SMOKEHOUSE
INTERIOR
*by Margaret Graham
Kranking, 1983, 22" × 30"
(56 × 76 cm), 140 lb.
rough paper, collection of
Mr. and Mrs. Michael W.
Haley. Photo by Edwin
Darby Nye.*

In a very low-intensity painting like this, areas of relatively bright color play an important role in design.

yielded will be greater than ³/₄ intensity. Hence you can derive this general rule for color mixing: mix full-intensity hues that are closer to the desired hue for higher intensities; mix hues farther from the desired hue for lower intensities.

Intensity and Value

The intensity of a hue is almost always related to its value. Notice that the full-intensity colors on the hue scale differ in value. They are arranged so that yellow, the lightest, is at the top of the scale and would be at about value two, while purple, the darkest, is at the bottom and would be at about value eight. Orange and green are nearly the same in value, at about value four, as are red and blue, at value six. Since each of these colors is shown at the highest intensity achievable with paint, it follows that *any* change in them will lower their intensity. If you add black or white to one of them, you will lower or raise not only its value but also its intensity. This is because both black paint and white paper (the "white" of transparent watercolor) are neutrals. Modeling, therefore, will inevitably involve some degree of intensity reduction. You should also note that, due to the variation of value among hues at highest intensity, light and dark *ranges* of different hues vary.

THE ELL
by Loring W. Coleman,
A.W.S., 1976, 20" × 39"
(51 × 99 cm), cold-pressed
paper, private collection.

In this painting, value contrasts and descriptive detail are united by a harmony of relatively low intensities.

Ask Yourself . . .

What is my palette like?

For this exercise you will need your painting materials, including a couple of discarded paintings with clean backs, some scrap paper, a ruler and compass, and a fresh water supply, along with your brushes and palette. Put all the tubes of paint you own in a handy spot.

Draw a circle eight inches in diameter on one of your sheets. Mark the center, then mark off the yellow and purple positions at top and bottom and the red-orange and blue-green positions at left and right. Use your compass to establish the remaining eight hue locations and measure off two points, by eye, between each of the four established positions. Make three interior concentric circles one inch apart to represent the intensity scale. Label the location of each of the twelve hues—Y, YG, G, BG, and so forth—but do not paint them on.

The object of this exercise is to discover something about your palette's actual potential. Checking first to see that your paint is absolutely clean, take up a brushload of one of your yellows. Put a dab on a piece of scrap paper. While it dries slightly, try to remember its tube name. (If you can't remember, don't worry). Now look at the dab. Does it seem more greenish than "true" yellow? More orangish? If it seems neither more green nor orange than "true" yellow, place a new patch of it *outside* your circle at Y. Otherwise, place the patch at the right or left of Y at a distance that seems to indicate about the degree to which it appears green or orange. (In art, color

is a psychological as well as a physical phenomenon, and everybody will have a slightly different notion of what a "true" hue looks like. So use your best judgment, and don't think you are establishing absolute hues for all time). Write the abbreviated tube color name near the patch, if you can. Go through this same process with all the full-intensity colors on your palette; by a process of elimination, if necessary, try to label even those you are unsure of.

Your next step will be a little more difficult. Estimate *both* the hue and the intensity (ignoring value) of your more neutral colors, such as burnt sienna, Payne's gray, and yellow ochre. In the same way as before, paint a patch on scrap paper. Consider first what hue (or, if it is very low in intensity, its hue family—for example, reds) it most closely approximates. Next, checking the patch against the full-intensity colors outside the periphery of your circle and against the center gray, if you have one, judge which of the intensity lines inside your circle most closely corresponds to the intensity of your sample. Then paint a patch of it where the appropriate hue intersects the relative intensity circle. Label the tube name as before and continue with all the neutrals on your palette. This will produce a "map" of your palette.

You are now prepared to take a good analytic look at your palette as a working tool. You may want to set up your paintings now, along with this schematic map of your palette.

LOCATION OF MY PIGMENTS ON A HUE/INTENSITY SCALE

This is a hue-and-intensity map of the colors I have regularly used on my palette for the past few years. I add phthalocyanine blue and/or green occasionally.

Is my palette well balanced?

Do you have a lot of colors grouped in one part of the hue scale? This exercise may reveal that you have just one lonesome yellow. Does your palette map show the same preponderance of colors that you can see in your pictures? If you are not altogether happy with the overall color tonality of your pictures, it is easy to see what to do about it. Suppose, for example, your pictures tend to be dominated by a ½-intensity blue-green. Check your reds, red-oranges, and oranges. Have you only a few? Try eliminating some of your blues and greens and adding a red or two. Perhaps your paintings are dull in color, and you have many patches on your inner circles. Maybe you should consider eliminating a few neutrals and adding some full-intensity colors. In general the warm colors tend to be somewhat weaker in mixtures than the cool ones. So if your palette shows more warms than cools, this is usually all right. Fortunately, there *are* more warms than cools available among pigments.

Any serious gaps in your palette can be remedied at a good art supply store, since the colors available today cover the spectrum pretty thoroughly. In case your palette requires a really drastic overhaul, here are some suggestions. Remember that they are not prescriptions!

A good basic palette is the "double-primary" palette—that is, one with a warm and a cool version of each primary. For example, I have vermilion light and alizarin crimson golden; cadmium yellow deep and cadmium yellow lemon; ultramarine blue and cerulean blue. Such a palette allows considerable flexibility in mixing secondary hues. Many artists also like good intense secondaries, too, such as cadmium orange, Thalo (phthalocyanine) green, and Thalo purple. Thalo yellow-green and Thio or Acra violet (red-purple) have recently come on the market. Tertiaries are normally unnecessary except for their ability to add interesting new transparent and opaque colors to your palette. These qualities will be explored in the next chapter.

You will need some natural neutrals, too.

Among the most useful are Indian red, burnt sienna, raw sienna, yellow ochre, raw umber, sepia, and lampblack.

Some other useful colors are cobalt violet (a weak mixer with nice opacity), Thalo yellow-green (very intense and opaque), cobalt blue (as nearly "pure" blue as we have), manganese blue (not as strong as cerulean and a little greener), burnt umber (a good warm brown and a low-intensity yellow-orange), and ivory black (a warm black and a good mixer).

Sixteen to eighteen colors should provide you with ample range and flexibility for most painting. You can always add a color for special subjects.

Does my palette include more colors than I really need?

If your palette map is packed, perhaps you should think about some economies. Start with redundancies. Do you have phthalocyanine blues by two manufacturers? You don't need both on your palette at the same time. Do you seem to have a lot of browns? Check your palette to discover whether any of these have become hard and dry. They might be eliminated, since you are not using them very often anyway. In general, it is wise to strip down your palette while retaining as much richness for mixing as possible.

Do I frequently buy tubes of new colors?

This is an innocent indulgence and an indispensable way of exploring new coloristic ground, but it can produce a large number of rejects. If you have energy (and space) enough, you might either add to your palette map some samples from the additional tubes you have at hand or, better yet, place them on a new hue-and-intensity scale. This will suggest to you something about your color preferences. The new colors may reflect the same pattern as your usual palette, but they may also reveal a secret trying to get out. Are the colors more intense? Warmer? Are there more violets? If you seem to be trying to tell yourself something, why not act on it? Make some substitutions and see what happens.

Transparent and Opaque Pigments

Do you take advantage of the relative transparency of each pigment?

The usefulness of your palette depends on the degree to which you understand it as a tool. You should know it as profoundly as possible—where it is flexible; where it is obstinate; when, how, and why you must augment it; when you can limit it. It is as much an instrument of your will and feeling as your brushes. The colors you employ and the mixtures that express your ideas are only as rich as your palette's capacity. So don't take that array of paints too lightly!

Artists working in all media have long been aware of the different effects that result from the relative transparencies of their paints. Tempera painters of the thirteenth and fourteenth centuries treated the more transparent red madders in ways quite distinct from their handling of vermilion, which is fairly opaque. Oil painters of the seventeenth century, notably Rubens, also exploited the varying transparencies of paints.

To the watercolorist this variability offers perhaps even greater opportunities. The play between the limpid clarity of a wash of transparent color and the granulation left by more opaque pigments can enliven a painting, especially when seen at close range. In addition, the behavior of the two types of pigment in mixtures is distinctive, and all these variations can be used for particular effects. It is important, therefore, that you acquaint yourself with the relative transparency/opacity of the colors you use.

Using Transparent and Opaque Colors

Eliot O'Hara's *Cliffs, Bermuda* (see page 91) shows the brilliance and clarity that can be obtained by using mainly transparent paints. Working before the advent of the phthalocyanine colors, O'Hara used the nearest equivalents available in 1931—viridian and prussian blue as well as some transparent warms in clean mixtures, and the results are almost fluorescent. Compare this painting with my *Ebbing Tide, Kennebunkport*, in which the background interest derives largely from a very granular mixture of opaque colors such as

cerulean and cobalt blue, Indian red, and Thalo yellow-green. This adds the interest of paint texture to otherwise unmodulated areas.

In *South from Tucker's Town*, which was painted mostly with very transparent colors, I needed emerald green—which is a very opaque pigment—for the smaller ripples at left. By using it in small quantities, mixing it a little with other colors, and especially by keeping it above the middle value, I was able to prevent its disrupting the picture's overall feeling of transparency.

CLIFFS, BERMUDA (DETAIL)
by Eliot O'Hara, 1931, 14½" × 20" (37 × 51 cm), 140 lb. rough paper, private collection.

This detail shows the transparent quality resulting from O'Hara's use of viridian at the base of the cliffs and prussian blue in the middle foreground. Notice also the transparent warm colors in the cliffs. This painting is reproduced on page 91.

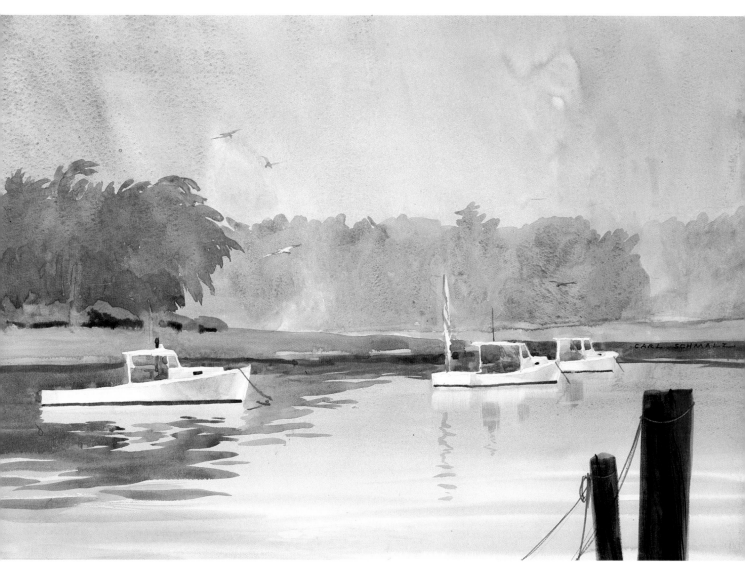

EBBING TIDE, KENNEBUNKPORT
by Carl Schmalz, 1976,
15" × 22½" (38 × 57 cm),
140 lb. hot-pressed paper,
collection of the author.

I used my most opaque colors in the sky and distance, painting them on very wetly to ensure the maximum granulation, which you can see in the detail at left.

SOUTH FROM
TUCKER'S TOWN
by Carl Schmalz, 1975,
15" × 22" (38 × 56 cm),
140 lb. hot-pressed paper,
collection of the author.

In this picture I used
mostly transparent
paints to help convey
the sense of clear light
and crystalline water.

Color Behavior

We have all watched some astonishingly aggressive color "invade" still-wet colors already on the paper. We also know that a smooth wash of deep value is impossible with some colors and that relative transparencies and strengths in mixtures vary greatly. Here is a general explanation of why some of these things happen.

Pigments are substances that absorb some light rays and reflect others. For example, cobalt blue absorbs nearly all rays (or wavelengths) except blue ones, which it reflects, making it look blue to our eyes. These substances vary in molecular structure, which causes them also to vary in particle size, in inherent transparency, and in refractive index (a measure of the power to absorb, transmit, and bend light).

There are two main classes of pigments—inorganic (mineral) and organic (vegetable). Today the latter are nearly all synthetic, and those from which artists' paints are made are often *lakes*. These are man-made pigments produced by dyeing powdered alumina hydrate or some other inert base. As a rule, inorganic pigments tend to be opaque, whereas organic ones tend to be transparent. This rule doesn't always apply, but it may be helpful as a guide. In general, the most opaque paints are best used in areas of lighter value because they can easily become muddy, whereas dark transparents are helpful for dark and very dark areas.

Precise recipes vary considerably, but watercolor paints are basically a mixture of pigment, a binder of gum, glycerine, and other substances, including ox gall, a "wetting" agent. Apart from the inherent transparency of the pigment particles, their particular refractive index affects their transparency when made up as paint. The closer the refractive index of a pigment is to that of water, the more transparent that watercolor paint will be. Some heat-treated earths, for instance, are far more transparent than their raw counterparts (for example, burnt and raw umber) because their refractive index has been changed. With some pigments, relatively little colorant is needed to make a satisfactory paint. This also increases that paint's transparency. Conversely, the synthetic organic paints very often contain proportionately more colorant, which is also often stronger than most inorganic pigments. That is why synthetic organics tend to stain the paper.

Among the inorganic pigment-based paints, some settle out, or granulate. This is the result of their "grind," the size of particle necessary for optimum color effect. Larger particles settle out of a wash or mixture as a granular sediment. Finally, some pigments require much more of the wetting agent than others if they are to flow and mix easily. When a paint with more wetting agent is placed next to a wet wash of a paint with less, the former will "invade" the latter.

Painters usually lack the scientific background necessary to understand or predict specific paint behavior, and so you must take responsibility for determining the functional properties of your paints. The exercises that follow will help you do this.

Ask Yourself . . .

What are the relative transparencies of my colors?

For this experiment you will need a half-sheet of paper; the back of a discarded painting will do. Get out your usual materials and, if you have it, some waterproof India ink.

Paint a line about one-half inch wide down the length of the left edge of your sheet, using the India ink or the blackest pigment on your palette. Leave enough space to write on the left side of the line. If you have more than about twenty-five colors, set down another line parallel to the first and about ten inches to the right of it. While these lines dry, survey your colors. Make notations to the extreme left at the top of the left line, indicating the first four colors you will use.

When the black line (or lines) is *thoroughly* dry, begin making pigment mixtures of the colors you already noted. To produce the clearest results, make your color mixtures fairly heavy. Use a brush that will give a stroke about one-half inch wide. The proportion of paint to water ought to be such that, although the paint flows on evenly, the color is as intense as possible. When your first color is ready, paint a three-inch-long strip across the black line. If you have used paint to make your black line, put on only *one* stroke of color; otherwise the black will pick up and muddy your test strips. Paint three-inch-long strips of the colors on your usual palette. If you wish, continue with any spare colors that you may have on hand. Be sure to label each stripe with the tube color and, if you have more than one brand of the same color, the brand name.

Now let the whole thing dry. As the stripes you painted first dry, you will discern differences in the opacity of each color against the black. The metal-based pigments will be the most opaque. Some of the earth colors (many of which are from natural metals or minerals) will be fairly opaque, too. There will be variables among the synthetic pigments, since some contain more of the inert base than others, but in general the organic synthetics will nearly always be virtually transparent, regardless of their inherent value and tinting power. In any case, you will probably discover some surprises.

Are the staining properties of my pigments related to their transparencies?

Using scrap paper to cover the stripes you've already made, mask off all but about one-half inch on the right side of each stripe. If you have two rows of stripes, do both, but also protect the left ends of the stripes on the second row. Hold the paper mask down well and, with a small sponge, wash as much pigment as you can from the exposed ends of the stripes. You won't need much water, but it must be clean.

Depending upon the make and quality of your paints, there will be some surprises here, too. (One phthalocyanine blue—a student grade—washed off my test stripe completely!) In general, the more transparent colors do not wash off as easily as the more opaque ones, but again, this is variable. The ultramarine blue of some manufacturers is quite opaque, but nearly all ultramarines stain fairly deeply, as do the darker cadmiums.

What is the light-fastness of the colors I am using?

It is imperative to test for light-fastness if you are using anything but the finest artists' colors produced by a reputable firm. Using a heavy opaque board, cover all but one-half inch of the left end of your stripes. Fasten the paper and board, paint side out, against the glass in a south window (or east or west, if you have no southern exposure), and leave it until you calculate that it has received between three and six hundred hours of direct sunlight. With good paints, you should find little change. Some reddish purples are still not very fade-resistant, and vermilion will occasionally darken and lose its brilliance. Overall, you should discover that your paints are remarkably permanent, but you should probably abandon, however reluctantly, any color that fades markedly under this treatment.

Apart from ridding my palette of any impermanent colors, what can these exercises tell me?

Most importantly, by identifying your opaque colors, you acquire the knowledge necessary to use them well. You were already aware of some opaques, but you have probably found more. You also know which ones are most easily removed. You can now decide which blue to use for a sky from which you will need to wash color for lighter yellow-green foliage. You know which colors *not* to use beneath a glaze.

Similarly, you have identified your transparent colors and know which ones lift most completely from the paper. Transparent pigments are good for any glazing or overpainting, and those that stain most are excellent for underpainting. Transparent colors are also your best bet for keeping dark areas lively. Those that are naturally dark are particularly good.

Finally, in mixing, you know which colors to reach for to produce a clear, luminous wash (of whatever size) and which will produce the lovely granulations mentioned earlier. Almost any two opaques will give you some granulation, but the most opaque will generally provide it best. Among the two-color mixtures most used for these effects are: cerulean blue mixed with Indian red, vermilion, cadmium red, or cobalt violet; cobalt blue and Indian red; cadmium yellow light and cobalt violet; and cobalt violet mixed with Thalo yellow-green.

TRANSPARENCY/OPACITY TESTS.
Column A shows the relative transparency of 18 colors selected from my own palette and a few from the palettes of my students. The extreme right ends of these color samples have been exposed to 350 to 400 hours of direct sunlight. Note that only one shows any change. This one, marked with an asterisk, is vermilion light, which darkened slightly. Column B shows similar colors, with phthalocyanine blue and green added. The right ends of these colors have been sponged off. The phthalocyanine blue, a student grade, washed off as completely as the cerulean blue. Indian red, a very opaque color, stained deeply. Surprises like this illustrate the importance of running these tests for any new color you acquire, even for the same color made by different manufacturers. These tests also reveal that artist-grade colors are far more reliable and predictable than student grades.

Color Mixing

Are you using the full range of colors possible with your palette?

Like the preceding two chapters, this chapter is more about the essentials of color than about criticism. It is also a necessary preliminary to the next chapter, "Color Design." Knowing the mixing capacities of your palette is necessary if you want to use it intelligently.

Since brilliance is one of the primary attractions of transparent watercolor, it is easy to forget that the reflection of white paper through a pigment layer, which is what produces watercolor's luminosity, is also responsible for some of the subtlest effects in all painting. Using pure color, or colors only slightly mixed, enhances brilliance, but you also need to know how to create softly luminous tonalities.

Fairfield Porter, in *Lawn*, masses the darks and softens colors so that nuances of hue and intensity are more perceptible. Color—overall about 1/2 to 3/4 intensity—is organized around a red/green balance, accentuated by touches of blue and orange.

My painting *Winter's Work* uses a nearly complete range of hues, but its color design is held together in part by the similarity of 1/2 to 1/4 hue intensities.

LAWN
*by Fairfield Porter, 1969,
11 1/2" × 15 1/2"
(29 × 39 cm), 140 lb. rough
paper, collection of the
author.*

This sketch has both strong value contrasts and richly modulated color.

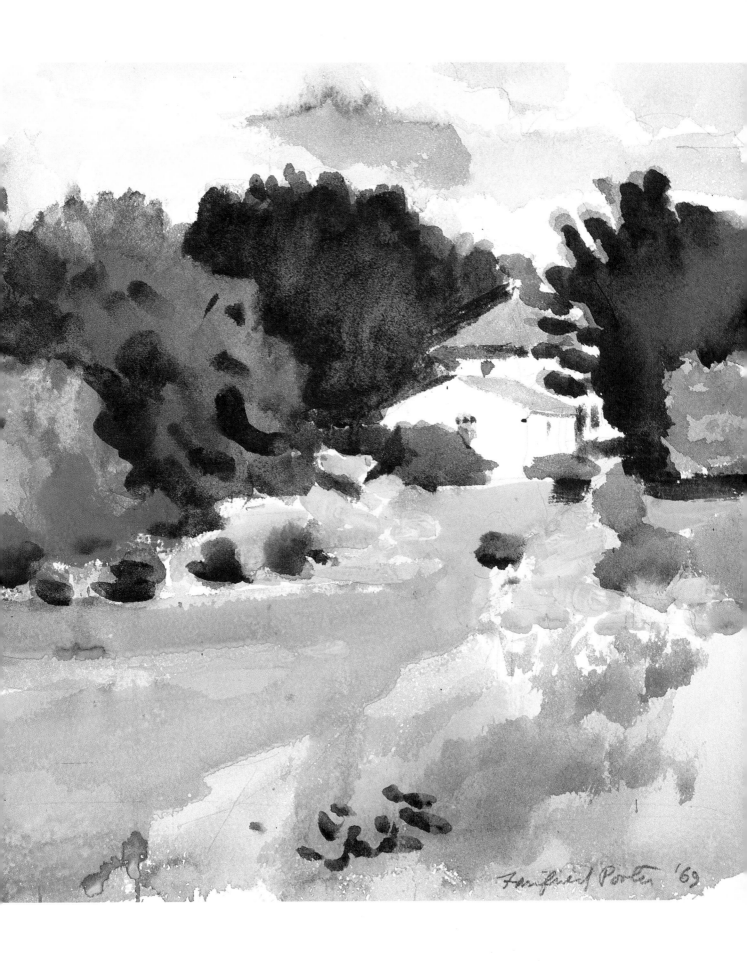

Fairfield Porter '69

COLOR MIXING

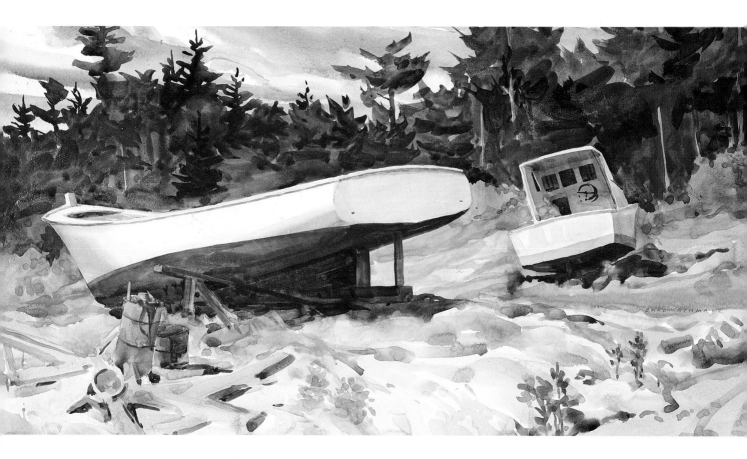

WINTER'S WORK
by Carl Schmalz, 1965,
13" × 30½" (33 × 77 cm),
140 lb. hot-pressed paper,
collection of the author.
Virginia Beach Boardwalk
Show, Frank Dewolf Award
for Traditional Watercolor,
1965.

Graying of hues in this
picture was done
mainly by mixing com-
plementaries.

Basic Principles of Color Mixing

The simplest color mixtures are of one color
added to another. If your palette contains 18
colors, the number of two-color mixtures that
are possible total 153. If you add to this num-
ber the variations in value and proportion pos-
sible with each mixture, your number of poten-
tial colors becomes astronomical.

Actually, you will choose to use only a few of
these possibilities and only some of the cus-
tomary three- and four-color mixtures as well.
You should try to be aware of your choices,
recognizing that color mixing involves selec-
tion. Remember that painting is ordering all of
your visual means—including color—accord-
ing to your personal priorities. Color organiza-
tion in my *12:15, Cape Porpoise*, for example,
is based on large quantities of blues, greens,

and yellow-greens at relatively high intensities
and values, accentuated by small quantities of
reds and purples at very low intensities.

For the representational painter, there are
usually two reasons for color mixing. The
principal one is to reduce intensities, or to gray
colors. This is because we normally see rela-
tively few full-intensity hues in nature, and
those few are usually small in quantity. (This is
why fall foliage is such a delight to artists.)
Apart from the blue sky (and its reflection in
water), birds, butterflies, flowers, fruits, and
berries are typical sources of natural high-
intensity colors. The other function of color
mixing is to alter the hue of a paint. Your
palette, no matter how copious, is hue-limited.
The particular yellow-green of a field in sun-
light usually must be mixed.

Rules of Thumb

Two simple rules govern the two types of mixing. (1) To gray a color, add its complement, and (2) To alter a hue with minimal loss of intensity, add the intense hue nearest it on the color scale toward which you wish to change it. For example, to push phthalocyanine green toward yellow, add cadmium yellow lemon, pale, or light, rather than cadmium yellow medium.

You are probably so familiar with the basic rules of color mixing that you scarcely think of them anymore. In fact, you probably have developed a number of shortcuts for graying colors. Most commonly, this involves mixing a color you want to gray with one already low in intensity, such as raw umber or burnt sienna. You can also deliberately mix hues that are distant from your intended color. For example,

phthalocyanine green and cadmium yellow lemon will yield an intense yellow-green, but a neutral yellow-green can be mixed from cerulean blue and cadmium orange. This neutral yellow-green will be quite distinct from one that you might mix from phthalocyanine green and cadmium yellow lemon, grayed with, say, alizarin crimson, although the two mixtures could be very close in hue and intensity.

The usefulness of color theory in predicting the results of any given mixture must, of course, be augmented by experience. Unless you are using a scientifically prepared spectrum palette—which is uncommon among watercolorists—you know that few of your pigments fall exactly on "true" hues. While this makes accurate prediction difficult, it permits all kinds of wonderful maverick mixtures; these you have to learn by making them.

12:15, CAPE PORPOISE
*by Carl Schmalz, 1976,
14½" × 21½"
(37 × 55 cm), 140 lb.
hot-pressed paper,
collection of Irene N.
Tourangeau.*

Complementary groups of analogous colors, at different intensities, help to organize this painting.

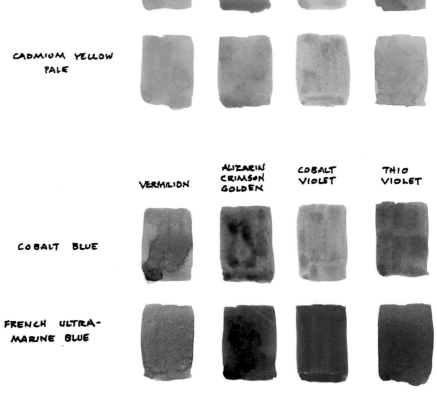

	VERMILION	CADMIUM ORANGE	CADMIUM YELLOW MEDIUM	CADMIUM YELLOW PALE
CERULEAN BLUE				
COBALT BLUE				
FRENCH ULTRA-MARINE BLUE				

	VERMILION	ALIZARIN CRIMSON GOLDEN	COBALT VIOLET	THIO VIOLET
CADMIUM YELLOW MEDIUM				
CADMIUM YELLOW PALE				

	VERMILION	ALIZARIN CRIMSON GOLDEN	COBALT VIOLET	THIO VIOLET
COBALT BLUE				
FRENCH ULTRA-MARINE BLUE				

What are the graying capabilities of my palette?

Get out your usual equipment, including your regular palette. If you use more than one kind of paper, make patches on each as you go along. You may also find that your hue scale provides a handy reference to the relative hues of the paints on your palette. *Remember to label all your mixtures.*

Begin by making three simple two-color mixtures, approximately half and half, of the intense hues on your palette that are most nearly complementary. Where you do not have an exact complement, use the hue that comes closest. For example, if you have no yellow-green, use your yellowest green or greenest yellow. If you have no red-purple, use the purplest red you have.

Your six mixtures may vary greatly in relative neutrality. Your blue-orange mixture may be quite gray and your yellow-purple one, much less so. You should come up with at least three pretty good grays, though, including red/green, red-orange/blue-green, and orange/blue. Fewer than three suggests that you may need to rethink your palette, substituting another paint for something presently there, to increase the graying strength of your complementaries.

Consider this with care, however. You may be graying largely with natural neutrals, such as Indian red with phthalocyanine green, or you may be graying very satisfactorily with black. Both are perfectly acceptable ways of graying colors, although many painters use little or no black because they feel other mixtures have finer undertones.

To complete the complementary mixing exploration, make samples of intense colors mixed with their neutral complementaries. These might include ultramarine blue and burnt sienna, cadmium yellow lemon with mars violet, and alizarin crimson mixed with terre verte. You might also mix neutral complements such as lampblack (which is bluish) and burnt sienna or yellow ochre and mars violet.

How can I alter hues with the least possible intensity loss?

For this exercise, make a continuous graded wash changing from, say, lemon yellow to phthalocyanine green. This will show you the range of hue changes and indicate how much, if any, intensity reduction results from the mixture. Do this with all your intense hues, going around the hue scale, mixing each color with the one closest to it.

What is the range of mixtures possible with my palette?

It is useful to try mixing secondaries from primaries, that is, using anything that might plausibly be called *yellow* and mixing it with anything that might plausibly be called *blue* to make your green range. Set up a grid, such as the one shown on page 64, and label each vertical and each horizontal row. Make similar grids for the orange and purple ranges.

How will my opaque colors mix with each other?

It is also helpful to try mixtures with each of the colors you have identified as relatively opaque. A grid will work well for this too.

How can I test more complex color mixtures?

Frequently, mixtures of three, four, or even more colors arise spontaneously during the painting process. If you want to test some of them, I recommend the grid procedure in which you use a particular two-color mixture for one coordinate and then mix it with a selection of other colors. For most painters, experiments with complex mixtures are most instructive if they are organized in some way; for example, you might try alizarin crimson and ultramarine blue as one coordinate, mixing it with any set of other colors. When using complex mixtures, be especially alert to the tendency of your opaque pigments to go muddy.

Color Design

Does your use of color enhance your range of design and expression?

Color serves such varied purposes that artists often avoid trying to understand it by taking refuge in the assertion that "color is personal." Of course it is, but so is every aspect of picture-making.

To achieve effective color design—the ordering of color—you must ask yourself what you are aiming to express as you begin a picture. This involves three main considerations: (1) What does your response to the subject demand—how does it make you feel? (2) What can your palette deliver? (3) What principles can you impose on both to make the best possible translation?

Ordinarily, you want to decide on some basic principle of color organization and then modify it to suit your particular circumstances. You think about similarities, contrasts, and other organizational principles such as sequence and balance, and you recognize that some are inherent in your subject. In fact, they may even be one reason for your interest in the subject and should be taken advantage of in your painting. Doing this will free you from the boring artificiality of rules that require you, for instance, to put an arbitrary dab of any color you see in two other places on your paper, and it will also free you from inadvertently producing paintings that are all similar in color.

Understanding the ordering principles of color gives you a handy, organized way of dealing with color problems in planning a painting. Although you may find planning color in detail before you paint inhibiting, it is easier to think about a general color plan when you understand color well. And whether you plan your color at all, knowing how color works helps enormously when you assess your efforts after completing a painting.

Similarity

The most basic form of color similarity is using only one color to paint a monochromatic picture. The simplest monochrome does not even use hue—just black, white, and grays. A monochromatic painting relies only upon value contrasts for representation, design, and expression.

The main difference between a completely neutral monochrome (using black) and one using a hue, of whatever intensity, is in the overall "feel" of the painting. This is one indication of the expressive power of color. For instance, the effect of a monochrome painted with a neutral warm, such as Indian red, would be different from that of the same picture painted in an intense cool, such as phthalocyanine blue.

Another way to work with similarity of hue is by using analogous colors (those in the same hue family, such as three adjacent colors on the scale—red, red-orange, and orange, for example). This sort of arrangement can make a picture both expressive and coherent, but because it lacks contrast, it permits very little descriptive scope, even with variations in intensity and value. Most often analogous color similarity is used at low, rather than full, intensities.

Similarity of intensity is a more common method of creating color coherence while simultaneously setting the emotional tone or mood of a picture, as in Karl Schmidt-Rottluff's *Landscape* (on page 98). He has used red, orange, yellow, green, and blue, all at or very near their fullest intensities. Because these colors cover a fairly wide value range, the combination maximizes your awareness of the different hues and adds excitement to the visual order in the painting.

Using relatively high intensities to organize color throughout a painting and suggest the sparkling brilliance of sunlight was an Impressionist invention. You will also find it in the watercolors of Childe Hassam, Maurice Prendergast, and Dodge Macknight, among other Americans.

Today paintings also are ordered by using colors of similar middle or low intensities. These are a result of what is frequently referred to as a "limited" palette. I prefer to call it a "controlled" palette, since every palette is to some extent controlled by the artist who selected it. For example, if you intentionally use Indian red, burnt sienna, raw sienna, terre verte, Payne's gray, and mars violet, you will

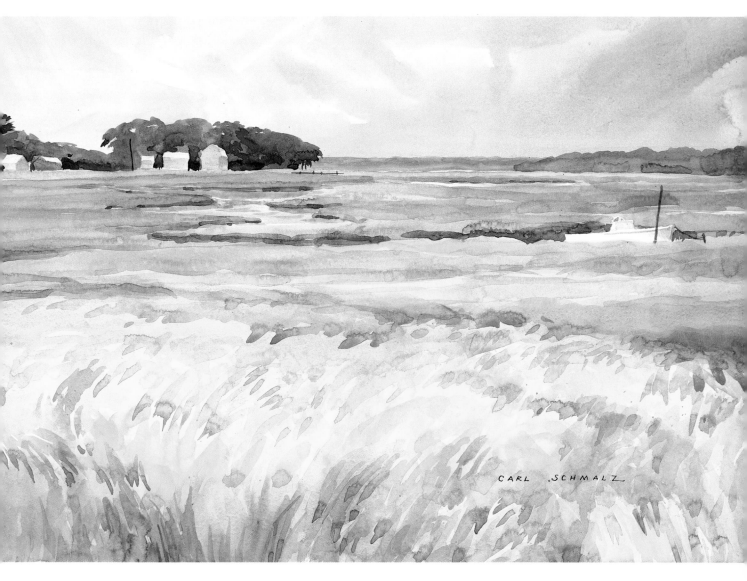

make a painting of low to medium intensity. You have all six major hues and a full value range, but you will have created color coherence through similarity of intensity. In the same way, you might select burnt umber, raw umber, and lampblack to paint a picture ordered by similarity of very low intensity.

For the representational painter, using similar *values* to order color does not usually work very well. When this method *is* feasible, rather strong contrasts in hue and/or intensity have to be used for both descriptive differentiation and visual interest. Susan Heideman's *Nursery* (page 126) uses near close values, as does my *Salt Marsh, June,* in which only a few darker and lighter accents interrupt a surface that is at value levels two to three overall. Contrasts of hue and intensity substitute for value contrast.

SALT MARSH, JUNE
by Carl Schmalz, 1976,
15" × 22" (38 × 56 cm),
140 lb. hot-pressed paper,
collection of Polly Bain.

This painting "carries" because of contrasts in relatively intense color, with minimal value contrast.

Sequence

Sequential relationships in color generally involve analogous colors that occur next to each other around the hue scale. My *Fort River, Fall* is organized by analogous hues—red, red-orange, orange, and yellow—with contrast created by touches of complementary blue and by strong value differentiation. Schmidt-Rottluff's *Landscape* (page 98) is also a good example, since it consists of red, orange, yellow, green, and blue. Charles Demuth's *Landscape, Bermuda* (page 101) also illustrates a sequential scheme; varying intensities of blue, blue-green, green, yellow-green, and near yellow are set off by low-intensity red.

Sequential changes of intensity, frequently accompanied by corresponding value sequences, are common in representational painting. A regular decrease in intensity often results from progressively raising or lowering values, as when objects are modeled from light into shade. In *Winter's Work* (page 62), the background is shaded by clouds. You can see the gradual reduction of intensity into the background on the right side of the painting. Atmospheric perspective can also decrease intensity and raise the darker values as colors of more distant objects gradually approach the color and value of the atmosphere itself.

FORT RIVER, FALL
*by Carl Schmalz, 1974,
15" × 22" (38 × 56 cm),
140 lb. hot-pressed paper,
collection of Ellen Berezin
and Lewis A. Shepard.*

Analogous hues were used to organize this picture.

Value Contrasts

Value (along with some spatial elements) is most often employed for contrast in representational painting, and likenesses among spatial elements, hues, and/or intensities provide similarity. To compensate for transparent watercolor's tendency to dry lighter—resulting in paintings that may be somewhat pale overall, lacking impact—value contrasts can be deliberately enhanced by pushing values together at one end of the scale. In my *Overcast Island*, for example, the darks are all low and close in value, giving extra leeway for variation of value from level six up. Compression of the light values strengthens my *Spring Studio:*

Swamp Azaleas. The lighter values are all pushed toward white, allowing a wider range of darker values to detail the varying rich colors of the interior. The same device is used by George Shedd in his *Maine Gables*, shown on page 71.

The object of these procedures is to retain the force of light/dark contrast while extending as much as possible the value range at one end of the scale. The powerful visual excitement of value contrast is used primarily for descriptive differentiation in representational art. But painters may equalize value contrasts over the picture surface to produce order and also use them to focus attention.

SPRING STUDIO:
SWAMP AZALEAS
by Carl Schmalz, 1970, 10"
× 23" (25 × 58 cm), 140 lb.
hot-pressed paper,
collection of the author.

In order to preserve the maximum possible value range for the dark interior, I forced the lighter values to near white.

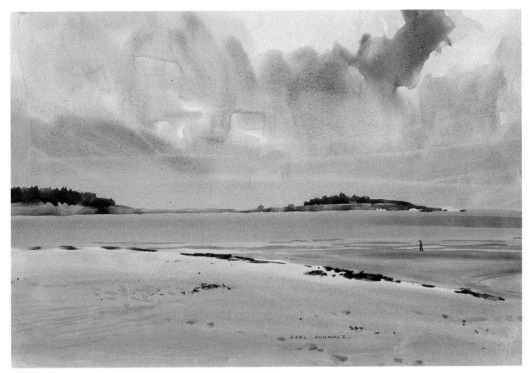

OVERCAST ISLAND
by Carl Schmalz, 1976,
14¹/₂" × 21¹/₂"
(37 × 55 cm), 140 lb.
hot-pressed paper,
collection of the author.

By compressing the
dark values here, I ex-
tended the range of
variation possible in the
lighter values.

MAINE GABLES
by George Shedd, c. 1972,
9¹/₂" × 12³/₄" (24 × 32 cm),
72 lb. rough paper,
collection of the author.

Here Shedd has com-
pressed the lights,
which are all unmodu-
lated white paper, re-
serving the fullest value
range for the middle
and darker colors.

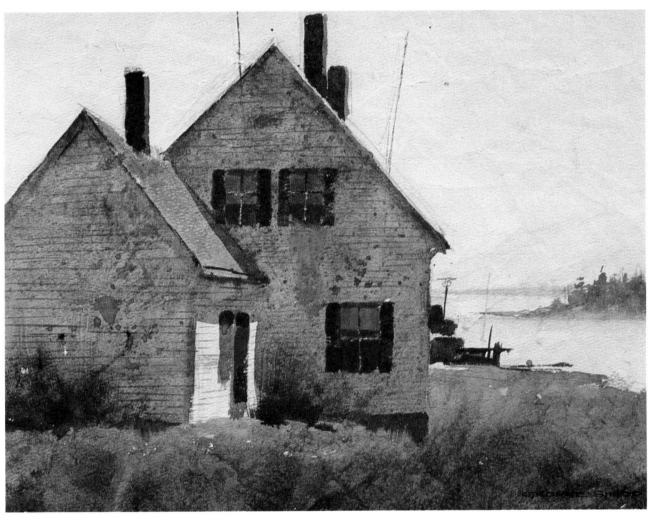

Color Temperature and Balance

Apart from value, the basic contrast in color elements occurs between warm and cool hues; that is, red-orange and the colors near it on the hue scale contrast with blue-green and its neighbors. Edwin Land, in preparation for the Polaroid color camera, did research indicating that the human eye has a tremendous capacity for distinguishing subtle differences among relative wavelengths quite apart from identifying the particular wavelengths that we name orange, green, and so forth. Possibly it is this ability that makes us so sensitive to the warmth or coolness of color.

Whatever the cause, color "temperature" is basic to hue perception, and the color organization of many paintings is rooted in this distinction, which we seem to appreciate as *balance*. As warm/cool contrasts become more pronounced, so that individual hues are clearly discernible, these contrasts become complementary. (Yellow and purple, although complementary hues, are neither warm nor cool until, by further contrasts, we make them so). Complementary hues exhibit similarity through opposition or balance, in which case contrast performs an ordering function.

Maine Still Life (page 120) is a warm/cool painting in which relatively high intensity oranges and yellow-oranges balance larger amounts of relatively low intensity blues and blue-purples.

Look at *Salt Marsh, June* again (page 67). I organized color by intertwining complementaries—basically, yellow-green and red-purple. Because the values are close and rather high, the yellow-green can be fairly intense but the red-purple will necessarily be neutral—and, as you can see, the red-purples in the foreground grass *are* quite neutral. Blue and orange are the complementary pair used as a counterpoint. The blue is not dominant—it is limited to a rather neutral bit in the sky and a bit in the water and the shadow on the boat. Orange, on the other hand, is intensely present in the middleground marsh grass, where it provides a hot accent; the blue in the water becomes vibrant against it. The hue complements and relatively high intensities keep the middleground as interesting as the more visibly stroked sky and foreground, so that all parts of the surface are about equally interesting.

A simpler picture based on color balance is my *July 6, 1976*. This is basically a green–red picture with a few accents of yellow-orange and blue. Because the intensities here are sufficiently high, the complementary organization is visible and appreciable. High intensities and snappy value contrasts balance and "contain" the inherently interesting flag. Containment could, of course, be achieved by *lowering* the intensity of the flag, but that would produce a less cheerful picture.

Color organization is often based on a three- or four-color scheme, such as a regular triad from the color circle or a triad plus one complementary, in which case we recognize the regularity of the intervals between the dominant hues. Susan Heideman's *Nursery* (page 126) illustrates this sort of organization. Heideman uses the triad yellow-orange/blue-green/red-purple, plus yellow-green. Most of the yellow-oranges are high in value and very low in intensity, but they pervade the picture. The red-purples are also of high value and low intensity, and so we are more aware of the yellow-greens and blue-greens that define the nursery plants.

While hue contrast can create order through balance, value and intensity contrasts act as differentiating agents. Contrasts of intensity are frequently used to focus visual attention and/or augment spatial description; in the absence of other modifying elements, an intense hue always appears nearer than a less intense one.

Remember that color, as is true of all other aspects of pictorial language, is relative. The color elements are relative to each other, of course, and also to the spatial factors in design. Relative size is especially significant, since a large area of intense color attracts your eye much more than a small one. Even more importantly, color is relative to your *expressive* needs.

JULY 6, 1976
by Carl Schmalz, 1976, 15" × 22" (38 × 56 cm), 140 lb. hot-pressed paper, collection of Mr. and Mrs. Robert Jacobs.

Color organization is basically red/green, with a subtheme of the contrasting complementaries blue, blue/purple, and yellow/orange.

Do my paintings resemble one another in overall value or value pattern?

Are your paintings all generally light or dark, or do a lot of them have a dark in, say, the lower right corner? If so, you may be using value in a habitual way rather than adapting it to the expressive requirements of each painting subject.

As you know, watercolor dries lighter than it goes on, resulting in a common tendency toward pictures that are uniformly pale in value. If your paintings show any evidence of this tendency, resolve to number your values for a while, and try to obtain a better proportional relationship between nature's values and the much narrower range your palette can produce. Precisely because of the value limitations of your palette, sometimes it is desirable to push the values at one or the other end of the value scale together arbitrarily, giving those at the other end greater power for contrasts. Check to see whether you are using this device in your allover "light" or "dark" pictures. Congratulate yourself if you are.

Since value is primarily useful to you for contrast, examine the ways in which you are exploiting it. Do your contrasts of value occur at points in your pictures where they tend to emphasize meaning, or are they merely creating unnecessary visual excitement? Value contrast is so powerful a tool that you want to use it as effectively as you can.

Do my paintings reveal good color organization, or are they coloristically chaotic?

Look at your pictures to see what you are doing with hues. Do you have some color preferences? Probably you do. As with value, though, you want to be sure that your selection of particular colors and color combinations is not just reflexive, but represents thoughtful purpose on your part.

The two most usual ways of controlling color are by selecting a limited number of hues, ordinarily related by similarity or complementarity—such as yellow, yellow-green, and blue-green; or yellow-orange, yellow, yellow-green, and blue-purple—and by using a fuller range of colors but imposing some intensity limitations on them. Try to figure out whether you are exploiting the different "feel" of hues and hue families; using different intensities as much as you might; playing off warm and cool as effectively as possible—all with reference to the expressive purpose you envisioned for each picture.

Have I been as adventurous and imaginative as I might be about selecting colors?

You might need to broaden or change your color selection—not just to be different, but to enhance your meaning.

If you like medium to low intensities, consider whether you are using as full a range of hues as you might. Also, could your pictures be visually richer and expressively more forceful with occasional high-intensity touches?

Do my pictures really hang together coloristically?

Ask yourself if there are places where a too-strong contrast in value or intensity seems to jump off the paper. Is there an overall balance or sequence (usually toward the focal point) in the color interest of your pictures? Are you using overall color and intensity for expressive effect—creating a similarity of, say, hue—not only for a coherent design, but also for unity of design and content?

Working with Light

CHAPTER ELEVEN

Lighting

Are you fully exploring all possibilities for lighting effects?

Light can be used both to unify a painting and to differentiate elements within it by emphasizing either similarity or contrast. Visual perception depends on light, and the appearance of objects is altered by the amount, kind, and color of light falling on them. This chapter will discuss the two fundamental kinds of ordinary daylight—direct and indirect—and explore some of the ways in which lighting can be used in your watercolors. This will help you gain a systematic understanding of the ways you represent light in your own work.

Direct Light

A consistently presented direct light from any angle is one of the strongest unifying agents in picture-making. At the same time, direct lighting offers you many ways of differentiating pictorial elements, including value, hue, and intensity contrast, as well as emphatic lines and shapes.

For artists there are four primary kinds of direct light—*side light, top light, back light,* and *front light.* Each has different characteristics, advantages, and disadvantages for you as a painter.

Side Light

Side light, sometimes referred to as cross lighting, occurs when the sun or any other light source strikes objects more or less from the side. When you are painting nearby objects, you can often change the light you see by moving yourself or the subject around to produce either more or less direct side lighting, or even a different kind of lighting.

Western artists have tended to prefer side lighting to other types because it most emphatically reveals three-dimensional form and the spaces between objects. In side lighting, strong value contrasts created by dark shadows provide visual clues to an object's form. Hence, in addition to the profile of an object's edge, you also see a shadow contour *on* the object that confirms or modifies the profile. Shadow contours give you much more information about surface shape than can profiles alone, as shadows also reveal the solidity or mass of an object.

Side lighting also creates relatively long cast

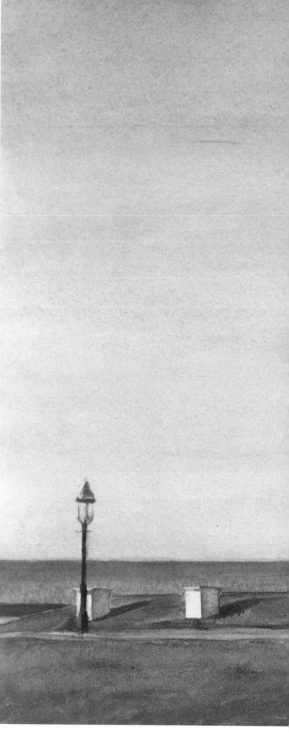

WINDSOR HOTEL, CAPE MAY
by Nicholas Solovioff, 1978, 18″ × 24″ (46 × 61 cm), 140 lb. cold-pressed paper, private collection.

The three-dimensionality afforded by side lighting is particularly evident in the shrubbery at lower center.

N. Sdoroff
Cape May 77

shadows, which are useful in orienting yourself in a world of space and solids. Cast shadows conform to the shapes of the surfaces on which they fall. This helps to indicate the distance between objects as well as the shape of the ground or other objects on which they rest.

With side lighting, value contrasts tend to be high and to overpower more subtle color relationships. Both the Impressionist and the Expressionist painters found that to maintain high hue intensities, it was necessary to "model" with intense hues, and so darks were painted with reds, blues, and purples—the naturally dark hues.

Windsor Hotel, Cape May (preceding page) by Nicholas Solovioff, is an excellent example of the way side lighting emphasizes three-dimensional solidity. Notice especially the shadow contours in irregular objects such as the trees, tree trunks, and rocks. These contours are helpful in clarifying shapes, and cast shadows aid in establishing spatial relation-

ships around the porch area. My *Maine Morning* shows how cast shadows reveal the form of each area on which they fall. Shadows in the foreground show the contours of lawn and road; and on the house in the center, shadows of leaves accentuate the vertical plane of the façade and the pitch of the roof. To the left, the cylindrical tree trunk is defined by the shadows cast upon it.

Top Light

Direct light from above occurs outdoors at or near noon, and it commonly produces a rather flat effect that can be very useful to artists. If you think of it simply as a kind of side light from above, you will realize that the three-dimensional forms of objects are not concealed by it but revealed in a relatively unfamiliar way. Nevertheless, because cast shadows are short and small, a great deal of light from surrounding illuminated surfaces is usually reflected onto the shadow sides of objects, lightening

MAINE MORNING
by Carl Schmalz, 1973, 15″ × 22″ (38 × 56 cm), 140 lb. hot-pressed paper, collection of the author.

Cast shadows, especially the longer ones that usually result from side lighting, clarify the forms on which they fall.

WORKING WITH LIGHT

them and generally reducing the modeling. Especially in regions close to the equator, this results in a strong sense of immateriality.

Since the sun always shines down at a slight angle (except at the equator), top lighting normally offers the artist a choice of viewing a scene from either a relatively illuminated or a relatively shadowed point of view. As in side lighting, strong value contrasts often characterize top lighting and thus reduce subtle hue relationships.

12:15, Cape Porpoise (page 63) is powerfully top lit, yielding strong three-dimensional forms, luminous reflected lights, and flickering dark accents, particularly in foliage areas.

In his painting *Up Somerset Way,* Steven Masters takes advantage of the visual excitement created by the sharp, often small darks created by top lighting. The upward-pointing, arrowlike shapes at right dramatically underscore the mounting sweep of the stairs, which is focused by the arched doorway and halted by the horizontal eave shadow across the top of the painting. Skillful variations in the bricks add interest to the foreground, and cast shadows from palm leaves serve to break up

the picture's architectural austerity while helping to locate the scene geographically.

Back Light

Sometimes referred to as up-sun, back light is an interesting choice for many artists. It produces intensified value contrasts, usually accompanied by strongly silhouetted shapes and a minimum of modeling. Hues become somewhat less important in this light, and intensities are often low. Back light is chiefly useful to the artist for its dramatic emphasis of dark (shadowed) shapes.

Nicholas Solovioff's *Lighthouse on Gibbs Hill, Bermuda* shows the advantages of back lighting, including reduced modeling (the silhouette effect), noticeable value contrasts, and emphatic shapes. There is also a deliberate play of sharp architectural darks among the doors and windows. Immediately visible from afar, the clear-cut shapes of the dominating tower and its forward-thrusting shadow—whose "cast darkness" appears to contradict the tower's purpose—announce the picture's expressive theme.

UP SOMERSET WAY
by Steven Masters, 1980, 14" × 21" (36 × 53 cm), 140 lb. hot-pressed paper, collection of Sir Peter Ramsbottom. Photo by the artist.

Top lighting offers Masters an opportunity to capitalize upon strong darks.

Front Light

Illumination from behind the painter falls on the fronts of objects and is often termed down-sun lighting. Artists use it less often than the types of direct lighting already discussed, but it should not be overlooked, for it offers some interesting possibilities.

Front-lit subjects, like back-lit ones, do not usually reveal much modeling. The relative flatness of such light is often relieved by small, very dark shadow accents. It also tends to emphasize color; most elements in such a scene are distinguishable by hue and intensity differences, since value contrasts are minimized. Hence, this light presents special opportunities for expression through high-intensity hues and tapestrylike patterns. Fairfield Porter's *Lawn* (page 60) exemplifies this, its near-frontal light softened by mild overcast. The somewhat flat shapes are characteristic of down-sun illumination. Boldness of color and shape is notable also in Eliot O'Hara's *Cliffs, Bermuda* (page 91), which fairly radiates frontal light back to the viewer.

Indirect Lighting

The various forms of indirect light give you the chance to increase pictorial coherence through similarity of hue and/or intensity. In rain, snow, and fog you have opportunities to define shapes and space with value contrasts. In most temperate climates, indirect light occurs often, and so it will be helpful for you to understand what is involved in painting it.

Just as we would be unable to see form in shadows without some reflected light, so we would not see things on sunless days without indirect light. Indirect, or diffused, light occurs when clouds cover the sun and cut down the amount of light coming through. Clouds, fog, rain, snow, dawn, and dusk all produce indirect light.

One important effect of clouds obscuring the sun on overcast days is a lessening of value contrasts compared with the contrasts apparent in direct light. This means that hue and intensity variations tend to become richer and more visible. The reduced value contrast created by diffused light also means that your palette's value range corresponds more closely to nature's.

Because fog and snow (as well as heavy rain) actually fill the air with a material substance, they tend to produce accentuated value contrasts between foreground and background, as in *Morning Fog* (page 104). They also reduce hue and intensity variation, pulling all colors toward their own relative neutral, as in *Ebbing Tide, Kennebunkport* (page 55).

LIGHTHOUSE ON GIBBS HILL, BERMUDA
by Nicholas Solovioff, 1983, 15″ × 22″ (38 × 56 cm), 140 lb. cold-pressed paper, collection of the artist.

Using rather neutral color to depict his back-lit subject, Solovioff maximizes value patterns and the shapes formed by areas of light and shade.

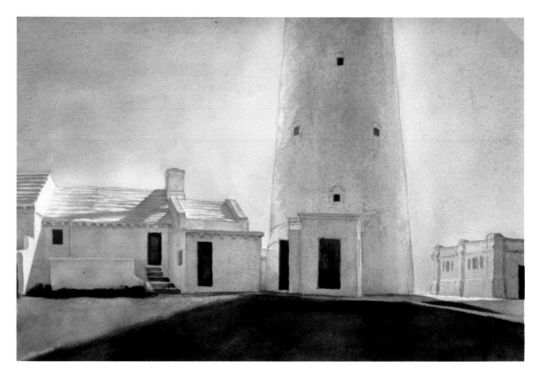

WORKING WITH LIGHT

Ask Yourself . . .

Do I tend to prefer direct or indirect lighting in my paintings?

Take an overview of your work to determine which kind of light you seem to prefer. Either preference is perfectly all right; neither is inherently better than the other, and sometimes an artist is much more responsive to one type of lighting.

If you have not previously made a conscious decision about the kind of light you generally use you will probably find that about two-thirds of your pictures are painted in direct light and one-third in indirect light. This proportion does not reflect the weather in your part of the world—it just indicates that watercolor landscapists seldom paint in rain and snow! A substantially different ratio of subjects painted in direct or indirect light may indicate a real preference.

Why do I paint subjects in the light I seem to prefer?

Is it accident, or do you actually feel better on sunny days? Do you like the muted color of overcast days? Does the drama of stormy weather attract you? What personal reasons for your choice can you discover?

Are there artistic reasons for this preference? Do you enjoy working with a strong indication of volume? Do you prefer high intensities? Low intensities?

The answers to these questions are neither right nor wrong; they simply yield information about you as a painter and show you where you might increase your range or build on your strengths.

Do I make good use of the effects of direct side light?

Side lighting can have a powerful unifying effect if you are careful to indicate the consistency of your light source. This applies equally to other direct lighting situations, but it has a special force in side lighting because of its implications for space and solidity.

Are you capitalizing on the information about volume and surface offered by the shadow contours on objects? And are you using cast shadows to help you model the forms on which they fall, as well as to help define the space between objects in depth?

How often, and how, do I use top light as an option?

Do you use it frequently, occasionally, or never? Could you profitably explore it further?

Do you make the most of the unusual shapes created by top light? Are you using the flattened forms sometimes associated with top lighting to enrich your picture pattern and surface? Are you seeing and exploiting the visual excitement offered by the small darks that top lighting frequently produces?

Do I use back lighting in my pictures?

If not, have you thought about how its accentuated value contrasts and emphatic shapes might answer your expressive needs?

Have I explored the possibilities of front lighting in my paintings?

If you are interested in the unifying effect of surface patterns and the similarity of intense hues, this may be something to try.

Do I take full advantage of the expressive and design potential of indirect light?

Your palette has the capacity to reflect more accurately the narrow value range created by an overcast sky. This can produce greater subtlety in value relations than is usually possible in direct light.

Don't forget about the unifying possibilities of medium- to low-intensity similarities and the rich color relationships typical of overcast days. You also might want to ask yourself if you have made the most of the neutral colors and spatially gradated values created by hard rain, snow, and fog.

Colored Light

Do you understand how to use colored light in your paintings?

Colored light sources present special problems as well as unusual opportunities for the water-color painter.

You can expect to find colored (or perhaps only tinted) light at sunrise and sunset, and in moonlight, firelight, and light from nearly all artificial sources. Any night scene, interior or exterior, will almost surely involve colored light.

The primary artistic advantage of painting subjects in colored light is its strong tendency to unify color throughout the scene. This can also, of course, be considered a disadvantage because it limits color. Although the color of the light itself imposes color coherence on the subject—which contributes to pictorial consistency—the problem of painting lively darks can be discouraging. In transparent water-color, large areas of low-value colors can be tricky to handle effectively.

Overcoming the Difficulties

In addition, virtually all colored-light subjects *must* be painted in the studio from notes. If you habitually paint on the spot, this change of working procedure may be deterring you from attempting such subjects.

The problem of the darks can usually be overcome by thoughtful selection of paints and extra care in execution. Learning to paint from notes takes a little practice, but it is no reason to deny yourself the fun of dawn, dusk, and nocturnal subjects. All you need is a notebook, drawing tools, and a good method for noting hue, value, and intensity. A color-annotated sketch, including enlarged drawings of particular details, comments, and other memory aids, gives you plenty of information for a painting. With a little experience you will learn to include whatever other kinds of information you find useful.

If you are still reluctant to try pictures set in colored light, remember that they stand out on a wall, not only because they are generally dark and dramatic, but because there are so few of them!

SUNSET BETWEEN SANTA FE AND TAOS
by Eliot O'Hara, 1936, 15½" x 22½" (39 x 57 cm), 140 lb. rough paper, courtesy of O'Hara Picture Trust.

This picture illustrates the way colored light pulls all colors on which it falls toward its own color.

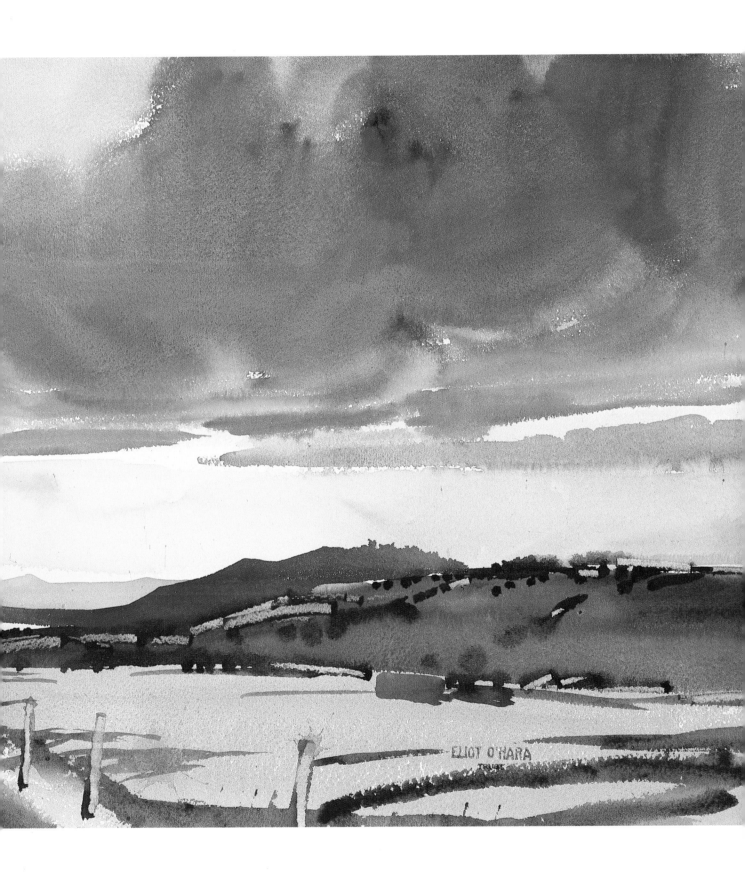

ELIOT O'HARA
TRURE

COLORED LIGHT

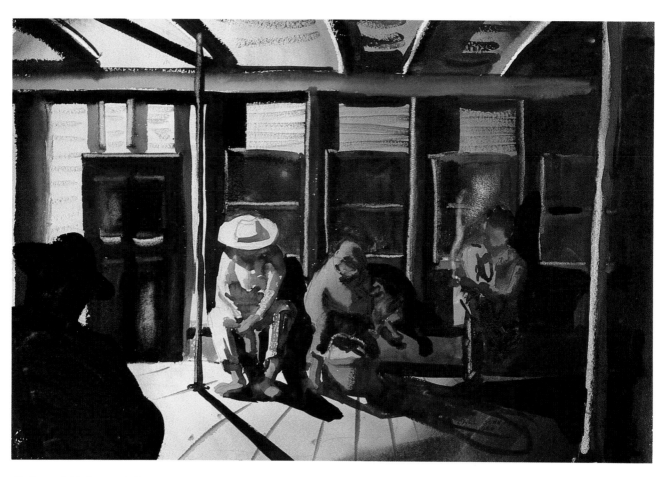

Colored Light and Color Perception

The first thing to remember about a tinted or colored light source is that it is *incomplete* light. White light contains all wavelengths of the visible spectrum, from the long reds to the short violets. A colored light source is deficient in some wavelengths. Firelight, for instance, contains virtually no short wavelengths, whereas moonlight contains almost no long ones. This means that you cannot see blue by firelight or any red by moonlight. Everyone has probably had the experience of seeing lipstick and other reds go black under mercury-vapor street lamps. We cannot see reds by this light because there are no red wavelengths in it to be reflected back by the pigment that appears red in ordinary daylight. When complete (white) light falls on something that looks red to us, it appears red because its surface absorbs most other wavelengths and reflects only the red ones.

It follows that in a firelight picture, all colors will be warm or black. Since human vision is remarkably adaptive, however, we actually perceive a surprisingly wide range of hues in colored light. This capacity is called *color constancy*. Because of it we see the shadow side of a white building as white, even though it may be bluish gray. Much of your task as a representational artist is to edit color constancy. In ordinary light you want to learn to see the actual color, the bluish gray, so as to paint it. But in colored light, color constancy can be extremely useful, since it permits you to avoid painting a completely monochromatic picture. To go back to the example of the firelight scene, color constancy allows you to include some low-intensity blues and greens, rather than paint only black, for cool colors. Usually this phenomenon also gives you the opportunity to employ some low-intensity warms in a moonlight picture.

Because colored or tinted light is incomplete, it is usually quite weak compared with sunlight. It generates little or no reflected light, and so shadow areas tend to be very dense. Silhouette effects are frequent, and shapes are prominent because contrasts of value are strong. These offer you splendid opportunities for powerful, dramatic paintings.

MEXICAN BUS
by Carl Schmalz, 1946, 13" x 19" (38 x 48 cm), 90 lb. rough paper, collection of the author.

One small incandescent bulb provided the only light source in this scene, which accounts for the very dark shadows and almost total absence of reflected light.

POLLY'S PIANO
by Jonee Nehus, 1976, 22" x 15" (56 x 38 cm), 140 lb. hot-pressed paper, collection of Mr. and Mrs. Robert L. Chew.

Nehus understates the darks here; thus the viewer only slowly recognizes the significance of the dark windows.

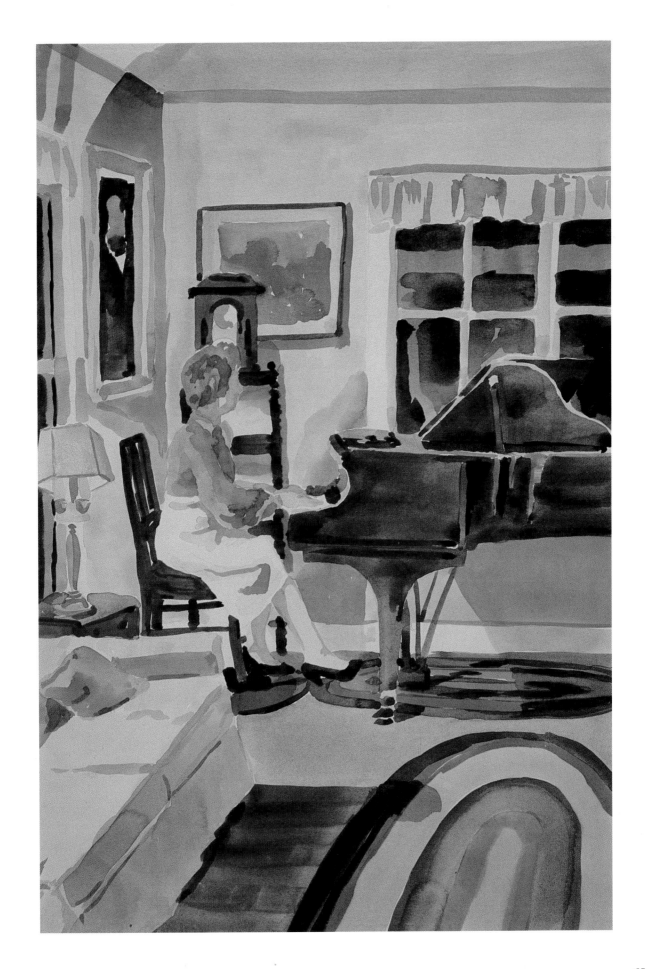

COLORED LIGHT

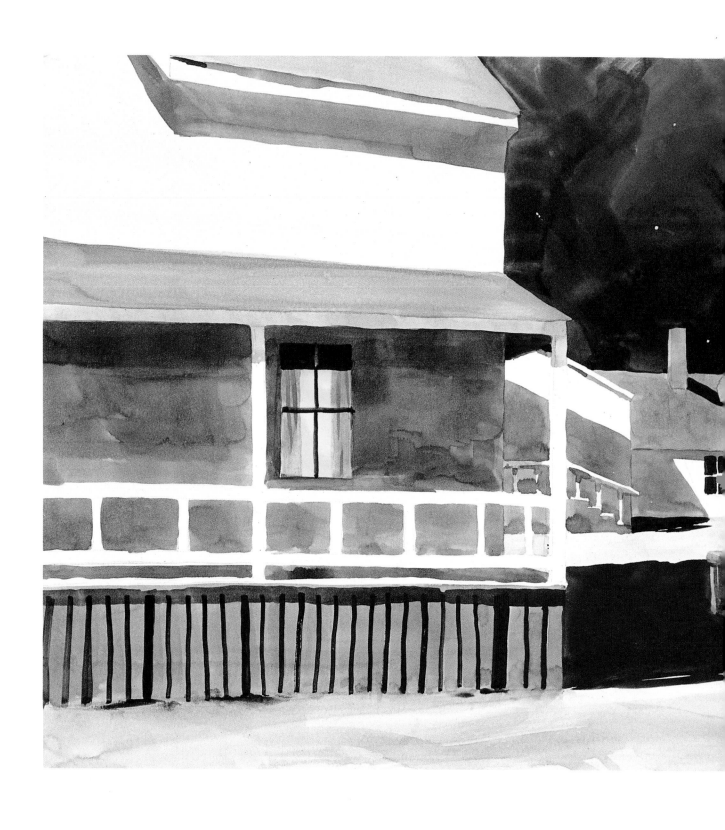

Unifying with Colored Light

Eliot O'Hara's *Sunset between Santa Fe and Taos* (page 82) is a fine example of the unifying effect of tinted light. Almost every visible object leans from its normal color toward red-orange/red/red-purple. Even the snow picks up a red-purple reflection from the clouds, and the most distant mountains are veiled in orange haze. The picture is unified by this natural similarity of hue. A few blues, justified by the dark clouds and sky above, act as a color counterpoint to the dominant similarities. Value contrasts strengthen the picture and emphasize the forms of the mountains.

I painted *Mexican Bus* many years ago, before my personality as a painter was developed, but it is of interest here because of the telling value pattern and the way the strong light/dark contrasts are unified by the pervasive yellows from the incandescent bulb. More importantly, the low intensities and generally warm colors help reinforce the tranquil mood of waiting for a bus to start late at night. Although the scene was painted from memory—I had no notes and was working six months after the experience—the vision remained clearly enough in my mind for me to reconstruct it.

Chez Leon (page 38), O'Hara's mildly abstract Paris night scene, has some of the same expressive qualities. It, too, is a low-intensity picture in which value contrasts are fairly strong and are responsible for most of the accented shapes. Light comes from several sources and is reflected in the wet street surfaces. The architectural clarity of the painting helps make it quite serene. It depicts a far-from-nasty night.

Handling Darks in Colored Light

Jonee Nehus's *Polly's Piano* treats a night interior with great sensibility. Value contrasts of light and shade are understated. Nehus reserves her darks for shape accents across the picture surface and exploits the limitation of warm incandescent light to create a range of muted, middle-intensity colors of great subtlety. These visually emphasize the auditory harmony suggested by the piano, and the varied darks strike the eye in much the way separate piano notes would strike the ear. The whole evokes a palpable mood of the delight of music in a quiet room at night.

My *Moonlight Demonstration* provides another example of how to handle darks in a low-key scene lit by tinted or colored light. Note the relative intensity of the green boards under the porch, as opposed to the very neutral warms of the illuminated roofs. Cast shadows and the sky are very dark and were mixed from naturally dark transparent pigments.

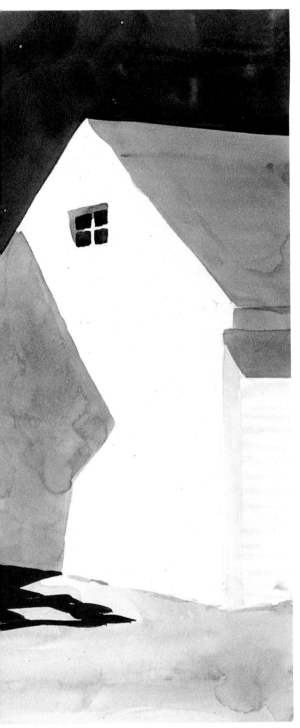

MOONLIGHT
DEMONSTRATION
*by Carl Schmalz, 1977,
15" x 21" (38 x 53 cm),
hot-pressed paper,
collection of the author.*

The darks here were kept alive by mixing them from the darkest, most transparent pigments available.

Do I make full use of colored light as a unifying factor?

Your selection of pictures may not include any in which you have employed colored light. In case you do have one or two, or would like to try using colored light in your work, consider this question and those that follow.

Do you overemphasize the unity of color—is your picture too exclusively pink, orange, green, or whatever? If so, you may have disregarded the factor of color constancy.

I recall once painting an upcoming summer storm at dusk that turned out all pink, gray, and black. The representational drawing and painting techniques were fine, but the picture lacked coherence because the color—which reminded me of Hollywood bathroom decor or the colors of a youngster's carefully planned party costume—was abstract and conflicted with the rest of the picture.

Have I capitalized on the value contrasts in scenes illuminated by colored light?

In an interior scene with a single light source, the strongest value contrasts, as well as the most emphatic silhouettes, tend to be located near the middle of the picture. A moonlit scene, on the other hand, may not arrange itself so easily. Outdoor, sunset, or night subjects must be as carefully thought out as any scene in sunlight. You must consider, for instance, the best angle to use to take advantage of long, descriptive cast shadows.

The type of colored light you paint makes a significant difference in your painting, mainly because not only the tint but the amount of light varies so much. One candle, such as Georges de La Tour often painted, provides a single weak, warm source in which forms are potently relieved against extreme darks. Sunset often produces fairly diffuse, but still quite strong, warmly tinted light. Moonlight is bluish or greenish and, after you adjust visually, it appears single and strong, even though it is actually too weak to create reflected light. A typical modern-day interior includes multiple light sources, often of different tints, which present you with quite complicated problems.

But let's take sunset as an example. In this colored light, would you paint up-sun (subject back lit), which is customary, since the sunset color is in that direction? If you did, you would lose the pronounced modeling that results from side light, as well as the greens and blues that are lost when your subject is illuminated by such deeply orange light.

If I have used cross light, did I achieve warm neutral greens in trees and grass?

Again, have you utilized the long descriptive shadows? Have you made your whites sufficiently pink or orange?

If I looked into the light source (up-sun), did I get sufficient color into the silhouettes?

And did you color the sky enough?

Are my darks dull and lifeless, or glowing and vibrant?

As you know, the very nature of transparent watercolor is hostile to large areas of extremely low value. Since the luminous quality of the medium depends on light reflecting from the paper's white surface up through the paint layer, you want to avoid a paint layer so dense

that reflection from the paper through it is prevented. The result would be a dead or muddy passage, which would stand out because it disrupted the surface coherence.

To minimize the chance of deadness in extreme darks, you must use the most transparent darks on your palette. These may include sepia, alizarin crimson, red-purple (such as Thio violet), purple (such as Winsor or Thalo purple), some ultramarine blues, and phthalocyanine blue and green. Working carefully with these or comparable colors, you can attain low-value areas that still remain quite vivid. Mixtures and glazes often yield even lower values, although you will probably not produce an absolute black. The trick is to push your whole value range up just enough to make your darkest darks *read* as black.

What's a good way to try a picture illuminated by colored light for the first time?

Since we have been dealing mostly with landscape in this book, try a moonlit landscape. First, you need a painting to work from. Select one from among your supply—not necessarily one that you've been using in these exercises. It should be a relatively simple scene painted in direct light. Check your palette to be sure you have fresh, workable amounts of your most transparent darks, squeeze out new color if desirable, and get a clean sheet of paper. Draw your scene on the paper as usual.

Now think about colors. Moonlight is a very cool, neutral blue or green tone. If your picture includes anything that is normally white in direct light, a very pale wash of neutralized blue-green should go over it. Don't make it too dark; you want to constrict your value range as little as possible.

This neutral blue-green tint will affect every other object in the picture. Cool colors will therefore tend to be more intense than warm-colored objects. The latter should also be painted considerably darker than they appear in daylight, since little cool light can be reflected from warm surfaces.

The sky also will be proportionately darker than it is in the daytime, and so you want to delay painting it until the values of objects in direct light have been put in. It will be a neutral blue, lightening slightly toward the horizon. When the picture is finished, you can pick out a few stars with the tip of a knife.

The value of all things in the picture will be somewhat darker than in your daylight version of the scene, but remember that both the shadow sides of objects and the cast shadows will be especially dark. Be sure to reserve enough of your lower value range to accommodate these. The strength of the contrasts they present is absolutely necessary to the illusion of moonlight.

Look carefully at the warm colors in your original picture. You will have to cut their intensity greatly and also reduce their value. But allowing for color constancy, you can include some warm darks. Think about where they might look best and be most believable.

Continue painting at this point, moving generally from the lighter to the darker tones. Begin thinking about your deep darks shortly after you start painting values below the middle level, and be conservative about warms. It is the effect of cool light, after all, that provides part of the unity of your picture.

Drawing, Pattern, and Darks

Are you seeing and using dark shapes effectively?

Good painting requires good drawing because clarity, precision, and the expressiveness of shapes and their relationships underlie forceful representation. Virtually all painting *is* drawing, but this is particularly true of direct painting with transparent watercolor. Like pen and pencil drawing, watercolor is applied to a white (or light) surface—generally in a light-to-dark sequence. Since you do not normally *add* any lights, the darks have an especially important function: they must describe the shapes of both dark things and lighter ones, while also giving visual excitement or "sparkle" to the image.

The chief differences between drawing and transparent watercolor are that, with the latter, you work in washes as well as strokes (which tend to be somewhat wider than drawing strokes), and you normally cannot erase your darks, as you can with pencil or charcoal.

How Darks Work in Watercolor

Because darks serve so many purposes and because they are largely ineradicable, it is important to understand how they function. Although there is some overlap, for clarity's sake this chapter will divide the use of darks into four categories that can be considered more or less separately: (1) as characteristic silhouette, (2) in shadow patterns, (3) relative to reserved lights, and (4) for design or composition. As a representational painter, you must learn to use darks intelligently in all of these ways, if your pictures are to have clarity and expressive power.

Characteristic Silhouettes

The point of view from which you approach a subject, as well as the lighting conditions surrounding it, will alter the placement of your

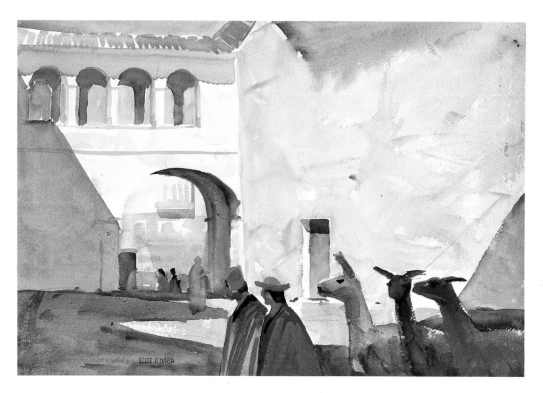

LLAMAS, CUZCO
by Eliot O'Hara, 1933, 15½" × 22¾" (39 × 58 cm), 140 lb. rough paper, courtesy of O'Hara Picture Trust.

O'Hara adroitly uses dark silhouettes to help define the illuminated space behind them.

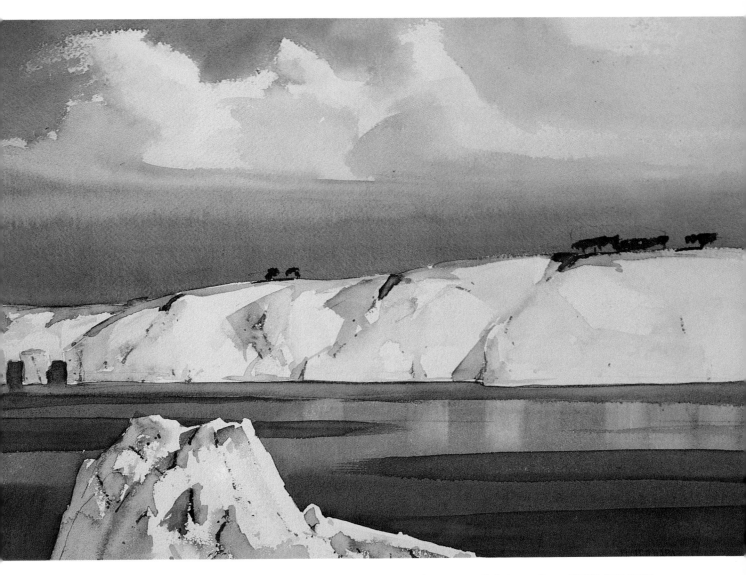

darks. Because of the role these options can play in descriptive clarity, you need to be aware of them as you begin a painting.

In *Llamas, Cuzco,* Eliot O'Hara's bravura handling is matched by a bold and skillful selection of darks. The figures, animals, and shadowed arches set off against blazing lights tell the viewer of the thin air of this high-altitude city. Architectural shadows, and the subtle hue and value changes within the forms, give shape to the plaza space and volume to the creatures in it. We see here that taking advantage of strong silhouettes can include using shadow contours. This is how Solovioff gently models the lighthouse tower in *Lighthouse on Gibbs Hill, Bermuda* (page 80).

With front, or down-sun lighting, the silhouette may be light against dark. An excellent example of this occurs in O'Hara's *Cliffs, Bermuda,* in which the darker sea and sky in the background provide "punch" for the sun-drenched cliffs and the clouds. The shape of the nearby rock, repeated in the clouds, helps to give coherence to a painting with powerful hue and value contrasts.

Selection of descriptive darks is necessary in both diffused and direct light. *Shack at Biddeford Pool* (title page), for instance, depends heavily on the size and placement of the major architectural darks, as well as upon the sequences of smaller darks in the vegetation below.

CLIFFS, BERMUDA
by Eliot O'Hara, 1931, 14½" × 20" (37 × 51 cm), 140 lb. rough paper, private collection.

O'Hara has compressed the lights slightly and taken full advantage of the small, flickering darks that are so often a feature of down-sun conditions.

DRAWING, PATTERN, AND DARKS

Shadow Patterns

Seeing and painting the patterns of shadow areas—both the shadow sides (and shadow edges, or contours) *on* objects and the shadows cast *by* objects on other surfaces—is an inescapable necessity in working with transparent watercolor. It is particularly important in representing foliage and other nongeometric volumes, but it applies to all forms.

Complex (especially, nongeometric) volumes reveal their structures through shadow patterns, just as simpler forms do; discerning them requires only an analytical eye. Note the difference in shadow shapes (and relationships) between white pine trees and deciduous trees or bushes in my *Rural Fire Station* and *Winter's Work* (page 62). Also note the difference between the shadow shapes among the background trees, the dahlia leaves, and the baby's breath in *Enclosed Garden*. The shadows on

the picket fence were painted before anything else, in continuous strokes across the paper. They were dry when the time came to paint over them to define the pickets with darker colors.

Merely distinguishing dark shadow shapes is not the point. Rather, the idea is to observe the *characteristic* shadow shapes of commonly encountered trees and shrubs. These shadow patterns, in addition to typical silhouette and branch structures, can then be used descriptively to identify particular kinds of greenery. Accurate observation almost always promotes economy of means, helping you deal succinctly with most complex forms, such as rock formations, wood piles, industrial detritus, and other apparently confused subjects. Remember, too, that you can deliberately make some of these shapes *similar;* that is, you can use them to unify rather than differentiate.

RURAL FIRE STATION
by Carl Schmalz, 1976, 15½" × 21½" (39 × 55 cm), 140 lb. hot-pressed paper, collection of the author.

The vaguely triangular wavelike shapes of the shadows on the white pine foliage differentiate it from the rounder, irregular shapes of the shadows at left.

ENCLOSED GARDEN
by Carl Schmalz, 1976, 15½" × 21½" (39 × 55 cm), 140 lb. hot-pressed paper, collection of Mr. and Mrs. Constantine L. Tsomides.

In this painting the preponderant darks function in a passive way, defining areas lighter than themselves.

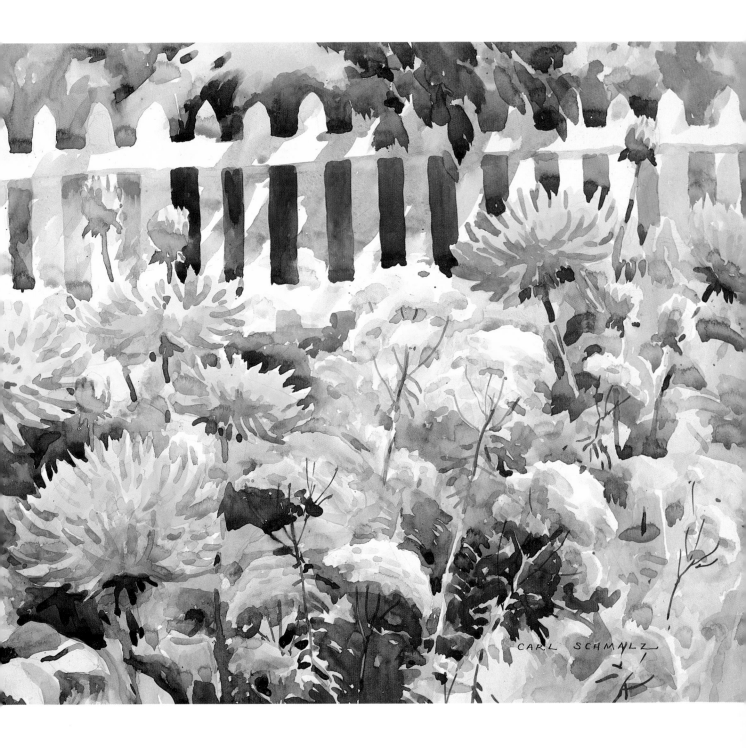

205 HILL STREET
*by Dee Lehmann, c. 1974,
15" × 22" (38 × 56 cm),
140 lb. cold-pressed paper,
collection of Mr. and Mrs.
Nat Baker.*

Lehmann employs reserved lights deftly and with economy, defining shapes by placing darker color around them.

Reserved Lights

Watercolor darks are applied as *positive* marks, even though they often serve to define something light. Hence, when they are used to affirm and clarify lighter shapes, they have a negative, or passive, function. That is why, in addition to thinking about drawing shapes in shadow areas, you must consider this self-effacing but vital role of the darks.

Dee Lehmann's *205 Hill Street* is full of retiring darks that "draw" the reserved lights, notably in the porch columns and railing. The windows of the cupola at the top left of the house are another example. The shadows on the side of the house isolate and bring forward the illuminated corner of the wing projecting toward us, and the darks under the porch at left describe the low branch of the shrub in front of it. The artist's accuracy of observation and economy of technique contribute to the coherence of this painting.

I sought a similar correspondence of method and representation in *The Anchorage, October.* The subject particularly interested me because it encouraged playing with reserved lights. The erratically lighted trunks and dead leaves of the oak trees were painted in a series of variegated washes so that some of the illuminated lower trunks and the more distant foliage masses were painted at one time. I did the same thing with intermediate values and then defined particular trunks and branches last with low-value mixtures of reds, purples, and oranges.

In *Government Wharf* (page 11), the darks not only describe the outer pilings of the pier, but also suggest the great granite slabs and interior structure of the wharf. Try not to let your darks become mere "filler" behind the reserved lights; they should also be able to function in their own right as darks.

THE ANCHORAGE,
OCTOBER
*by Carl Schmalz, 1976,
15½" × 21½" (39 × 55
cm), 140 lb. hot-pressed
paper, collection of the
author.*

Virtually frontal lighting here contrasts architectural and organic patterns, but what interested me most was developing the trees simply, by planning reserved lights.

Focal Contrast and "Sparkle"

You already know that it is desirable to locate strong value contrasts at or near the representational focus of your painting. Remember, though, that this device is more effective if the contrast also announces the pictorial theme. This can be done quite simply, as in Mary Kay D'Isa's *A Brush with Winter.* Here the central mass of dead weeds and bushes contrasts strongly with the surrounding snow—the fundamental visual theme. Not only is this shape repeated with variations in the distant woods, but also you see it in the swelling mounds of the snow-covered ground. In addition, at the representational level, the contrast of dormant life against hostile snow expresses the idea of the whole painting.

Sidney Goodman's *Eileen Reading* (page 140) is a very complex picture, but it, too, has the basic design theme near the center in the contrast of the light, rectangular paper against the dark, rounded head.

Visual "sparkle" can result from the contrasts of relatively small darks against lights. It may be largely nonrepresentational, as in the left foreground of D'Isa's *A Brush with Winter,* or it may be more descriptive, as in my *Enclosed Garden.* Remember, however, that this delightful, eye-catching possibility can easily become arbitrary visual "noise" if you use it without justification, and you must also be careful not to overdo it.

A BRUSH WITH WINTER
by Mary Kay D'Isa, 1974, 22" × 30" (56 × 76 cm), 300 lb. rough paper, collection of the artist.

The power of D'Isa's picture lies in the sparkle of her expressive means: wet against dry, spatter against scraping, low dark against white.

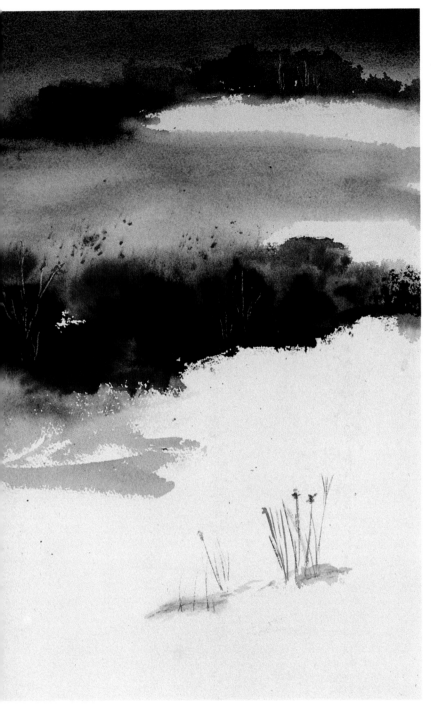

Ask Yourself . . .

Do the silhouettes in my paintings accurately characterize the objects they depict?

Do they enable you to identify the objects readily? Drawing requires seeing and recording accurately—not necessarily with scientific exactitude, but rather, with an eye to revealing inherent patterns.

Drawing is also recording the illusion of volume (modeling) and the relationship of things in illusory space. In modeling objects, do you often use the shadow edge or contour to give extra information about a subject's shape?

Am I making wise use of shadow patterns?

Do you use them to organize complex volumes such as trees, shrubs, and rocks? Are you analyzing shadow contours to aid you in defining the structure of the subject? If you are not, the shadows on most of your trees, bushes, rocks, and other objects probably look much the same; they may appear mushy and undifferentiated except for color.

Crispness and sureness in representation are a mark of consistent handling, which is a part of pictorial coherence. If you have been neglecting the visual order in shadow patterns on the surfaces of complicated volumes, practice sketching them with pencil or felt pen whenever you have the chance.

Do I pay enough attention to the role of darks in reserving light shapes?

This question has two parts. Are you using darks for economy in painting by reserving lights with them, and are you tailoring the darks so that they also act as independent, positive darks whenever possible? Ask yourself where, in your selected group of paintings, you deliberately allowed an initial lighter wash to overlap an area that would eventually be darker, and where did you set in a color because you *wanted* to reserve it later? The more economically you use strokes or colors, the more integrated your paintings will be.

Is the "sparkle" of small, sharp value contrasts a part of my painting repertoire?

How well are you uniting the eye appeal of major value contrasts with the expressive focus of your painting? Are you using it purposefully, or is it using *you* and perhaps robbing your pictures of focus and expressive clarity? "Sparkle" must be used with tact and knowhow if it is not to be disruptive.

Coherence Without Using Light

Is light your only means of unifying your paintings?

About 1900, many progressive representational artists deliberately gave up using light to unify their paintings. Instead, they began to explore non-naturalistic methods of representation. John Marin and Maurice Prendergast were among the first. Later, artists such as Arthur Dove and Charles E. Burchfield continued these explorations.

Karl Schmidt-Rottluff's *Landscape* is unified, not by light but by intense colors in a sequence around the hue circle. The powerful, brilliant color acts like a light source, almost the way stained glass does.

Although the painting's effect derives primarily from the luminous color, the sense of wholeness also depends on similarities and contrasts of line, shape, and size. The blue roof shape at the center of the picture is repeated in a varying gradation to the left, and the reserved gable shapes are echoed at right. The embracing beach shape above the center roof appears inverted in the edge of yellow grass at the bottom of the painting. These curves are sharpened in the various globular trees and shrubs and more loosely reaffirmed in the top of the dark forest between the houses and the foreground. Curves similar to the beach are also visible in the ocean. All the curves and angular shapes contrast strongly with each other, heightening and qualifying the visual excitement of the intense complementary colors.

Today many watercolorists work primarily in non-illuministic styles. You may be among them, or you may want to experiment with options you haven't tried before. If so, this chapter will discuss some things you should consider.

LANDSCAPE
by Karl Schmidt-Rottluff, 1911, 19½" × 25½" (50 × 65 cm), collection of the Dr. William R. Valentiner Estate.

German Expressionist Schmidt-Rottluff has substituted bold strokes and intense colors for the effects of natural light.

Expressing Nature Rather Than Describing It

The chief reason for eliminating or modifying light effects is that you wish to emphasize something else. Your expressive concerns may range from a sense of the dynamic forces of nature, as is often the case with Marin or Healy, to the more tranquil emphasis upon structure so often seen in Demuth.

When you deliberately give up the unifying function of light, you must rely much more heavily on nonrepresentational elements for pictorial coherence. You must be especially aware of the "abstract" possibilities for similarity and contrast in the surface, spatial, and color elements. Many representational elements also can be used to unify a painting, but with little or no light effect, these must often be used differently and organized even more tightly.

As a non-illuministic artist, free from dependence on light, you gain alternative expressive possibilities. Even if you paint within the constraints of natural appearances, you will think of a multitude of ways in which you can adapt non-illuministic methods to your purposes.

If you normally organize with light, you already will have faced many times some of the problems addressed by this chapter. Arthur K. D. Healy's *Rocks and Sea* was done on the kind of day when considerations of light are minimal. How does Healy's picture differ from a "normal" treatment of this subject? First, spatial illusion is minimized so that all of the intense activity confronts the viewer at the picture surface: there is little air, or breathing room, permitted by represented space. Second, specific accuracy in the rocks and water is played down in favor of general shapes. Finally, there are a number of arbitrary marks in the picture that do not perform a descriptive function.

Rather than concentrating on the look of nature, Healy has suggested the forceful clash of rocks and sea in a manner based purely on "abstract" means. The breaking surf is wet, the waves at left drybrushed (note the gradation between these treatments across the upper section of the paper), but neither really describes actual appearance. Powerfully opposed to these areas are the rich dark marks that stand for wet rocks. Many are spiky or rough, recalling the way rocks feel, rather than the way they look. The strong value, shape, and size contrasts of these marks against the water create an allover visual excitement that the viewer recognizes as equivalent to the forces and noises experienced in nature.

Playing with such powerful contrasts is hazardous in terms of making a coherent painting; even Marin did not always bring it off successfully. But it offers tremendous expressive possibilities—and besides, it is fun!

ROCKS AND SEA
by Arthur K. D. Healy, 1953, 7" × 10½" (18 × 27 cm), 140 lb. cold-pressed paper, collection of the author.

Achieving coherence without light does not mean eliminating value contrast. Healy's foreboding image combines dramatic light/dark opposition with size and texture contrasts.

WORKING WITH LIGHT

LANDSCAPE,
BERMUDA
*by Charles Demuth, 1916,
8" × 10½" (20 × 27 cm),
hot-pressed paper, courtesy
of Amherst College
Collection.*

In the absence of light effect, Demuth unifies this little landscape chiefly through the hue sequence and the interlocking of sharp-edged shapes of similar sizes.

Surface Unity

A quite different approach is taken by Bill Tinker (page 138). The calm created by many carefully controlled washes unites the picture's surface and invites us to ponder, to journey in our minds. Once again, spatial illusion is of relatively little significance. Instead, Tinker deliberately confuses spatial cues, suggesting the fluctuating perception of dreams. He relies heavily on his washes, color, line, interval, shape, and size, as well as multiple sequences, to give this image its strength and unity.

Charles Demuth's *Landscape, Bermuda* is a deceptively simple little painting in which a sense of light arises only from the luminosity of the clear washes and the few value contrasts. Three-dimensional space is relatively unimportant, having been sacrificed for an almost cubistic simultaneity. Color has been designed carefully. Its sequential ordering, implying change, augments the impression of pulsating space. By unifying his image with similar sizes, shapes, and crisp edges, Demuth stabilizes this activity. The painting expresses the permanence of growth as well as the transience of life—like Kaep's *Antique Dealer's Porch* (page 36)—but the means could scarcely be more different.

Expressing Feelings Visually

Susie's *Haunted Island* (page 137) illustrates a very different expressive aim. Here we have no difficulty in accepting the idea of deep space seen on a cloudy, overcast day. The scale of the rocks relative to that of the island gives a credible sense of space, and the feeling of light results from the uniformly low intensities. But these illusions are terribly fragile, and neither is a dominant organizing factor in the picture.

Susie's world is not one of appearances, but of events—not the bitter struggle between rock and surf that Healy addresses, but the brisk fragrance of salt-laden air that seems to sweep through the picture. It is the dry, scraggly brushstrokes that both unify the surface and qualify our response to the image. Gaps of white paper form a network through which we almost feel the wind blowing, causing us to overlook contradictions in appearance such as the island, which—though in the background—is darker than anything else in the picture. Notice, too, that the water at right has greater visual weight than the rocks at left. Far from being a "naturalistic" rendering, Susie's painting *interprets* her home place through coherent brush marks that convey her feelings.

How literally do I transcribe objects and the effects of light in my painting?

Looking at one painting at a time, try to remember as well as you can how their subjects actually appeared to you. If you have been extremely faithful to what you saw—and we'll assume that this was your intent and is a part of your "style"—give some consideration to what alterations, minor or major, you might have made to increase coherence and add expressive force. You are looking for minor changes now, small things that would affect the representation very little. For example, could you have sacrificed some descriptive texture, as in a rough tree trunk, for more consistent handling of the paint? If you had done so, would that have made other textures visible? Are there any lines or shapes that might have been changed a little? For instance, a barn gable, if shifted slightly, might parallel a major tree branch or form part of a linear sequence of shifting diagonals. Would such a change disrupt a similarity of shape between the barn gable and a shed gable? Or could you have made the line alteration and echoed the shed gable more closely at the same time?

If I do not "copy" exactly, what changes do I make, and why?

This question can prove tricky because you may find that you tend—as do most artists—to make involuntary adjustments in your subject. These are usually expressed in terms of representation: "I made the tree larger"; "I moved the house to the right"; "I raised the horizon."

Having identified one or more such alterations, ask yourself what *compositional* ends were served by your change. Did it actively increase similarity of size or shape? Did it create some similarity of interval? Did you modify any of the color elements for analogous reasons?

Next, ask yourself what *representational* ends were served by your changes. Were representational relationships clarified? Did you intensify linear, shape, or color contrasts to sharpen your *visual* means of expression?

In your analysis, how well do you think your strategy worked? Have you, for example, oversimplified relationships or created ones that look forced? Are your color similarities too obvious?

Are my alterations in a subject deliberate or unconscious?

If most of your changes are conscious, and they work unobtrusively and effectively, you are painting with excellent control and probably are fashioning pictures that reflect your hoped-for result a good percentage of the time. If most changes are conscious but a bit clumsy, you need to consider toning them down a little. If your unconscious changes seem to work, you probably don't need to do anything other than becoming more aware of them so you can use them even more effectively.

If you have discovered unconscious changes that don't seem to be doing the job very well, you should look carefully again at what you've been doing. Get rid of changes that are simply habitual. Try to refine, more consciously, those that have possibilities. Don't worry about jeopardizing your "creativity" by being more conscious of what you do. You will constantly develop new unconscious ways of stengthening your compositions.

How can I experiment with unifying methods other than light?

If you have never attempted a painting unified by other means, it would be instructive to try one—not because that is the way you ultimately wish to structure your work, but because it obliges you to think fiercely about other ways of achieving coherence and to consider kinds of content that can be emphasized without using light.

One way to experiment is to look thoughtfully at one of your paintings and see what it might express but does not. Then figure out how you could strengthen that expression by freeing yourself from normal appearances of light, atmosphere, and, to a lesser extent, form, space, and natural color. Instead, consider changes in surface and paint texture as well as the spatial and color elements. Try it! You might like it!

Painting Techniques

Working from Light to Dark Values

Is the basic light-to-dark painting procedure helping or hindering you?

In some transparent watercolors, the relationship between technique and representation is so close that it creates an effect of great simplicity and economy. Such a painting looks "easy" to the viewer.

The transparent nature of watercolor normally dictates the sequence in which it must be applied; that is, you must paint the lightest colors before you can add the dark areas that abut, overlap, or surround them. Instead of adding opaque pigment to achieve white or light areas, you "reserve," or leave them visible. The purpose of this chapter is to help you determine whether you are using the light-to-dark painting procedure effectively and with economy in your watercolors.

There are some obvious advantages to working light to dark. One is the necessity of working the surface as a whole, which forces you to keep the entire painting in mind from start to finish rather than concentrating on any one area. This creates a natural harmony among all areas of the painting.

Working from light to dark is also admirably suited to certain types of subjects, such as darker foreground objects seen against a light background. The typical procedure requires you to put in the background first, let it dry, and gradually add the darker foreground objects. In such cases, the painting sequence follows the spatial "logic" of the subject. This procedure is also well suited to painting subjects in indirect light—in fog, for example, or under an overcast sky. Again, in those cases it is easiest to lay down the distant, pale tones first and add the nearer, darker tones last.

Though you may not have the option of painting your center of interest first, as the oil painter does, you can still achieve a natural pictorial unity because the order in which you lay your washes corresponds to that of the spatial planes—background to middleground to foreground.

MORNING FOG
by Carl Schmalz, 1969,
12¹/₂" × 21³/₄"
(32 × 55 cm), 140 lb. rough
paper, collection of the
author.

The easy progression from light to dark, background to foreground resolves itself into four basic value levels—sky, distance, shack, and boat.

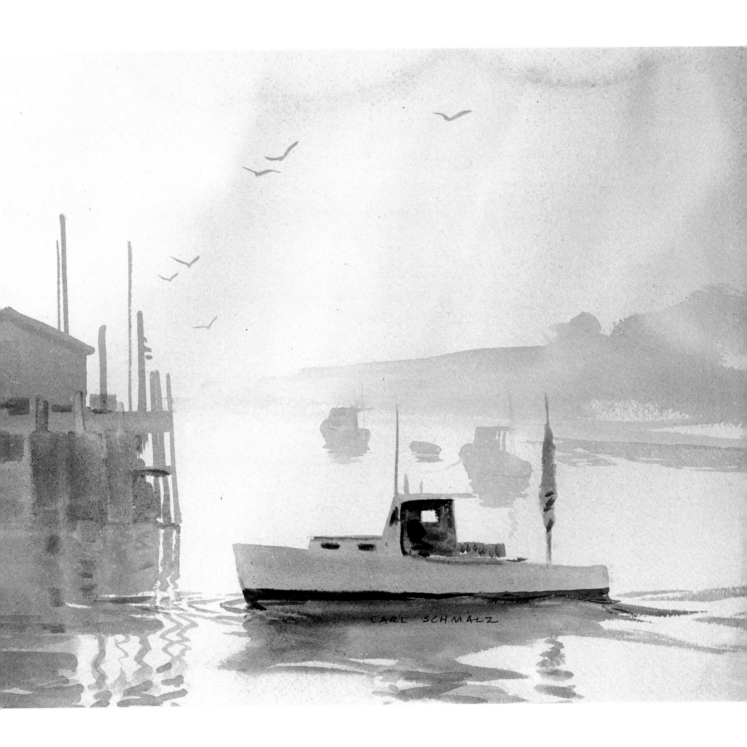

CARL SCHMALZ

WORKING FROM LIGHT TO DARK VALUES

Although in its purest form this method may not be suitable for many watercolors, it can be used in parts of most paintings. Because it is the "natural" way to apply transparent watercolors, it will contribute an air of ease and sureness to a painting.

Direct Light-to-Dark Painting

I began *Morning Fog* by laying in a sky wash in which wet-blended brushloads of orange-violet streaked the area, suggesting veils of drifting fog. When the lightest and most distant tone was dry, I added the shoreline to the right. While this was still wet, I lifted out a few strokes with a wrung-out brush to suggest wisps of fog. The silhouetted boats and their reflections went in next, in the middleground; then I put in the slightly darker tones of the wharf, reserving the pilings and ladders, and painted the greenish reflection of the dock. Last of all, I set the lobster boat and its reflection in the foreground. I had to wait for the other colors to dry before painting the darkest values in the painting—the boat's interior, portholes, and other descriptive details.

There are two aspects of this procedure that bear thinking about. One, which is purely technical, is the fact that with direct light-to-dark painting, you generally have fewer and more easily organized drying times. *Morning Fog* required only three drying periods. The other point is that the light-to-dark sequence corresponds almost exactly to the process by which the illusion of space is established in the painting, and this order is immediately (if subconsciously) perceived by the viewer.

Modifying the Method

In practice, most paintings we perceive as "easy" are not quite so simple. Look at *Above Lexington Ave.* by Eliot O'Hara. Like *Morning Fog*, it is procedurally uncomplicated. The sky wash went on first at the top of the page, and before it dried, the light washes of the buildings at center and right were added to dry white paper. When the light washes had dried completely, middle values were added in the nearer buildings.

Up to this point, except for the area left white for the steam, this picture had progressed easily from light to dark tones. But the middle-value structures in the foreground and at extreme left interrupted the normal background-to-foreground, light-to-dark sequence of wash applications. Even so, we feel the economy of technique and the clarity of space in this painting. O'Hara was able to apply his paint in a fairly sustained rhythm and to think over his next steps between applications of paint.

Despite the fact that its painting procedure is not perfectly "pure," the picture projects a satisfying simplicity that stems largely from the viewer's sense of the logical link between the technical means and the pictorial illusion. As in *Morning Fog*, the observer feels and appreciates the way in which the subject has been translated into terms appropriate to the process of transparent watercolor.

Overcoming Procedural Problems

The most common reason for not working light to dark in watercolor is greater familiarity with an opaque medium, usually oil. In using opaque media, which *cover* the surface, the procedure is generally to work from the middle values toward both light and dark tones. In oil painting, since lights are more opaque than darks, they usually can be placed adjacent to darks more satisfactorily than the other way around. The overall value pattern begins to emerge early and can be developed along with the representation. If you do not normally work from light to dark in watercolor, it may be because you feel uncomfortable about carrying your paintings past the halfway point without clear signs of an emerging value pattern.

There are several common ways to deal with this problem. Many watercolorists make one or more value sketches, like the one shown here, before beginning the actual painting. This might be a good practice for you as well. You can also plan to put in one or two small darks relatively early in the painting to help you gauge your final value range.

Another good cure for those "value shakes" is to number the broad value areas from light to dark on a scale of 1 to 9. (For a detailed discussion of value scales, see Chapter 7.) These numbers go right on the drawing, just before you start to paint; they serve the double purpose of reminding you to study your value relationships carefully while providing a ready reference to wash sequences during the painting process. You can remove the most obvious numbers later with a soft eraser.

ABOVE LEXINGTON AVE.
by Eliot O'Hara, 1931, 21½" × 14½" (55 × 37 cm), 90 lb. rough paper, courtesy of O'Hara Picture Trust.

Here the artist ignores consistency of light effects and uses darks arbitrarily to clarify spatial relationships.

PAINTING TECHNIQUES

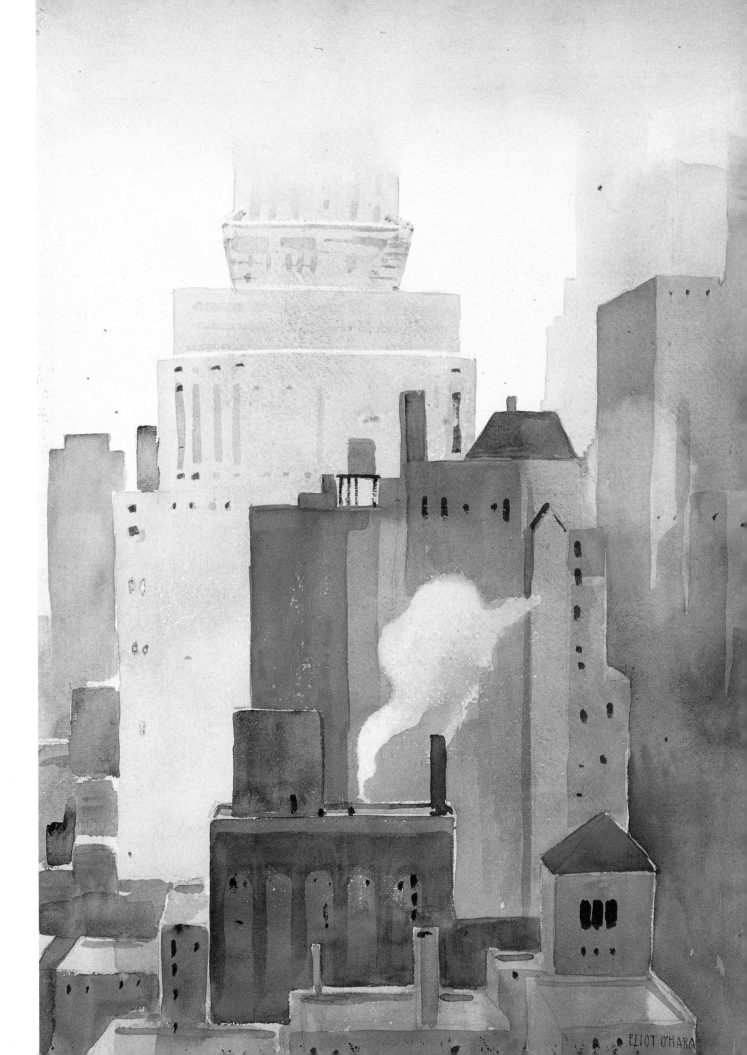

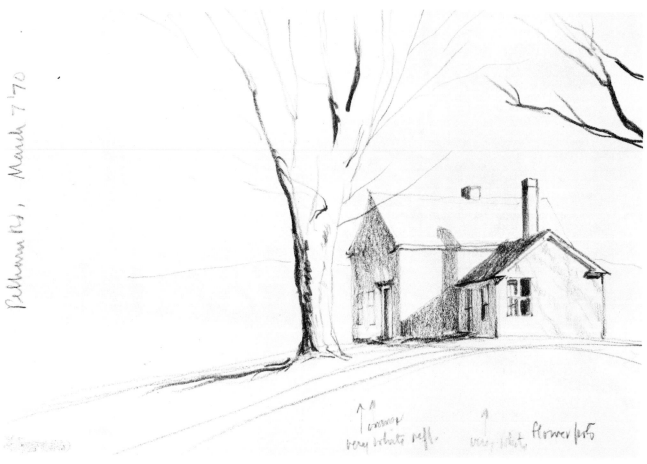

SKETCH FOR KITCHEN
ELL
by Carl Schmalz, 1970,
5" × 7" (13 × 18 cm),
collection of the author.

This simple notation,
from the sketch book I
always carry with me,
served as an initial
value plan for the paint-
ing reproduced here
and on page 32.

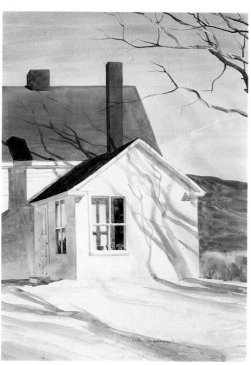

108

Ask Yourself . . .

Are any of my paintings built entirely from light to dark?

Compare your selected paintings and try to recall your exact painting procedures. If there are three or four light-to-dark pictures among the group, you are probably using transparent watercolor economically and effectively.

If none of them were painted entirely from light to dark, did you use this procedure in parts of them? If not, you may be making the technical part of painting more difficult for yourself than necessary. If confusion about values is the problem, plan them before you proceed.

There may be a host of good reasons why you have no "easy" paintings in your study collection. You may prefer to paint subjects, for example, that are not conducive to this type of handling. It is important to recognize your reasons so you can decide whether they really are valid, given your artistic aims. For instance, even if you work in a highly detailed fashion that you think makes the light-to-dark process impossible or undesirable, you can still use this method within each spatial plane if you plan your reserved light areas carefully.

What is a good way to try a light-to-dark painting?

You can do this by adapting one of your own pictures. Think through your painting sequence before you even set brush to paper, and keep the following aims in mind: (1) wherever possible, reduce the complexity of the painting procedure; (2) minimize the number of drying times; (3) avoid awkward edges, so far as you can, by eliminating the need to juxtapose lighter tones against darker ones already on the paper; (4) include reserved lights in your light-to-dark plan.

When you are ready to start, simply get out a fresh sheet of paper, draw in the main areas broadly, imagine that the entire scene is in thick fog, and then paint from light to dark, background to foreground. Increase intensities and value contrasts as you come forward. The resulting image may not look like your usual painting, but it will give you an eye–hand

understanding of the simplicity of this process, its usefulness, and the technical and pictorial unity it produces.

If, as you paint, the light-to-dark procedure *seems* to prevent establishing your overall value pattern early on, do not be discouraged. Your half-done picture may tend to look anemic, as though it could never come to a strong and healthy maturity. Have faith in the procedure—and in yourself—and remind yourself that you *will* introduce some stronger darks soon. Don't forget that you also can get around this problem by making preliminary value sketches, by introducing just a few darks deliberately out of sequence, and by numbering your values.

Do my paintings have a lot of overlapped or blurred edges?

A painting with many edges of this sort may appear awkward, and thus usually indicates insufficient attention to the light-to-dark procedure. A darker area can overlap a paler one with little sign of the double edge, but a light value set next to a medium or dark one will frequently show the "seam" or blur the edge by picking up some of the dark.

Do I often resort to sponging out, scraping, sanding, erasing, or other devices for lightening areas after a painting is "complete"?

Excessive use of these perfectly legitimate techniques is usually a sign of value problems. Once again, you may be failing to appreciate the effectiveness of the light-to-dark painting procedure, and you may need to plan your values more carefully.

Do I exploit the inherent correspondence between painting light to dark and the spatial planes in nature?

Do you use lighter tones in the distance, darker ones in the foreground? If so, in how many paintings do you do this, and which ones? You will probably find that you have organized at least some areas in your paintings according to the light-to-dark principle.

Strokes and Washes

STONEHENGE
*by Carl Schmalz, 1965,
10" × 22" (25 × 56 cm),
140 lb. hot-pressed paper,
collection of the author.*

The surface coherence here results from consistent use of visible brush strokes all over the paper.

DUSK, STONEHENGE
*by Eliot O'Hara, 1968,
22" × 30" (56 × 76 cm),
300 lb. rough paper,
courtesy of O'Hara Picture Trust.*

This painting's surface organization is based on washes—large ones in the sky and foreground, and smaller ones in the megaliths.

Paintings have always been built up through an accumulation of strokes; this is as true of watercolors as it is of fresco, tempera, and oil paintings. But transparent watercolor differs from other media in its capacity to flow over a surface, creating an effect called a wash. A *stroke* is the result of your control over the brush, whereas a *wash* is the result of your control over the medium.

Although the wash is one of the distinctive aspects of transparent watercolor, only a few major artists have used washes as their primary technique—probably because, except in the hands of master artist, a painting consisting exclusively of washes is apt to be rather bland. On the other hand, nearly all watercolorists incorporate washes somewhere in their paintings. Unless you are alert to possible inconsistencies when you combine strokes and washes, you may create a chaotic surface that could destroy the coherence of your painting.

The major cause of surface inconsistency in transparent watercolor arises out of the medium's versatility. You have not only washes and strokes but also wet blending and many other surface treatments ranging from scraping to spattering. This variety of choices can easily lead to too many techniques in a picture.

Because a painting is a created thing, it must exhibit not only the order imposed by the artist's perceptions, but also an order that results from the nature of the medium and the procedures it demands. Order also arises from the way the paint is applied, what we call the artist's "handwriting"—the very basis of a personal style. Indeed, it is through the basic ordering of materials that we recognize individual styles.

Methods of Organizing the Surface

In transparent watercolor there are four fundamental ways of applying paint:

1. Exclusively in washes

2. Exclusively in strokes

3. In an approximately equal and regular mixture of strokes and washes

4. In some orderly gradation or sequence of strokes and washes

The fourth method is the most common because it permits the greatest flexibility. But it also invites more surface inconsistencies, since it requires the most careful monitoring.

The four basic methods dealt with in this chapter do not exhaust all the possibilities. They are meant, rather, to give you a handle on the problem so that you know what surface organization with watercolor involves and how to identify it. You will probably find that, like most painters, you favor one fundamental method, varying it to suit your subject and your expressive needs in any given painting. Your study collection may even exhibit a *range* of *related* surface organization methods.

The Stroke Method

For my version of *Stonehenge* I selected a smooth, hard-surfaced paper that would retain the direction and movement of each individual brushstroke. Looking at the finished painting, you can see that the impression of brushstrokes is present even in the sky and grass, where the paint handling comes closest to a wash technique. The painting fully reveals the interlocking strokes that make up both the image and the paint surface. Through this consistent, easily perceived surface integrity and its unity with the image, you can grasp the wholeness of the world created by the artist.

The Wash Method

Eliot O'Hara's painting *Dusk, Stonehenge* was painted on rough paper. The paper's depressions retained water and allowed the pigments to flow into one another more freely during the extended drying time made possible by the extra water. O'Hara maintained a consistent surface by treating sky, ground, and monoliths as washes. In keeping with this broad wash treatment, rather than building the stones with individual brushstrokes as I did, O'Hara permitted most colors within the stones to merge into one another. He kept the dark strokes of the hedgerows in the background broad and undetailed so they would not interfere with the unified wash surface. Although the total statement is quite different from mine, O'Hara's world is just as whole and complete.

Other Wash and Stroke Treatments

Don't let the first two examples in this chapter mislead you into thinking that a stroke painting must be relatively tight and a wash painting relatively loose. *Up for Repairs* by Domenic DiStefano is a bold, splashy painting. Its breezy, open character gives an impression of generosity and vitality, yet there is scarcely a washed area on the paper. DiStefano achieves a unity of effect by keeping his strokes similar in size, shape, and direction. By contrast, DeWitt Hardy's *Woman Resting, Winter* is done entirely with washes and evokes a sense of serene precision. Hardy is more interested in creating a strong two-dimensional pattern than in describing three-dimensional form, and the consistent treatment of the washes helps emphasize this surface interest.

UP FOR REPAIRS
by Domenic DiStefano, c. 1974, 22" × 30" (56 × 76 cm), rough paper, collection of the Springfield Art Museum, Springfield, Missouri. Watercolor U.S.A. Purchase Award, 1974.

A stroke painting need not be tight and detailed.

WOMAN RESTING, WINTER
by DeWitt Hardy, 1984, 30" × 22" (76 × 56 cm), 140 lb. cold-pressed paper, collection of the artist.

This painting owes its strength both to linear precision and to the uniformly soft merging of color washes.

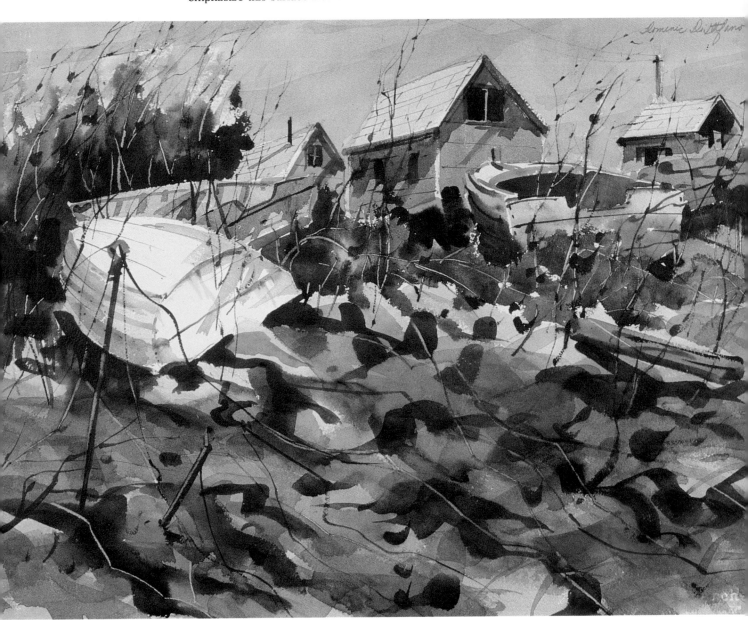

PAINTING TECHNIQUES

Integrating Both Techniques

One way to integrate stroke and wash techniques is by interspersing them more or less uniformly over the entire surface, as James A. Elliott did in *From Wood Island.* He managed it partly by using strokes where the contours are incidental instead of drawing descriptive shapes or lines. In the foreground, for instance, small, varied wet-wash areas suggest rocks and nearer plants. The more distant water and the background hillside are composed of relatively large washes that Elliott manipulated while they were wholly or partially wet. Modulations of color and value within these areas, especially the soft edges left by irregular drying, vary the washes enough to suggest foliage while preserving the appearance of a worked surface. The world Elliott creates is coherent and forceful.

Sequential Washes and Strokes

You can also achieve surface unity by following some logical sequence from wash to stroke. For example, you can treat all background areas with washes and gradually add more strokes as you work toward the foreground. This would establish a logic in which wash means "distant" and stroke means "near." Something similar to this can occur when you paint wet-in-wet. An example is A. di Carlo's *Snow/Crocus,* where wet blending gradually decreases from the picture's edges toward the central flowers. The melting spring snow and pine-needle cover are thus played down, emphasizing the bright yellow blossoms near the middle of the paper. Slow drying allowed the artist to focus our attention by means of increasingly clear descriptive strokes in the sharp leaves and stamens.

SNOW/CROCUS
by A. di Carlo, 1984,
20″ × 28″ (51 × 71 cm),
140 lb. rough paper,
collection of the author.

Di Carlo exploits the natural order of drying; softer, broader strokes at the periphery give way sequentially to sharper, smaller, more descriptive ones at the lower center.

PAINTING TECHNIQUES

FROM WOOD ISLAND
by James A. Elliot, c. 1960,
15" × 30" (38 × 76 cm),
140 lb. rough paper,
courtesy of the Amherst
College Collection.

A general shift from
background wash to
foreground stroke here
results in surface unity.

STROKES AND WASHES

GENTLE SURF
by Carl Schmalz, 1975,
15" × 22" (38 × 56 cm),
140 lb. hot-pressed paper,
collection of the author.

The focus of this pic-
ture is the cluster of
small strokes suggest-
ing surf and ripples, but
for surface consistency
I reserved similar
shapes in the sky.

Wet blending is not the only way to obtain a coherent surface. Look again at my painting *Stonehenge* on page 111. Although the sky was painted wet-in-wet, I made sure that the brush marks remained on the dried surface so it would be clear that the area was painted in strokes. But I kept these strokes (and those in the distant grass) broader and less defined than the strokes on the monoliths and the near foreground. Thus, the broader strokes corre-

spond to areas of lesser emphasis, and the more specialized and descriptive strokes correspond to areas of focus.

In *Gentle Surf,* all the basic tones went on in broad strokes, although I included considerable variation in the sky and rocks. I was careful to reserve some hard-edged lights in the sky that resemble the smaller, negative strokes of approximately the same shapes and sizes as those I used to define both rocks and water.

PAINTING TECHNIQUES

Ask Yourself . . .

Do my pictures demonstrate surface coherence, and which method for obtaining it do I tend to favor?

If you can't seem to identify a particular method, perhaps you are using one of the four methods described on page 110 but realizing it imperfectly. If you still have trouble, you can settle the matter by painting a small picture in each method. It will take a little time, but the results will be worth it.

Tear up some paper with one clean side into four quarters, each about 11″ × 15″ (28 × 38 cm). From your paintings or sketches, select a subject that is not too complex, something with mostly large areas. Using each of your four sheets in turn, make a painting entirely in washes; in separate, distinguishable brushstrokes; in washes and strokes combined; and in a gradation from wash to stroke as you work from background to foreground. You will probably feel more comfortable with at least one of these methods, and you'll be able to see—in your own "handwriting"—which painting most resembles the ones in your collection. Now you're ready to go on to the next questions.

Am I using wet-blended areas for only one part of the picture surface?

Since clouds, for example, are "soft," it is easy to assume that skies should be painted wet-in-wet. But unless other parts of the picture are also painted in this fashion, your sky may seem to belong to a different world from that of the rest of the painting. This can disrupt the painting's surface and reduce its unity.

Do I habitually rely on linear strokes for clarification or to enliven my washes?

Disruption of the surface can arise from ill-digested linear accents in trees, rocks, and bushes. In a basically wash-organized picture, lines (and sharp edges) must either be scattered all over the surface or organized so that they build gradually from related parts of the painting to your center of interest. Because of this, many painters using the wash method avoid using too many lines.

Do I vary my brushstrokes?

Are you using broader strokes for more general areas and reserving smaller strokes for areas you intend to emphasize? Another way of organizing the surface, of course, is to keep all your strokes the same size. The point here is not that you must handle your brushstrokes according to either method, but that you should work out some system for variations you adopt.

Do I overlay too many strokes, creating dead spots that break the consistency of my surface?

Overpainting is another hazard for the stroke painter, particularly in the darker sections of paintings. Muddy tones kill any part of the painting where they occur. They reveal that the artist has a poor understanding of how to use the medium, since muddy color is simply a result of using transparent watercolor inappropriately.

Do I achieve a fairly even distribution of washes and strokes over the surface of my paintings?

If not, you may be using—or slipping into—one of the other methods of achieving surface coherence. But if you intermix washes and strokes, make sure they are not distributed haphazardly across the painting's surface.

Do your washes and strokes vary a great deal in size? Harmony of size, within a reasonable range, is usually necessary when you intermix washes and strokes. A large, flat wash, for example, will look unrelated to areas treated by combining washes and strokes. But when that same large area is modified by some wet-blended variations or defining strokes, it will match the rest of the surface.

Do I unify my picture surface with gradations from wash to stroke?

You may belong to one of the other categories of painters. But if you do use gradations, do you stick to a particular system? If your answer is no, maybe your system is not fully developed. Look at your paintings again. Are you leaning toward a background-to-foreground organization or a periphery-to-center system? Do you want to express distance and atmosphere? If not, maybe you'll want to adopt the edges-to-center organization. Decide which pattern fits you best, and then analyze where you're weak in executing it. Perhaps your transition from background wash to middleground or foreground strokes is too abrupt. Or the lack of a good transition from washed periphery to stroked central focus could be isolating the rest of your painting from the center.

Edges and Reserved Lights

Are razor-sharp, unexpected, or messy edges reducing the surface coherence of your paintings?

Edges present problems to painters chiefly because, although we recognize the contours of different objects, there are no lines in nature. What we perceive as lines are actually juxtapositions of color and value, which range from sharp contrasts to scarcely visible gradations. Drawing conventions that render these distinctions as lines also carry over to painting, since brush marks have distinct edges unless they are deliberately modified.

Edges can be especially troublesome in transparent watercolor because of the potential inconsistency between the sharp, dry edges of strokes and washes and the contrasting edges that wet blending produces. Also, if you're not careful, the edges of your washes or group of brush marks can inadvertently create lines that can be hard to disguise or remove. Overlapped or blurred edges look messy and incompetent. These unintentional lines can alter your composition and interfere with both illusion and the picture's surface integrity.

Sharp Edges

When edges are said to be too *sharp,* the term is relative. It all depends on how and where the edges are used. For example, there are many sharp edges in *The Ell* (page 51) by Loring W. Coleman, but the architectural detail of his subject lends itself to a wealth of edges that are consistent with his central concern: descriptive texture. On the other hand, if your real interest in the subject is not the architecture but some other aspect, too many hard edges can be distracting.

When I painted the cottages in *Flop No. 2,* I was initially interested in the effect of the reflected light on adjacent cottages. But because I overemphasized the architectural shapes of the buildings and their shadows, I reduced the effect of the reflected light, and my picture had a split personality that diminished the power of both effects—the patterns of shapes and the reflected light.

The problem of overemphasizing sharp edges is not limited to architecture. My paint-

ing of rocks (below) failed because I made the central crack so dark and detailed that it lies on the *paper* surface instead of retreating into the rock surface. In both attempts the paintings fail because a basically technical error interferes with our perception of the picture as a whole.

Accidental Lines of Darks

Unexpected edges or linear elements often slip into your work unnoticed when you're adding details or darks such as shadow accents. Used with restraint, these dark touches can enliven a potentially dead area. But dark strokes can add unwanted lines if you're not careful. When painting seaweed on a beach, for example, I have had to refrain quite consciously from overaccenting a sandy slope with these "helpful" darks. I ruined the painting shown in *Flop No. 3* by thoughtlessly outlining the top of an exposed ledge with shadows from the foliage above it. This caused the formation of a "line" that seems to exist on the surface of the painting independent of light effect and illusion. The shadow darks on the lower rocks were also placed insensitively.

FLOP NO. 1 (DETAIL)
*by Carl Schmalz, 1976,
11" × 8½" (28 × 22 cm),
140 lb. hot-pressed paper.*

I ruined an interesting painting by making the central crack in this detail too powerful.

FLOP NO. 2 (DETAIL)
by Carl Schmalz, 1975,
12" × 19½" (30 × 50 cm),
140 lb. hot-pressed paper.

My preoccupation with sharp edges created an overemphasis on shapes in this failed picture.

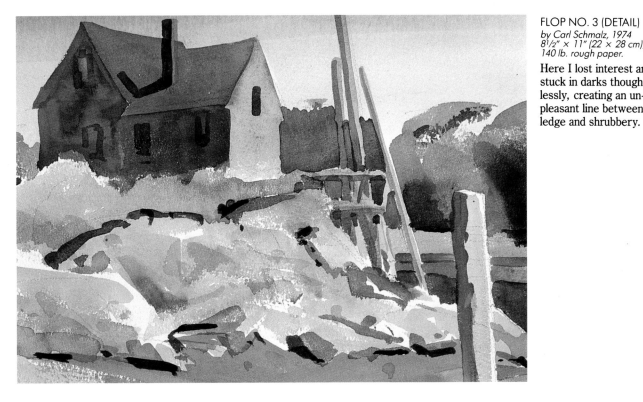

FLOP NO. 3 (DETAIL)
by Carl Schmalz, 1974
8½" × 11" (22 × 28 cm),
140 lb. rough paper.

Here I lost interest and stuck in darks thoughtlessly, creating an unpleasant line between ledge and shrubbery.

Reserving Lights

The easiest way to work in transparent watercolor, of course, is from light to dark. But in order to do this, you must plan the location and value of your lights in advance. This planning allows a surprisingly large number of lights to do double duty and also lets you control edges.

The obvious question that follows is "Why is it necessary to reserve lights? Why not use commercially available masking fluid and save myself the time and energy of planning?" The answer is that sometimes you can do this very successfully, but this is the exception rather than the rule. You'll be using reserved lights, at least in modified form, for the major portion of most of your paintings. When you mix reserved lights with masked areas, you break up the consistent, unified look of the picture surface with two different types of edges. Unless you modify the edges considerably after removing the masking fluid—and you'll probably spend as much time "fudging" them as you would have spent working around them in the first place—you'll have incongruous positive shapes among your reserved lights. The same problem also exists when you use opaque white, which is why you should use it sparingly. Of course, there are times when it is easier to use masking fluid or an opaque white—for very small lights such as tiny flowers in a field, or for a glint of light along a wire or on an icicle, for example. For the most part, however, it is almost always easier to reserve lights by working around them.

In *Maine Still Life* I had many lights to reserve. In fact, the entire picture was virtually painted "backward" compared to the typical light-to-dark procedure. After a quick pencil drawing, I painted the palest tones of the lilies, stems, and weeds. The light-middle value of the lobster pots went on next, and I reserved the previously painted vegetation. This tone, which I deliberately varied to give a sense of texture to the oak slats, covered the entire group of pots, the shaded areas as well as the sunlit ones. I then turned to the modeling and detail of the lilies, finally setting in the deeper darks on the leaves and stems, which I also used to define details on the lobster pots. Wherever possible, I let a lighter tone run under the edge that the darker surrounding colors would overlap. This "reverse" procedure gave me almost complete control over the edge I wanted.

Planning Ahead for Reserved Lights

Andrew Wyeth's painting *Bermuda* makes a good starting point for further discussion of reserved lights. For the most part it is a straightforward light-to-dark picture, but the houses, their roofs, and the glint of light on the man's hat had to be reserved. The trick in making this process easy is to plan ahead and especially to consider ways in which lights can be used doubly. Wyeth allowed some sky tones to slip down into the roof at left, where they become variations within the roof area.

MAINE STILL LIFE
by Carl Schmalz, 1974,
15" × 22" (38 × 56 cm),
140 lb. hot-pressed paper,
collection of the author.

Major portions of this picture were done almost entirely by reserving lights, which allowed me to paint economically and relatively quickly.

PAINTING TECHNIQUES

BERMUDA
by Andrew Wyeth, c. 1950,
21" × 29" (53 × 74 cm),
courtesy of Bowdoin
College Museum of Art. Gift
of Mr. and Mrs. Stephen
Etnier, in Memory of S.
Foster Yancy, 1961.

Wyeth mixes blended
edges, crisp ones, and
rough ones almost
equally in each section
of the painting. The few
reserved lights are
skillfully integrated.

SMALL POINT, MAINE
(DETAIL)
by Carl Schmalz, 1965,
8½" × 11" (22 × 28 cm).
Finished painting 13" × 31"
(33 × 79 cm), 140 lb.
hot-pressed paper, courtesy
of Julia I. Schmalz.

The lights of the dead
spruce trunks and bran-
ches went on with the
lights in the sky, the
distance, and the grass.
I reserved them when
painting the darker foli-
age and later modified
their color where ap-
propriate.

A detail from *Small Point, Maine* shows
how undertones in the trees function as fine
branches above, while the reserved lights
have become trunks and larger branches be-
low. This kind of economy is often apparent in
Winslow Homer's paintings.

Using Edges to Achieve Surface Unity

In *Maine Still Life* I used sharp edges almost
exclusively, letting the character of the smooth
paper add to the visual crispness that unifies
the surface.

On the other hand, Andrew Wyeth's *Ber-*
muda contains all types of edges without re-
gard for distance. Instead, surface coherence
is maintained by distributing edges over the
entire painting. Thus, some clouds have hard
or ragged edges, some rocks have soft ones,
and the figure and the boat (the focal center)
share the same general spectrum of edges as
the less important areas. The artist has con-
structed a compellingly unified picture world in
which the viewer perceives a connection be-
tween Wyeth's personal vision and the materi-
als he's used. This gives the picture vitality
and force.

Do my edges work for or against my pictorial interests?

Set up your pictures and look at the way you treat edges.

If you are a wet-in-wet painter, you will have relatively few edges to check, since most will be softly blended. Nevertheless, a study of your use of edges, especially the relatively firm ones, will help you determine whether you are:

1. Relating edges well to your main pictorial interest.

2. Using edges effectively for representational focus and compositional emphasis.

3. Using edges to help unify your paintings overall.

Concerning the first point, a little thought tells you that the stronger the value contrast, the sharper the edges appear. For example, the bare branches of leafless trees make striking patterns against a light sky, but when grouped together, as at the border of a meadow, separate branches are scarcely distinguishable. So one of the first places to look for overstated edges is where tones that are close in value meet. Softening these will tend to emphasize broad areas of value and, hence, stress the value pattern of your painting. On the other hand, you may deliberately want to keep these edges hard so that individual objects can be seen more readily. In this case, you may want to soften other, more contrasting edges arbitrarily for balance. This will increase the visibility of objects close in value while maintaining broad value patterns.

Am I using edges to help define space and focus the composition in my paintings?

Edges can help create visual emphasis or focus, both representationally and compositionally. As we have seen, a gradation from wash to stroke—which can also be seen as a gradation from softer to firmer edges—is commonly used to indicate a movement from far to near in the illusory space of a picture.

Am I using edges to unify my paintings?

You can unify the surface by using the same type of edge throughout or by varying the hard and soft edges fairly evenly throughout the painting. Whichever method you choose, the important thing is consistent treatment of edges.

Am I reserving my lights economically by planning ahead?

If you *are* reserving lights, you know that placing a deep dark against a very pale tone poses few difficulties because the coverage normally will be complete, but with middle tones you must *plan* in order to avoid overlaps, because the darker of the two tones is likely to be quite transparent and result in an unwanted seam or blur.

If you are not painting light to dark and reserving lights, you are asking for blurred edges. Try a technical exercise to gain facility in planning for reserved lights. Select a subject (perhaps something you shy away from) with plenty of light-against-dark elements. This might be some birches or other light-trunked trees against evergreens; an architectural subject, possibly including a picket fence; or dry, sunlit weeds in front of a shaded building. Remember that this is not an attempt to make a painting, so don't undertake anything too complex. Get out your paints and a half-sheet of your usual paper, and make a quick pencil sketch of your subject.

Now sit a few minutes to plan your attack; this is the most important part of the process. Your aim is to achieve your desired effect using the simplest possible procedure. Check your birch trees, for example. They may be white against a hillside, but are they white against the sky? Can you run some sky tone into them, reserving only a few scraps of white paper, thus making painting the sky easier for yourself? You might accent the branches against the sky with a few dark tones to get the effect of branches with minimal effort. Or, where your fence is in shadow, maybe you could let that shadow tone run under the building behind it to avoid having to paint the pickets twice—once to put on the shadow and once to paint the fence in relief against a darker background.

Look for every possible opportunity to economize your procedure. For example, the shadow on your picket fence may really be a neutral blue, but it will work just as well if you paint it the same warm gray as the trim on the building behind it. Try to complete your picture in as few steps as possible.

Paint Texture

Are you using paint textures imaginatively for visual interest?

When we speak of paintings, the word *texture* may be confusing because it can mean different things. Sometimes it signifies *descriptive* texture, which represents the surface appearance of objects such as rough stone or slick glass. But *texture* also refers to the look of the paint itself, which may be dry or wet and flowing, as well as to the look of the painted surface as created by strokes or washes.

This chapter is primarily about the use (and possible misuse) of paint textures, which can either enhance or diminish surface coherence. The "natural" texture of transparent watercolor ranges from the flow of very wet paint to the bristly character of paint applied to rough paper with virtually no water. Your paper surface also affects your final painted texture, as do the brush, the relative coarseness of the different pigments you use, and the mixtures you select. Many special textures are possible when you use tools and materials other than brush and paint and when you give special treatment to the paper before, during, or after the painting process.

The availability of so many diverse surface textures offers the watercolorist a broad range of opportunities for expression. The difficulty is in controlling these textures effectively.

Paint Textures That Are Also Descriptive

Sometimes the primary meanings of *texture* can overlap. In Andrew Wyeth's *Lawn Chair,* for example, a generally fine-grained paint texture characterizes the whole surface, including the grass, foliage, building, bucket, and chair—though this unifying paint texture becomes descriptive as well.

In my painting *Transparencies,* I flooded the entire shadow area onto the paper while courting deliberate variations of hue and value within it. This produced visual interest in the paint itself that is equal to, but different from, the more descriptive clapboard shadows on the illuminated surface of the building. Similar treatment of the steps, grass, and foliage unifies the surface.

Steven Masters, in *Out Back,* has joined and overlapped both paint and descriptive textures at many points. Notice especially the base of the wall at the left and the green door at the right.

TRANSPARENCIES
by Carl Schmalz, 1983, 14½" × 21½" (37 × 55 cm) 140 lb. hot-pressed paper, collection of the author.

This picture illustrates a very obvious way of using paint texture as a *substitute* for descriptive texture.

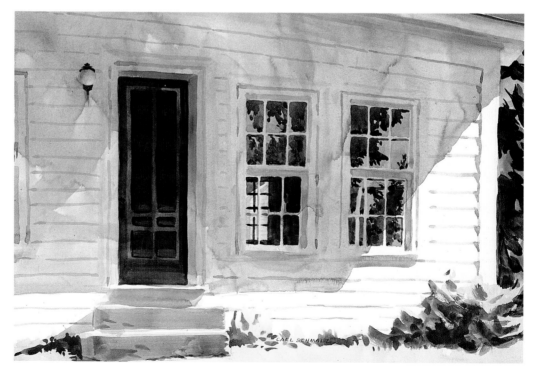

PAINTING TECHNIQUES

LAWN CHAIR
by Andrew Wyeth, c. 1962,
22" × 15" (56 × 38 cm),
smooth paper, courtesy of
the Joan Whitney Payson
Gallery of Art, Westbrook
College.

Here the artist builds
sequentially from less
detailed areas of paint
texture to more de-
tailed areas of descrip-
tive textures.

OUT BACK
by Steven Masters, 1979,
14" × 21" (36 × 53 cm).
140 lb. hot-pressed paper,
collection of Mrs. Richard H.
Masters. Photo by John
Bechtold Studios.

Using smooth paper,
Masters creates a sur-
face medley rather
evenly divided between
textures that are purely
paint and those that are
descriptive.

Allover Paint Texture

The simplest way to unify a painting's surface is by using pretty much the same texture all over the paper. Susan Heideman's *Nursery* is a good example of this method. Working on a fairly smooth, hard surface, she employed a moderately wet brush so that the paint would dry with small "oozles" within most strokes. The strokes themselves are organized by sequential changes in size—but, whether they are large or small, they all have a textural resemblance.

Charles Culver's *Cattle* appears very different to the eye, but it is organized according to the same principle of overall textural similarity. Here, however, a harsh, dry texture unifies the surface.

Contrasting Paint Textures

Many watercolorists—perhaps most—like to contrast paint textures. Such contrasts add visual excitement and drama, but they also endanger a painting's coherence. The sample paint textures on this page illustrate what I mean. I've placed very rough drybrushing and spattering on top of a wash applied very wetly. The great difference between the two is clear, and even though the effect is visually arresting, you can see that it must be controlled or the *surface* may become more interesting than the painting.

Textural Gradations

One means of controlling textural contrasts is by using gradations or sequences. This is a variant on the wash-to-stroke sequence, in which other textures may play a part. Like wash-to-stroke, it is most often organized in periphery-to-center or distance-to-foreground fashion. For instance, in *Lavender Blue,* Mary Kay D'Isa capitalizes on a variety of textures created by the gessoed paper surface, scraping, spatter, salt, and so forth, to provide nonrepresentational visual interest around the edges of her picture. These build gradually toward more descriptive shapes and textures in the tiny flowers and the iris petals at center and upper left. This textural excitement is controlled, contained, and assimilated into the vitality of the flowers themselves.

Integrating a large number of textures produced by other than "normal" means poses one of the trickiest problems faced by the watercolor artist. But applying the organizing principle of sequence will often help to solve it.

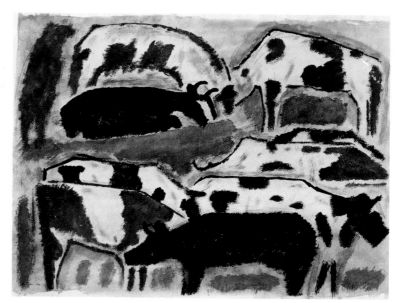

NURSERY (TOP LEFT)
by Susan Heideman, 1976
22" × 30" (56 × 76 cm),
140 lb. rough paper,
collection of the artist.

In this painting, the strokes share a similar fluid texture but vary in size within a controlled range.

CATTLE (MIDDLE LEFT)
by Charles Culver, 1947,
19" × 24" (48 × 61 cm),
90 lb. rough paper. Photo
by Sylvester Lucas.

The use of a very dry brush on rough paper gives a bristly look to the overall picture surface, unifying it and enhancing expression.

TEXTURE SAMPLE (BOTTOM LEFT)
by Carl Schmalz, 140 lb.
rough paper. Photo by
David Stansbury.

These utterly different textures contrast so greatly that it is virtually impossible to "read" the spatters and rough brushing as being *behind* the wet-blended strokes.

LAVENDER BLUE (RIGHT)
by Mary Kay D'Isa, 1981,
20" × 14½" (51 × 37 cm),
gessoed paper, collection of the artist.

Here texture shifts from nonrepresentational to descriptive as it moves from periphery to center.

PAINT TEXTURE

Unusual Textures

Adding textures not normally obtained with the usual materials and tools of transparent watercolor can be particularly risky to pictorial unity. I am not suggesting that such textures are taboo. On the contrary, as *Lavender Blue* shows, they can be very effective when carefully controlled and used to serve an expressive purpose.

The surface of John H. Murray's *Cranberry Island, Maine* is unified by knifed textures.

Linear scratches and gouges animate the rocks, beach, and water, but they are visually linked with the rough brushing in the sky and background to produce overall textural similarity. The rough striations of knifework in the rocks, shown in the detail, correspond not so much to the descriptive look of such ledges as to the glacial grinding that formed them; that is, the scratches profoundly *express* rather than merely *record* the geological formation of the rocks.

CRANBERRY ISLAND, MAINE
by John H. Murray, 1962, 15" × 23" (38 × 58 cm), rough paper, courtesy of Mrs. Virginia Murray.

The roughness of the paper, brushing, and knifing forms a coherent surface in Murray's picture. In the detail below, you can see clearly how paper, brush, and knife work together.

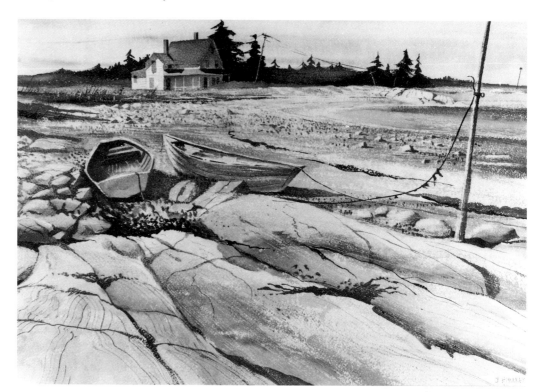

PAINTING TECHNIQUES

Ask Yourself . . .

Do my paint textures tend to be bland?

Your textures may be similar, helping to create surface coherence, but they may lack variety and visual interest. You should not rush headlong into using paint textures without thinking, but perhaps you can introduce some more contrasts. You can integrate these paint textures into your surface by using balanced mixtures of textures and gradual sequences from one texture to another.

Is there too much textural contrast in my pictures?

This may be the case if there appears to be a kind of purposeless activity in them, a degree of visual excitement not justified by the subjects. To overcome excessive contrasts, work for similarity of textures, a balanced mixture of textures, or sequences of textural change.

If you are especially prone to overstate texture, try to become more aware of this when you paint. It is good to ask yourself *why* you are about to introduce a new visual accent. Is it necessary? Can you integrate it with the surface of your painting? Will it enhance meaning, or is it merely decorative?

When I use extraordinary textures, are they well integrated into the painted surface?

To work really well, knifing and scraping must be done with the authority of brushstrokes. Usually the natural movement of your hand makes your strokes with a knife sufficiently similar to your brush marks. But it is also useful to remember that modifying such strokes with brushed-on tones will very often rectify an outrageously visible knifed or scraped area. An example might be fence pickets, knifed out and then modified with brushed-on shadow tones.

A good question to ask yourself is: what reason did I have for using that unusual texture there? If you didn't have a reason, or can't recall it, you may be using these powerful techniques arbitrarily. It may be helpful to look at these areas carefully and consider whether and how the effect you wanted could have been achieved using paint textures of the more "normal" sort.

What textures can I create with materials other than brushes?

There are a few possibilities worth exploring.

Get out some discarded paintings with clean backs, or use fresh paper. Select several different surfaces and weights if you have them. Squeeze out some black or dark paint and assemble as many of the following materials as possible:

Sponges

Salt

Sand

Knife

Single-edge razor blade

Plastic scraper

Blotters (facial tissues)

Cheesecloth

Plastic wrap

Erasers (different kinds)

Old toothbrush

Bristle brushes

Wooden sticks (match, orangewood, twigs)

Leaves (fresh or dry)

Cardboard scraps

Volatile fluids

Inks (including India)

Instead of outlining all the possible textures and combinations you can make with these materials, I'll suggest a general procedure you can follow as you experiment.

Line up your different papers, your regular materials, and your unusual tools in a convenient way. Working as quickly as possible, place two or three wet patches of middle-value color, about 3″ × 3″ (8 × 8 cm), on several papers. Then methodically use each of the unusual tools or materials on one or more of the patches. Repeat the process until you have tried all the possibilities.

Now paint new patches, allowing them to dry to the semigloss stage before manipulating them. Some of the tools and materials must be used on dry paint, so prepare a group of patches to dry. On these you can experiment with erasers, sandpaper, scratching with single-edge razor blades, and spattering. By pressing something into wet paint and then onto the dry patch, you can explore various printing or stamping techniques with the veined backs of fresh leaves; corrugated board; pieces of rubber flooring, door mats, or stair treads; crumpled plastic wrap or paper; sponges; and other materials. Remember also that you can use your hands and fingers to modify wet or dry areas by painting.

As you produce varied surfaces, think about how you might be able to exploit them in paintings. But you must also consider how you will integrate them into your picture surface.

Putting It All Together

Coherence and Viewing Distance

A good painting works well from any viewing distance. When you enter a gallery and glance around at the pictures on the walls, some usually stand out more than others—perhaps because they have especially strong overall patterns or value contrasts. A painting that attracts you in this way invites closer inspection, and so you want to move up to a more comfortable distance—usually from four to eight feet away, although distance varies for extremely large or small paintings.

At this "normal" viewing distance, your attention is most likely to focus on the subject and narrative content of the painting. Then, if you are like most lovers of good painting, you'll be irresistibly drawn farther forward, perhaps to within inches of the surface. At this more intimate viewing distance, you admire the artist's technique—the brushwork, the flow of colors, and the deftness of characterization.

As you move back for another overall look, you know you have had a thoroughly satisfying experience. This is what all good paintings provide, and it is what you want yours to give. You want to produce paintings that attract attention from afar, sustain it at a normal distance, and reward the close inspection.

The three viewing distances are a reality, of course, but delineating them in this way can be helpful in analyzing your pictorial problems, and that is the purpose of this chapter. You will find it useful to scrutinize your own work in this way periodically—perhaps twice a year. And you also will learn a lot by looking carefully at any pictures available to you. Go to museums, traveling exhibitions, your library, friends' homes. Try to analyze pictures whenever you can. You will learn a lot about what works and what doesn't—and why. You will also learn to identify ways of improving your own work—what to try, what to avoid.

Distant Viewing

Imagine yourself fifteen to twenty feet away from Loring W. Coleman's *Among Bare Maple Boughs* (pages 132-133). As it catches your eye, you cannot help but be gripped by the thrusting central darks against light and the massive light against dark below. At the same time, you recognize a huge, bare-limbed tree. When you draw closer, you realize that Coleman has achieved his first aim: he has intrigued you.

Whether you choose to look at a painting or pass it by is determined by its composition. From the distant viewing position, the most important aspect of a painting is the force of its major design components, which include value contrast, linear structure, the patterns of primary shapes, often size and interval relationships, and sometimes color. In a representational painting, the design elements are so closely allied with the subject that they also announce the dominant expressive theme of the painting.

Composition, then, is not simply a matter of creating a pleasant, balanced design; it is your means of stating simultaneously both the visual and expressive themes of your painting.

Normal Viewing

As you draw nearer to Coleman's painting, you increasingly sense its complexity—not just the descriptive detail, but its design. Whether you initially read the design motif of the tree as a strong vertical axis, as modulated S-curves, or as a basic X (all, and others, are possible), you find that these readings can alternate with each other. You find, too, that each reading becomes richer and is supported by more and more echoes as you get close enough to see more layers of meaning.

You are now at a normal viewing distance, about four to five feet, from this painting. Perhaps you become newly aware of the focal role of the big limb scar in the middle of the tree (and nearly the middle of the paper). You can almost read it as the intersection of the X. You notice how many times and with what subtle variations the slight curves of the limbs are repeated, and you observe the way the white birch at left and the larger trunk to the right echo each other while picking up the branch shapes. Perhaps you also enjoy the

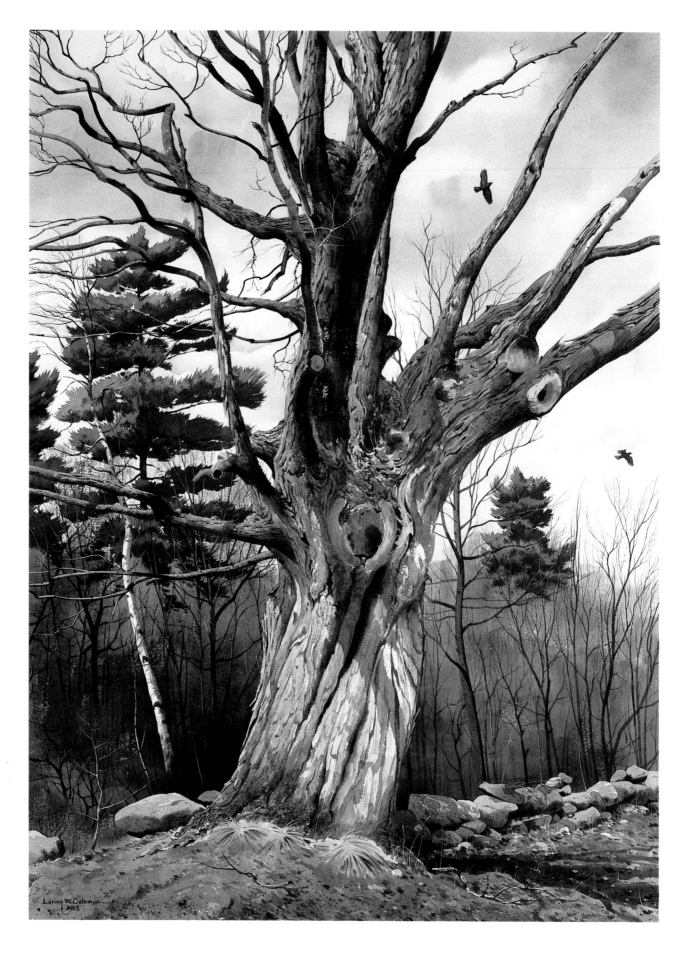

PUTTING IT ALL TOGETHER

interplay of wedge shapes of similar size in the sky, background, trunk, and foreground.

Above all, however, you are now in a position to appreciate the artist's interpretation of his subject. The huge-crowned maple spreads its limbs all about it, but those to the right, away from the sun, seem to be dead or dying; are these the "bare boughs" of the title, so stark in contrast to the lively, interlaced small

branches at left? You see that someone has cared about this tree; some dead limbs have been cut off fairly recently. The birds, the wall, and the shadows point you to the right, however, to the dead side of the tree. So you may sense that although the imposing old maple has little time left, it stands as a monument to itself, a record of its own complex life. And with this awareness, you recognize that the complex twists and alternations of our perception of the design parallel the artist's expression of it.

Intimate Viewing

Having been intrigued and then held by the complexities of Coleman's *Among Bare Maple Boughs,* you may be eager to see how the magic was done. You draw in close to admire the paint handling, noticing how nicely the background wash is varied (and linked to parts of the coarse bark) by patches of rough brushing. You look, too, at the many examples of crisp, deft drawing in details, the economy of effect in some of the stones, the freshness despite precision.

Perhaps you value overall results and are not much interested in facility of technique. You will be intrigued, then, by Edward Hopper's *Interior, New Mexico,* which, at close range, provokes wonderment of a different sort. How can such seeming clumsiness resolve into so solid and unassailable a statement? At the intimate viewing distance, Hopper's painting is fascinating.

AMONG BARE MAPLE BOUGHS
by Loring W. Coleman, c. 1975, 28" × 20" (71 × 51 cm), private collection.

Coleman's painting carries well at normal viewing (opposite), captures attention at distant viewing (left), and invites enjoyment of descriptive textures at close range (below).

INTERIOR, NEW MEXICO
by Edward Hopper, 1925, 13⁹/₁₆″ × 19⁹/₁₆″ (34 × 50 cm), courtesy of the Art Institute of Chicago.

Hopper's almost deliberately awkward technique ensures clarity at a distance but also shows that he wanted the viewer to sense, close at hand, how the paper surface had been worked and changed. This painting is reproduced in full color on page 6.

WESTERLY
by Carl Schmalz, 1965, 10¹/₄″ × 23″ (26 × 58 cm), 140 lb. hot-pressed paper, collection of the author.

The visually exciting pattern of this painting tells the viewer about the subject even from a distance.

PUTTING IT ALL TOGETHER

Ask Yourself . . .

Do my paintings have visual impact from a distance?

Pick four or five paintings that you consider your best and set them up together in a way that allows you to get at least eighteen or twenty feet away from them (outdoors, if the weather is good, but place them in the shade). If possible, try looking at them from even farther away. Do you see clear patterns or compositional structures in your pictures? If not, your paintings do not "carry" well. Not all of them should carry from so far away. The farthest viewing distance possible will depend on your expressive aim and the final purpose of the picture.

If you are inadvertently making namby-pamby pictures, resolve to make much more forceful value studies before you begin to paint. Also get well away from your work at least three or four times during painting to check on the development of your composition. Remember that with the light-to-dark painting procedure, your value pattern is slow to emerge, and so you have to see your picture as leading toward your initial value sketch.

Do all my paintings tend to have the same basic composition?

As you look at your paintings, observe what "sticks out" in each. Look from one to the next. Are there similarities among the major patterns? If so, ask yourself whether they are justified. For instance, are the similarly patterned paintings all pictures of similar subjects? If the subjects are different, it is possible that you are relying on the same composition through habit. This generally means that you are not thinking enough about the expressive quality of art. Variety for variety's sake is a step in the right direction, but it is better when it springs naturally from your expressive purpose in each picture.

How well do I integrate detail into my overall compositional design?

Ideally, from a distance your pictures reveal strong, varied compositions. Wonderful! But do the compositions provide clues to the design details, subject, and meaning of each work? Again—ideally, they do, but you can still profit from working at making this integration more effective. Trial sketches can help you think through your particular interest in a subject. Painting a subject over and over will work, too. The main idea is to give yourself an opportunity to explore variations of design, point of view, color, and so forth that invite the viewer to take a closer look.

At a normal viewing distance, how well do my paintings deliver what they promise from a distance?

At a distance of four or five feet, does your design follow through with elaborations on its initial theme? Does the first impression tell you what the subject theme is and make you curious to see it more closely? Are you, in fact, rewarded by finding out more about it? Finally, does the composition support and qualify the subject?

The answers to these questions should give you a good idea about whether you are using your artistic knowledge to best advantage. If any of them is negative, tackle the problem a bit at a time by working on whatever flaws seem most apparent in your work. Don't worry about any other problems until you have that one under control.

How do my paintings hold up at close range?

From a distance of a foot or so, you can examine your paintings for technical finesse. Apart from good, workmanlike watercolor, are there some nice felicitous passages? Are there surprises? These may be "happy accidents," or they may be places where something worked even better than you thought it would. Look especially carefully at those areas where you were most sure of yourself. There you may find the best indication of your own stylistic bent.

Discovering Your Style

Are you developing what is "right" in your work, or are you bogging down in what seems "wrong"?

By this time you may have decided that your paintings are pretty good, or you may never want to look at them again! Nevertheless, as you've examined them from one point of view after another, you have doubtless been identifying and thinking over your preferences in subject, design, color, and technique, as well as in many other aspects of painting. You have also begun to differentiate these *preferences* from practices that are merely *habits*. The distinction is a significant one, for preferences are the foundation of your style, while unexamined habits are its enemy. Skilled habits may help you achieve a picture that is mechanically coherent but does not have much content or expressive purpose.

Your preferences reveal the deeper elements of your personality, the essential "you" who paints and leaves an imprint—for better or for worse—in the visible structure of your painting. This is why self-criticism is so difficult; you are having a discussion with yourself. This book has attempted to insert itself into the middle of that conversation as a third voice, to provide some necessary objectivity and detachment so you can see yourself as clearly as possible in your work.

Building on Your Strengths

You may have said to yourself or a friend, "Gee, if only I could paint like so-and-so!" It isn't all bad to study what fails in your work and get ideas from the styles of other artists, but why not build from strength? Identify the best aspects of your painting and improve them.

This may mean looking carefully at the ways you've handled "insignificant" parts of your work—distances, corners, perhaps foregrounds—those parts of paintings where you were most confident. Here you may unexpectedly find fluid brushwork, economy of representation, delicacy of color, or similar evidence of your talents and preferences. These can give you an index of capacities—and your painting personality—that you may not have even considered.

Facing the Facts

Identifying the best in your work may also involve accepting the "worst." To the degree that you honestly put yourself on paper, you expose your weaknesses—*all* of them—from shaky drawing and clumsy execution to a host of insensibilities and biases. Okay. We can't all be Michelangelo or Rembrandt, but the Jan Steens and Alfred Sisleys of this world have their place, too. In any case, the one thing that you can count on is the impossibility of seriously altering yourself. This is a fundamental reason for building on the things you do best, and trusting that they will eclipse your weaknesses.

You may say to yourself something like, "If my color is weak, I'll use a controlled palette and work on strengthening values," or, "Since perspective is my *bête noire,* I'll stop worrying about spatial effects and concentrate on color and pattern."

Actually, no artist fully exploits all of the options discussed in this book. Each of us must select the elements that most suit our own temperament, preferences, and expressive aim. This kind of ultimate congruity between artist and painting produces the visual wholeness called *style.*

Style and Originality

Style is frequently equated with "originality" (although they aren't necessarily either identical or inseparable), which sometimes appears to be prized above all else in painting. The result is that artists can be made to feel they are nothing until they have achieved *their* style.

Style is really only the evidence of visual thinking, and so if you pursue style merely for its own sake, you risk shallowness and imitation. The only style that counts is the one that develops out of your own painting personality. But although having a style permits you to create your own coherent picture world, it is also limiting, for it can be responsive only to a particular set of possibilities. The world of dynamic natural forces created by Susie in *Haunted Island* is not accessible through my style, any more than the world of form and light in my *Granite Coast* is accessible through hers. And neither of our styles permits the sheer dash and flamboyance of O'Hara's *Morning Surf.*

GRANITE COAST
*by Carl Schmalz, 1975,
15¹/₂" × 22" (39 × 56 cm),
140 lb. hot-pressed paper,
collection of the author.*

My way of working emphasizes light, volume, and permanence rather than energy, movement, and change.

MORNING SURF
*by Eliot O'Hara, 1936,
15" × 22¹/₂" (38 × 57 cm),
140 lb. rough paper,
courtesy of O'Hara Picture
Trust.*

The dashing bravura of this painting is based on the artist's intimate knowledge of his tools—brushes, paints, paper—and a delicate sense of timing.

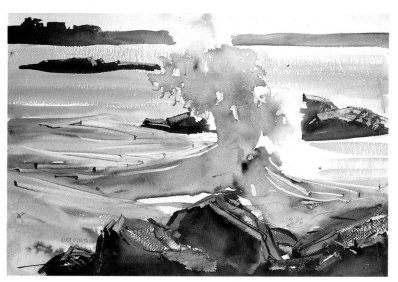

HAUNTED ISLAND
*by Susie (Wass Thompson),
c. 1957, 22" × 30" (56 × 76
cm), 90 lb. rough paper,
collection of the author.*

This self-taught artist, who learned a lot from John Marin (for whom she kept house during the later years of his life), has a style that is remarkably her own, despite the force of Marin's presence.

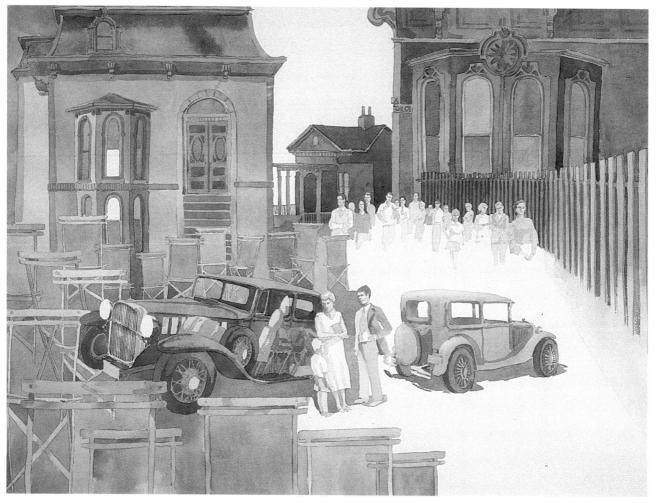

AUGUST 17
*by Bill Tinker, c. 1970,
29³/₄" × 36¹/₂" (76
× 93 cm), collection of the
Springfield Art Museum,
Springfield, Missouri.*

Tinker's style techni-
cally resembles that of
DeWitt Hardy, but Tin-
ker and Hardy each
give the viewer a very
different visual state-
ment about their human
experience.

Rather than consciously pursuing a style, work at developing your personal vision. This distinction may seem like splitting hairs. How-ever, it is intended to help you work in a way that will *produce* your style, rather than en-courage you merely to seek one as if it were a stationary "thing." The last thing you should want is to acquire your style and then just churn out paintings. Any style worth the name grows and changes precisely because it is a reflection of the artist's personal vision and experience of the world. For this reason it's best to look for what you respond to most deeply in your subjects, your paintings, and—cautiously—the paintings of others, gradually identifying and building on the unique bent of your talent. Your style will then start emerg-ing, expressing your own growth as a person and as an artist.

Comparing Styles

For a change, this chapter will encourage you to look at some pictures other than your own. The purpose is to show you what elements other artists have chosen to use and how they have put them together to form their different coherent picture worlds.

August 17 by Bill Tinker does not progress from light to dark, although he has economi-cally placed darker modeling washes over lights in many areas, reserved lights, and maintained loosely crisp edges. It is basically a wash painting in which surface coherence arises in part from the uniformity of texture.

The composition is a modified center-fo-cused design: the couple with the child are placed at the vertical center just below the horizontal center of the paper. Visual richness derives from the complex interplay between similarities and contrasts of line, shape, and size, as well as value contrasts. The large value pattern of lighter areas from lower right to upper center, contrasted against middle tones, creates an attractive thematic state-ment from a distance, while smaller darks create flickering contrasts at a normal viewing distance.

Tinker has relied heavily on the force of his design for coherence because he chose an essentially non-illuministic kind of representa-tion. Notice, nevertheless, how effectively he has selected the darks and how they define the automobiles and architectural details.

The subject is a visual encapsulation of

time—a virtual collage of spatial contradictions and strange juxtapositions of objects and styles that suggest a jumble of visual memories. Time does not just stand still, it telescopes. The painting's large size is fully justified by its subject.

How does the artist make this bizarre assemblage work? He presents viewers with a coherent visual idea and gives them clues to it. For example, the cars and the clothing styles refer back to the late 1920s or early 1930s. The late-nineteenth-century architecture suggests a generation even further removed. This is confirmed by the empty chairs and the wraithlike presence of the people at right, who are thin and small compared with the building behind them. Contrast is the primary means by which the artist clarifies his meaning, while similarity helps maintain visual consistency.

Despite contradictions in the fractured picture space, there is a clear movement back into illusory depth. The sequential diminution of size in the fence, the chairs, and to a lesser extent, the figures creates movement, which also functions as a paradigm of passing time. One wonders whether the child at the painting's center is meant to be the artist.

Karl Schmidt-Rottluff's *Landscape* (page 98) is obviously a very different sort of picture. Although there is a sense in which all paintings of quality—even those with brutal subjects—can be said to be celebratory, Schmidt-Rottluff's undeniably is.

The picture is mainly a wash painting, but it was done with such verve that stroke marks remain embedded in the washes, recording the vibrancy of its execution over the entire surface. This liveliness informs the whole scheme and lets the viewer see it as perennially filled with light and life. It radiates affirmation.

Visual Organization and Style

Finally, let's compare two paintings that in a terse catalogue description might seem to have exactly the same subject: a girl lying down, reading. A quick glance at Sidney Goodman's *Eileen Reading* and DeWitt Hardy's *Studio Interior, Fall* shows that the paintings could not possibly be confused—underscoring the fact that paintings are couched in terms of *visual,* not verbal, organization.

How different *are* they? And *how* are they different? Let's try to articulate, as completely as possible, the reasons for the distinctive expression each painting projects. My purpose here is to give you an example that will help you as you try to analyze the unique qualities of your own work.

Both artists place the reading material at the center of the picture, together with the head and hand of the reader, and the whole of

Goodman's figure is there, too. Beyond this, however, the two artists develop their paintings very differently.

First, Goodman puts strokes on a fairly smooth paper, whereas Hardy puts washes on a moderately rough one. Goodman softens most edges and achieves surface textures through modulation of his strokes, whereas Hardy creates delicate but wiry edges and achieves texture through pigment granulation.

Goodman emphasizes strong diffused light to model forms and bleach away the reader's exterior world. Hardy's light is very gentle; even the direct sunlight coming through the window is muted. Form is softly rendered, and the exterior world is not only visible through the window but also brought within, through the vase of flowers.

Goodman looks perpendicularly toward the room's back wall and lets the sofa push directly into his vigorously created space. The arrangement creates strong vertical/horizontal contrasts on the two-dimensional surface. Hardy's space is less emphatic, stressing a very different two-dimensional pattern. Vertical and horizontal here form a contrapuntal theme played against two interlocked arcs in illusory depth. One is relatively light, moving from the reader's feet, along her body and left arm, and out through the light of the window. The other, darker arc extends from the table and books at foreground right and along the blanket to the books and shaft of sunlight at left. Just above the intersection of these arcs are the reader's head, magazine, and hand. Light, reflecting from the page she holds, illumines her face—expressive of the mind's illumination from reading (a device Rembrandt used). To the far left is the edge of a mirror, also symbolic of reflection and the private life of the mind. Notice, too, that the rectangular shapes of the closed books echo the magazine's shape and relate to the vision through the windowpanes as well—another way of stating the theme visually.

The vanishing point in Goodman's picture comes behind the center of the newspaper (also a device as old as Masaccio), which further emphasizes the newspaper and the part of the reader's face that we can see. Notice that Eileen's face, too, is illuminated by light reflected from her paper. The circular shapes that Goodman plays against his architectonic structure are emphasized by the strong lateral verticals. The primary curve of the sofa support relates to the more open reverse curve below; it is modified by the shape of the girl's hips and changed again to the shape framed by her legs. This is picked up and inverted in the table legs at right. As we study these changing shape relationships, we

EILEEN READING
by Sidney Goodman, 1974, 15" × 22½" (38 × 57 cm), collection of Mr. and Mrs. Michael Schwartz.

Goodman's vision emphasizes sturdy vertical and horizontal lines, full modeling of volumes in light, and eloquent contrasts of curvilinear and rectangular shapes.

STUDIO INTERIOR, FALL
by DeWitt Hardy, 1975, 32" × 22" (81 × 56 cm), cold-pressed paper, courtesy of Frank Rehn Gallery, New York.

Hardy's vision emphasizes diagonals, letting horizontal and vertical lines provide accents, and his marvelously limpid modeling is played down.

PUTTING IT ALL TOGETHER

see how the reader's head also inverts the sofa arm curve and how her head is picked up by the mirror above. As in Hardy's painting, it is not the overt subject, but the interplay of these shapes and their meanings, that provides the artist's expression.

Both paintings are about introspection and reflection and about privacy—and the weakness of one's defenses against invasion of it. Because both express this in terms of a woman's vulnerability, they carry erotic overtones. But because of the differences in each painter's approach and selection of artistic options, our response to each picture is quite singular. Goodman's is assertive but tender; Hardy's evokes a mood of pastoral innocence.

Finding Your Own Way

As you increasingly become yourself as a painter, your pictures will speak more and more clearly through their visible order of the worlds that only you can see.

Style is not just a way of handling paint or designing compositions. It is the way we see; it is our personal vision, ordered and structured in our own way. My painting *Charles Street Window* is a good example of my particular style—both visually and symbolically. For example, outerness and innerness speak to me about the ways in which we experience both ourselves and others. As a New Englander, I feel that the seasons reflect the passage of time. And the strange relationships between art and life are hinted at by the figurine turning its back to the fragmentary political sign while facing Coca-Cola. A further irony piqued and amused my art-historical self: the little cement garden putto is a steal from Michelangelo's David. You will find a similar weaving together of motives, interests, and impulses in your work as you refine means of expressing your personal vision.

What I have tried to do in this book is provide suggestions about some of the kinds of decisions you can and should make. Please don't take anything I've said as a rule—except one: your picture world must have a coherent order. It's your creation, you're its boss. You owe it form, clarity, and structure. Only then can it aspire to meaning or beauty. And on the way, remember: nothing that works is wrong. Good luck.

CHARLES STREET WINDOW
by Carl Schmalz, 1982, 22" × 30", (56 × 76 cm), 140 lb. hot-pressed paper, collection of the author.

In this picture a number of my personal interests coalesce, reflecting some important aspects of my style.

Bibliography

Albers, Joseph. *Interaction of Color*. New Haven and London: Yale University Press, 1971. Examples and discussion of relationships among pure colors, size, and shape.

Arnheim, Rudolf, *The Power of the Center. A Study of Composition in the Visual Arts,* rev. ed. Berkeley: University of California Press, 1984. A psychological and aesthetic study of various sorts of visual centers.

Evans, Ralph M. *An Introduction to Color.* New York: John Wiley & Sons, 1948. A thorough discussion of optics and the physical behavior of light, with good material on vision.

Fisher, Howard T., and Carpenter, James M. *Color in Art: A Tribute to Arthur Pope.* Exhibition Catalogue, Fogg Museum, Harvard University, Cambridge: 1974. A complete presentation of the Pope color theory, with examples of its use in analyzing works of art.

Gettens, Rutherford J., and Stout, George L. *Painting Materials.* New York: D. Van Nostrand Co., Inc., 1942. London: Dover, 1966. An especially thorough treatment of pigments and supports.

Gombrich, Ernst. *Art and Illusion.* Bollingen Series XXXV 5. New York: Pantheon Books, 1960. An interesting discussion of the process of picture-making from the point of view of both history and the psychology of perception.

Gregory, R. L. *Eye and Brain, The Psychology of Seeing.* 2d ed., New York and Toronto: McGraw-Hill Book Company, 1963. A history, and discussion of the present understanding, of human visual perception.

Grumbacher, M. *Color Compass.* New York: M. Grumbacher, Inc., 1972. A concise summary of color as it affects the artist.

Hill, Edward. *The Language of Drawing.* Englewood Cliffs, N.J.: Prentice-Hall, Inc., 1966. A provocative and illuminating analysis of drawing.

Land, Edwin H. "Experiments in Color Vision." *Scientific American,* May, 1959. (Available in separate reprints.) A report on some interesting possibilities regarding human color vision.

Mayer, Ralph. *The Artist's Handbook of Materials and Techniques.* 3d ed., New York: Viking Press, 1970. London: Faber and Faber, 1964. A complete compendium of materials and their uses.

Pope, Arthur. *The Language of Drawing and Painting.* New York: Russell and Russell, 1968. An excellent introduction to drawing, painting and color.

Ross, Denman W. *A Theory of Pure Design.* Boston: Houghton Mifflin Co., 1907. An early publication, outlining an analytic theory of design.

———— *On Drawing and Painting.* Boston: Houghton Mifflin Co., 1912. An introduction to the principles of design and their application to representational art.

Shahn, Ben. *The Shape of Content.* Cambridge: Harvard University Press, 1957. A description by an artist of an artist's working process as well as other thoughts on the artist's place in society.

Index

Above Lexington Ave., 106, *107*
Allred, Osral B., 12, *14*
Among Bare Maple Boughs, 131-133, *132;* detail, *133*
Anchorage, October, The, 95, *95*
Antique Dealer's Porch, 36, *36-37,* 39, 101
Atmospheric perspective, 68
August 17, 138, *138,* 139

Backdoor, 24, *27*
Balance, 36, 39-40
Beinn Tangaval, Barra, 17, 33, *34*
Bermuda, 120, *121,* 122
Boat House Basement, 20, *21*
Brush with Winter, A, 17, 96, *96-97*
Brushstrokes, 17, 19, 33, 110-117, 124, 126-127, 131, 139
 to create focal distance, 17, 19
 to organize surface, 110-117
 texture of, 124-129
Burchfield, Charles, 27, 98
Burns, Paul C. 12, 13, *12-13*

Cattle, 126, *126*
Charles Street Window, 141, *141*
Chez Leon, 38, 39, 87
Cliffs, Bermuda, detail *54;* 80, 91, *91*
Coherence,
 abstraction and, 100
 color and, 98-99, 101
 expressiveness and, 100-101
 using surface texture, 110-117
 viewing distance and, 131-135
 without light, 98-102
Coleman, Loring W., *51,* 118, 131, *132, 133*
Color,
 choice of, 53, 74
 complementary, 50, 74-75, 98
 elements of, 48-51
 primary, secondary, tertiary, 48-50
 scale of, *49*
 temperature and balance, 72-73
 triad of, 73
 see also Hue, Pigments
Color constancy, 84, 88, 89
Color design, 66-75, 98-99, 101
 using color similarity, 66-67
 using sequential relationships, 68
Color mixing, 60-65
 intensity, 62-63, 65
 graying, 63-65
Color perception, 84-85
Colored light, 82-89
 darks in, 87-89
 shadows in, 84-85
 unifying with, 87-88
 values in, 87-88
Complementary color, 39, 50, 74-75, 98

Composition, 30-35, 36-41, 42-46, 131, 138
 using the center, 30-34, 138
 using contrast, 42-46
 using similarities, 36-41
Constable, John, 10
Contrast, 42-46, 72-73
Cranberry Island, Maine, 128, *128;* detail *128*
Crawl Hill, Bermuda, 17
Culver, Charles, 126, *126*

Darks, 87-89, 90-97, 138
 in colored light, 87-89
 composition and, 92
 function in watercolor, 90-97
 reserved lights and, 94-95, 97
 shadow pattern, 92-93
David, 141
Demuth, Charles, 68, 100, *101*
Design, *see* Composition
di Carlo, A., 114, *114*
D'Isa, Mary Kay, 12, *14,* 17, 96, *96-97,* 126, *127*
DiStefano, Domenic, 112, *112*
Dock Square Florist, 22, 23
Do's Hat, 25
Dove, Arthur, 98
Drawing, 90
Dusk, Stonehenge, 110, *111*
Dürer, Albrecht, 10

Ebbing Tide, Kennebunkport, 54, *55;* detail, *55;* 80
Edges, 118-123
Eileen Reading, 96, 139-141, *140*
Ell, The, 51, 118
Elliott, James A., 114, *115*
Enclosed Garden, 12, 92, *92-93*
Expressionists, 78
Expressing *vs* describing, 100, 101, 135

Fisherman's Morning, 10, *11,* 12
Flaubert, Gustave, 8
Flop No. 1 (detail), 118, *118*
Flop No. 2 (detail), 118, *119*
Flop No. 3 (detail), 118, *119*
Flory, Phoebe, 20, *20,* 24
Focal contrast, 96, 97
Focal distance, *see* Focus
Focal point, 31, 96-97
Focus, 16-20, 23
 distant, 17-19
 foreground, 16-17, 20
 middleground, 17, 19, 34
Format, 26-28
Fort River, Fall, 68, *68-69*
Fractured Face, 24, *25*
From Wood Island, 114, *114-115*

Gargoyles Over the Seine, 22, *23*
Gentle Surf, 116, *116*
German Expressionist, 98
Glazes, 89
Goodman, Sidney, 96, 139-141, *140*
Government Wharf, 10, *11,* 12, 95
Graham, Margaret, *51*
Granite Coast, 136, *137*
Great Maple II, 39, *39*

Hardy, DeWitt, 112, *113,* 138-141, *140*
Hassam, Childe, 10, 66
Haunted Island, 101, 136, *137*
Healy, Arthur, K., 100, *100,* 101
Heideman, Susan, 67, 73, 126, *126*
Homer, Winslow, 10, 122
Hopper, Edward, *6,* 22, *22,* 133, *134*
Hue, 48-50
 analogous, 63, 66
 complementary, 50
 similarity of, 66-67
 warm and cool, 72-73
 see also Color
Hue/intensity scales, *49, 52*

Impressionists, 10, 66, 78
Intensity, 48-51
 of color, 62-63
 contrasts, 73
 designing with, 66-67
 mixing using complements, 50
 scales, *49, 52*
Interior, New Mexico, 6, 133, *134*
Intervals, 36-41, 42, 45

July 6, 1976, 72, *72-73*

Kaep, Louis J., 36, *36-37,* 39, 101
Kakemono, 24
Kinstler, Everett Raymond, 20, *21,* 24
Kitchen Ell, 30, *32*
Kline, Franz, 12
Knife textures, 128-129
Kranking, Margaret Graham, 12, 43, *43*

La Tour, Georges de, 88
Land, Edwin, 72
Landscape, 66, 68, 98, *98-99,* 139
Landscape, Bermuda, 68, 101, *101*
Latch, The, 16, *16*
Lavender Blue, 126, *127,* 128
Lawn, 60-61, 80
Lawn Chair, 124, *125*
Lehmann, Dee, *94,* 95
Light-to-dark painting, 104-109
Lighthouse on Gibbs Hill, Bermuda, 17, *80,* 91
Lighting, 76-81, 102
 direct, 76-81
 direction of, 76, 81, 95

indirect, 80-81
 reflected, 84
 source of, 81, 87, 88
 three-dimensionality and, 76-79, 81
Line, 36-41, 42
Llamas, Cuzco, 90, 91

Macknight, Dodge, 10, 66
Madame Bovary, 8
Maine Gables, 70, *71*
Maine Morning, 78, *78*
Maine Still Life, 12, 72, 120, *120,* 122
Marin, John, 98, 100, 137
Marineland Porpoises, 33, *33*
Masaccio, 139
Masters, Steven, 79, *79,* 124, *125*
Meditation, Warwick Long Bay, 18-19, 19
Mexican Bus, 84, *85,* 87
Michelangelo, 136, 141
Moonlight Demonstration, 86-87, 87
Morning Fog, 80, *104-105,* 106
Morning—19th St., 20, *21,* 24
Morning Surf, 136, *137*
Murry, John H., 128, *128*

Nehus, Jonee, 84, *85,* 87
Nursery, 67, 73, 126, *126*

O'Hara, Eliot, 22, *23,* 33, *33, 38,* 39, 54,
 80, *82-83,* 87, *90,* 91, *91,* 106, *107,*
 110, *111,* 136, *137*
Out Back, 124, *125*
Overcast Island, 70, *71*

Paint texture, 124-129, 138
Palette colors, 48-53, 73
Paper, 2, 24-28, 110, 124-125, 128, 139
 size and shape, 24-28
 surface of, 2, 110, 124-125, 128, 139
Pigments, 54-59, 65, 124
 opaque, 58-59, 65
 organic and inorganic, 57
 test for light-fastness, 58
 test for staining properties, 58
 test for transparency/opacity, 58-59
 texture, 124
 transparency, 57
Polish Rider, 8
Polly's Piano, 84, *85,* 87
Pope Julius III, 26
Porter, Fairfield, 60, *60-61,* 80
Prancing Wooden Horses, 12, *14*
Prendergast, Maurice, 66, 98
Procedural problems, 106, 117

Raphael, 26
Rembrandt, 8, 136, 139
Repetition, 36-39, 42, 45
Reserved lights, 94-95, 97, 104, 109,
 120-123
 planning, 120-123
Rocks and Sea, 100, *100*
Roman Prospect, 44-45, 45
Romanticism, 10
Rural Fire Station, 92, *92*

Salt Marsh, June, 19, 67, *67,* 72
Sargent, John Singer, 10
Schmidt-Rottluff, Karl, 66-68, 98, *98-99,*
 139
Secondary mixing exercises, *64*
Sequence, 36-39, 45, 68
Shack at Biddeford Pool, 2, 91
Shadows, 76, 78, 80, 84-85, 89, 91-93,
 97
 architectural, 91
 cast, 78-79, 88-89
 characteristic shapes of, 92
 in colored light, 84-85
 contours, 76, 78, 91
 patterns of, 92-93, 97
Shapes, 36-43, 92
 contrasting, 42-43
 of shadows, 92
 similar, 36-41, 43
Shedd, George, 70, *71*
Shore Rain, 42, *42*
Similarities, 36-41, 43
 color, 66
 in design, 33, 36-41, 43
 intensity, 66-67
 shape, 92
Sisley, Alfred, 136
Sizes, 36-41, 43
Sketch for Kitchen Ell, 32, 108
Sketches, 82, 106, 108, 135
Small Point, Maine (detail), 122, *122*
Smokehouse Interior, 51
Snow/Crocus, 114, *114*
Solovioff, Nicolas, 17, *17, 76-77,* 78, 80,
 80, 91
South from Tucker's Town, 54, *56-57*
Space, 20-23
Spatial organization, 20-23
Sparkle, 96-97
Spring Studio: Swamp Azaleas, 45, 70,
 70
Steens, Jan, 136
Steven's Studio, 45, *46*
Stonehenge, 110, *111,* 116

Strokes, *see* Brushstrokes
Studio Door, 12, *12-13*
Studio Interior, Fall, 139-141, *140*
Style, 136-141
Subject,
 altering the, 102
 architectural, 33, 45, 80
 choice of, 10-15
 nature as a, 92, 100
 placement of, 18-19
Sunset Between Santa Fe and Taos,
 82-83, 87
Surface, 20, 100, 101, 124-129
 coherence, 110-117, 124, 138
 strokes and washes, 110-117
 texture of, 124-129
 unity, 110-117, 122
Susie, 101, 136, *137*

Tender, The, 12, *14*
Texture, 124-129, 138
Texture Sample, 126
Tide, 24, 30, *31*
Tinker, Bill, 101, 138, *138,* 139
Transparencies, 124, *124*
Transparency, 57-59
Transparency/opacity tests, *59*
Turner, J.M.W., 10
12:15, Cape Porpoise, 62, *63,* 79
205 Hill Street, 94, 95

Universalist Church, Gloucester, 22, *22*
Up for Repairs, 112, *112*
Up Somerset Way, 79, *79*

Value, 48
 contrast, 45-46, 60, 70-71, 74, 87, 97,
 138
 intensity and, 50
 pattern, 80, 87
 scale of, *49*
Viewing distance, 131-135, 138

Waiting for Spring, 12, 43, *43*
Wall Pattern, Venice, 20, *20,* 24
Washes, 17, 110-117, 138, 139
Webster, Larry, 16, *16,* 22, *23,* 24, 27,
 27
Westerly, 134
Wet-in-wet, 114, 116, 117, 123
White light, 84
Windsor Hotel, Cape May, 76-77, 78
Winter's Work, 60, *62,* 68, 92
Woman Resting, Winter, 112, *113*
Wyeth, Andrew, 120, *121,* 122, 124, *125*